Fetishism

Visualising Power and Desire

Edited by Anthony Shelton

in association with Lund Humphries Publishers, London

First published in Great Britain in 1995
by The South Bank Centre
and The Royal Pavilion, Art Gallery and
Museums, Brighton in association with
Lund Humphries Publishers Limited
Park House, 1 Russell Gardens
London NW11 9NN

on the occasion of the
National Touring Exhibition *Fetishism*
from The South Bank Centre 1995

Fetishism: Visualising Power and Desire
© The South Bank Centre 1995

Essays © the authors 1995

British Library Cataloguing in Publication Data
A catalogue record of this book is available
from the British Library

ISBN 0 85331 677 5

Exhibition curated by Dawn Ades,
Roger Malbert and Anthony Shelton
Exhibition organised by Fiona Griffith and
Roger Malbert at the South Bank Centre
and Nicola Coleby and Louise Tythacott at
Brighton Museum & Art Gallery
Educational material for the exhibition
prepared by Helen Luckett

Lund Humphries House Editor: Lucy Myers
Catalogue designed by Ray Carpenter
Typeset by Nene Phototypesetters Ltd,
Northampton
Printed in Belgium by Snoeck Ducaju
& Zoon N.V.

South Bank Centre publications may be
obtained from Art Publications, The South
Bank Centre, Royal Festival Hall,
London SE1 8XX

Exhibition tour:

Brighton Museum and Art Gallery
Brighton
29 April - 2 July 1995

Castle Museum and Art Gallery
Nottingham
22 July - 24 September 1995

The Sainsbury Centre for Visual Arts
University of East Anglia
Norwich
9 October - 10 December 1995

Contents

Acknowledgements

This publication accompanies the exhibition organised by National Touring Exhibitions at The South Bank Centre in collaboration with the Royal Pavilion, Art Gallery and Museums, Brighton. We should like to thank the artists and lenders who have made the exhibition possible, and in particular Marc Leo Felix for the generous loans from his collection. We are extremely grateful to the many people who have given valuable help and advice, especially the following: Jeremy Adams, Elizabeth Adcock, John Allan, Janita Bagshawe, Marla Berns, Frances Calvert, Camay Chapman-Cameron, St John Child, Birthe Christensen, Kevin Conru, John Cooper, Neil Cummings, Nigel Cunningham, James Donald, Fabian, Roy Flint, Mark Erisian Garbs, Sarah George, Teresa Gleadowe, Audrey Gregson, Joanna Haire, Jim Hamil, Gerry Hawkey, Cecile Hermans, Frank Herreman, Julie Hudson, Dale Idiens, Lianne Jarrett, Mike Jones, Hans-Joachim Koloss, Stella Lancashire, Antonia Lovelace, John Mack, Joy McCall, Piet Meyer, Nigel, Neil Oppegaard, Jenny Peck, Anthony Penrose, Harry Persaud, J. Roegiers, Nick Sinclair, Michael Sweeney, Anne Verbrugge, Gisela Volger, Niki Wolf, Tim Woodward and the staff of *Skin Two*.

Research and curatorial guidance for the contemporary section of the exhibition were provided by Kitty Scott and William Jeffett.

Picture research was coordinated by Louise Tythacott, with assistance from Elizabeth Adcock, Joanna Haire, Stella Lancashire, Joy McCall and Jenny Peck.

We gratefully acknowledge financial support for the exhibition from The Elephant Trust and The Henry Moore Foundation.

The Institute of International Visual Arts has collaborated with National Touring Exhibitions and the Royal Pavilion, Art Gallery and Museums, Brighton, in commissioning Sonia Boyce to create an installation parallel to the exhibition.

Henry Meyric Hughes
Director of Exhibitions, The South Bank Centre, London

Jessica Rutherford
Head of Museums and Director of the Royal Pavilion, Brighton

Roger Malbert
Head of National Touring Exhibitions, The South Bank Centre, London

Lenders to the Exhibition

Barcelona, Galería Ciento
Barcelona, Galería Joan Prats
Brighton, The Royal Pavilion Art Gallery and Museums (Ethnographic Collection and Booth Collection of Natural History)
Cologne, Collection SUMAK
Exeter, City Museums
Leuven, Katholieke Universiteit
London, Trustees of the British Museum
London, Faggionato Fine Arts (private collection)
London, Avril Giacobbi
London, Laure Genillard Gallery
London, The Board of Trustees of the Victoria and Albert Museum
Maastricht, Galerie Wanda Reiff
New York, Timothy Baum
Paris, Association 'Autour de Gilles Dusein'
Paris, Galerie Chantal Crousel
Paris, Galerie André François Petit
Paris, Lucien Treillard Collection
Washington DC, David Adamson Gallery

Collection Marc Leo Felix
Private Collection
The Artists

Introduction Anthony Shelton

THE IDEA of an exhibition on 'fetishism' had its origin some ten years ago, when Adrian Gerbrands, then Professor of Cultural Anthropology at the University of Utrecht, remarked that the so-called 'nail fetishes' of the Kongo people, properly called *nkisi nkondi*, may have had their origin in the beliefs and practices of medieval Europe. It seemed startling and significant that a genre of sculpture, the powerful and aggressive features of which had, more than any other, embodied the European ideal of 'savage' art drenched in superstition and soaked in occult and primitive motives, might be more closely connected to European imagination than to African belief. As we became familiar with the history and usage of the word 'fetish' and the connecting tissues of Western perceptions and Kongo beliefs and practices, 'fetishism' appeared to provide a model subject for a deconstructivist exhibition on the history of the different ideas which the word had come to express. In this way African art could be presented as a mirror to reveal Europe's historical prejudices, while showing the distant sources from which certain contemporary practices had borrowed their often problematic images, practices, thoughts and even analytical tools.

Part of the problem with 'fetishism' is the ambivalence which forms an essential quality of the term itself. Notions of 'fetishism' often imply ambiguity and disavowal (the simultaneous belief in the truth and falsity of something), and are used in discourses that are either about power or project power or authority on to supposedly subordinate groups such as foreign subjects, women, 'degenerates' and the insane. 'Fetishism' is an essential part, therefore, of the West's hidden history of sex, mind and commodity.

'Fetishism' has parodoxical meanings. In early theories of religion in psychiatry, and in the work of Freud and Lacan, 'fetishism' comes to be associated with deficiency, loss and disavowal, while for others, including Marx, Bataille and Baudrillard, it signifies excess. Frequently, deficiency and excess occur in the work of the same writer.

Categories of excess and deficiency are usually interpreted as transgressive and potentially disruptive to social order. In another paradox, nineteenth-century psychiatry and sociology, while defining 'fetishism' as perverse and pathological and recommending 'treatment', also found it a normal, though regrettable, component of everyday life. The narrator in Michel Tournier's play *The Fetishist* (1978) exemplifies the downfall of the 'miscreant' after the traumatic event that afflicted him with his fixation, from the partial resolution of his sexual difficulties by appropriately dressing his partner, to embarking on a life of crime to satisfy his increasing desires for the fetishised underclothes, and the transference of his fixation from silken clothing to similarly textured banknotes, ending in his eventual incarceration in the asylum. Despite the fear of the progression from sexual deviancy to criminality that the malady was thought to provoke, psychiatrists and social theorists alike also saw it as part of everyday behaviour. The nineteenth-century anthropologist Edward Tylor found it surviving in Europe as superstitious and irrational religious belief, while Alfred Binet and Freud agreed that a certain degree of fetishistic behaviour was part of 'normal' life.

A third and final paradox is that despite the insistence of psychoanalysis itself that women do not fetishise, the female fetish scene flourishes. High heels, lingerie, leather, rubber and PVC clothing proliferate, fetish shops such as Zeitgeist, Ectomorph and Ritual are doing a swift business, the number of clubs is steadily growing and spreading away from London to the regions, while women have recently become the largest growth market for pornography.[1] Psychoanalysis seems itself to have disavowed what is common knowledge.

These themes and ambiguities are explored visually in the exhibition and textually in the essays of this catalogue which accompanies it. 'The Chameleon Body' examines how 'fetishism', invented by Europe, misrepresented Africa's religious beliefs and intellectual capacities. By compounding religious and sexual 'fetishism', European discourse subordinated Africa to European tutelage, while at the same time endowing its womenfolk with sexual qualities denied their oppressors at home. Contemporary European 'fetishism' coalesced in the combination of some of the ideas underlying the relationship between religious and sexual 'fetishism' with philosophical, literary, dramatic and artistic elements.

John Mack's essay, 'Fetish? Magic Figures in Central Africa', also criticises the imposition of a Europeanised term, with its prejudices and presuppositions, on to practices and beliefs foreign to it. Through careful and detailed attention to the explanations and descriptions provided by Kongo specialists themselves, he is able to show the complex discriminations made between objects and their significance in relationship to wider religious beliefs usually ignored by missionaries and early travel writers. The essay not only challenges European assumptions about 'fetishism',

but questions whether the style and form of objects can provide useful clues to their significance. Comparing *minkondi*, bristling with nails and other hardware festooned with ribbons and impregnated with sacred medicines, with the fine, smooth naturalistic-looking king figures of the Kuba, another people of Zaire, he concludes that both shared similar purposes and uses.

Dawn Ades, in 'Surrealism: Fetishism's Job', traces the history of the term 'fetishism' from its adoption by nineteenth-century psychiatry to its incorporation and interpretation by the Surrealists. The Surrealists, she argues, became aware of fetishism more through the writings of Binet than Freud, though their attitude to it remained ambiguous. On the one hand, aware of the political and racial implications of the term, they were reluctant to embrace it, while at the same time they were unable to hide their intrigue with a term that had been deeply associated with the irrational and primordial instincts and dream-like reality they sought to provoke. Nowhere was this ambiguity more in evidence than in their submission of Catholic saints as Western 'fetishes' to the 1931 Anti-Colonial Exhibition while reviving 'fetish' through 'the Surrealist object functioning symbolically'.

Critical engagement with Western notions of the 'fetish' has continued through the work of the contemporary artists discussed by Roger Malbert in 'Fetish and Form in Contemporary Art'. Here the focus has been related to methodological insights provided by psychoanalysis and historical materialism. In these avowedly personal works, issues of fetishisation, alienation and sexual displacement, and disavowal are sometimes intertwined with individual biography and family history. In the case of Renée Stout, at least, the personal exploration of such complex and powerful forces has led to the reappropriation of the original African significance of 'fetish' and the positive affirmation of a strand of Afro-American identity which is only now becoming generally acknowledged.

FOOTNOTE

1. Anne McClintock, 'The Return of Female Fetishism and the Fiction of the Phallus', *New Formations. A Journal of Culture/Theory/Politics*, 1993

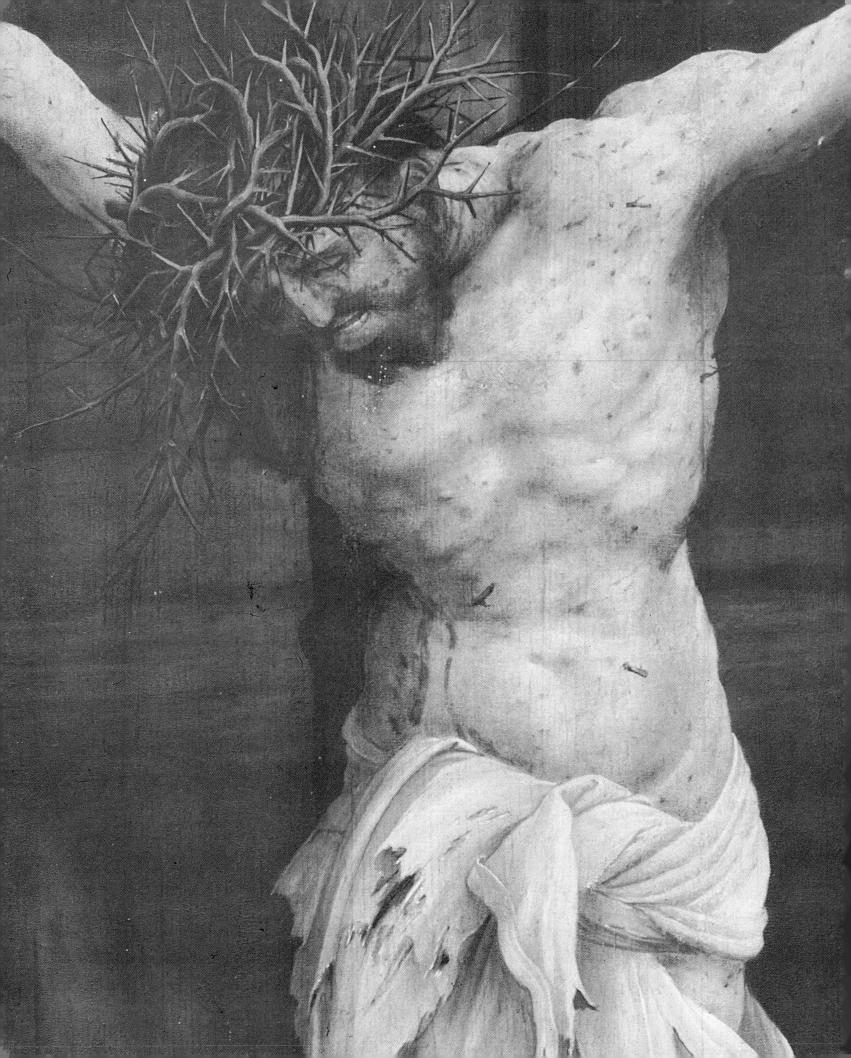

The Chameleon Body

Power, Mutilation and Sexuality Anthony Shelton

'Let us remember that "fetish" is an entirely European term, a measure of persistent European failure to understand Africa.'

Wyatt Macgaffey[1]

THIS ESSAY EXPLORES those European prejudices, practices and images which were woven together to provide a framework for the description of African 'fetish' beliefs. At the same time the view that religious 'fetishism' was the product of a regressive or degenerate mentality allowed Europeans to attribute to African women an excessive and exotic sexuality. Religious and sexual 'fetishism' were combined to reinforce prejudices about mind and body. In late twentieth-century Europe, less moralistic regimes have acknowledged a greater diversity of sexual pleasures, admitting forms of sexual imagery previously exiled to the colonies. European 'fetishism' has used the close links erroneously established between religion and sexuality in Africa by earlier writers to create new forms of sexuality stripped of their originally exploitative and often abusive meaning.

Books and Other 'Bundles of Mysteries'

The Western image of African 'fetishism' was constructed from a selective combination of medieval Christianity and witchcraft beliefs with fifteenth- and sixteenth-century Portuguese, Dutch and French explorers' and traders' accounts of the beliefs and practices encountered on Africa's Guinea coast. Originally, writers made no distinction between 'idols', used to refer to images, and

LEFT: Mathias Grünewald
Christ on the Cross (detail)
Date unknown
Staatliche Kunsthalle, Karlsruhe

'fetishes', a term then reserved for charms and amulets. By the eighteenth century, the meaning of the terms had become confused until both were subsumed under the gloss 'fetishism'. African religion thus became inextricably linked to European ideas of witchcraft.[2] These travelogues provided the source for an intellectually coherent but abstract view of 'fetishism' developed by Enlightenment philosophers and social theorists, who saw it as representing the most primitive stage of religious practice. The term was further elaborated and codified during the period of the rapid European colonisation of Africa (1880-1920) by writers such as Mary Kingsley (1897) and Robert Hamill Nassau (1904) who, from the personal reminiscences of missionaries and traders, combined with their own experiences, produced compendiums that contributed to the anthropological rationalisation of the subject. Such accounts were also influential in framing the descriptive conventions under which early twentieth-century writers recounted their experiences of African religion. Six authors, all men (missionaries, traders, administrators and adventurers), form a sufficient sample from which to abstract the main characteristics of European thought on the nature of African 'fetishism'. These six authors were chosen over others because of the greater attention given to the subject under discussion. Of these, three – Joachim Monteiro, R. E. Dennett and E. J. Glave – wrote prior to 1900; one – W. Holman Bentley – published on the eve of the new century; and the works of two others – Dugald Campbell and G. Cyril Claridge – appeared in the early twentieth century.

Early authors subsumed definitions of 'fetishes' under descriptions of their form and purpose. Not until the beginning of the twentieth century were more precise and cogent definitions attempted. The Baptist missionary,

William Holman Bentley, defined a 'fetish' as 'derived from the Portuguese *feitiço*, "a charm". A fetish is something which has the power of exercising an occult influence.'[3]

This was consistent with well-established usage but the relationship between magical charms and idolatrous images had been sufficiently important for him to provide more detailed information in the appendix to his *Dictionary and Grammar of the Kongo Language*, published five years earlier. Under the Kongo term *nkinda* (*nkindi*), Bentley wrote:

… a being strong, strengthening: also the charms worn to protect from evil, a phylactery.

N'kinda e evata, a fetish image placed in the centre or entrance of a town to protect the town and ensure its prosperity. A fetish image when carved is a mere piece of wood until a small portion of the contents of a bundle of fetish has been placed in a hole in the head or belly of the image; this portion is called the *nkinda* (strength), and so long as it remains in the image it is a fetish. The soul of the fetish is in the *nkinda*.[4]

Cyril Claridge, a traveller and adventurer with twelve years experience in Africa, also acknowledged the European usage of 'fetishism' to refer to both charms and images, writing:

Congo fetishism is a double-barrelled arrangement of charms (*mwangu*), and images (*teke*). An image is a charm but a charm is not always an image. It is then called *mwangu*. Images among the Ba-Congolese are not idols to be deified, but effigies to ward off aggressive spirits, or to win the favours of friendly spirits. They are more often instruments of revenge to incite the spirits to murder, to maim, or to inflict a malady. A charm may be anything dedicated by a priest for a fetish purpose.[5]

Other 'pioneers', such as Dugald Campbell, defined the term in a more restrictive sense to refer only to charms. 'Fetish,' he writes, 'comes from the Portuguese word, *feitiço*, meaning a superstitious charm or magic medicine.'[6]

Most authors agreed, even when they acknowledged African beliefs that 'fetishes' could not be used for evil, that the practice was abominable to civilised taste and reason. Later writers, however, tempered their distaste of the practices by agreeing that Africa had no monopoly over such beliefs and admitted, no matter how reluctantly, to similar 'superstitions' in their own homelands.[7]

All six authors under discussion distinguish between types of 'fetishes', usually according to the jurisdiction of their agency or by the material from which they are made. Dennett declares: 'I consider *nkissism* is to be divided into four parts, *ie* the family *nkissisi*, the general *nkiss*, the household *kiss-s-kiss*, and the *molongos* or medicines.'[8] And Glave writes: 'A peep into a fetish-man's sack discloses a curious assortment of preventive-eagle's claws and feathers, fishbones, antelope horns, leopard teeth, tails and heads of snakes, flintstones, hairs of the elephant's tail, perforated stones, different coloured chalks, eccentric shaped roots, various herbs, etc.'[9]

As for Bentley:

The fetish itself may be very various. The power may be contained in a rag, stone, water, pipeclay, or rubbish of all kinds; the more singular and uncanny the better. It may be red camwood powder mixed with pepper, ochrous earth, a snake's head or fang, the beak of a fowl or any bird, a bird's claw, a twisted root, a stone of strange shape, a nut, a piece of elephant's skin, the foot of a crocodile or monitor (*Varana*) lizard, a bead, or a piece of copal. The commonest form of fetish is a bundle of mysteries … the bulk of which is made up of the peppery red powder.[10]

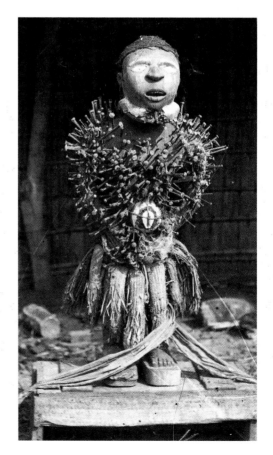

Power object outside a dwelling
Kongo people, Central Africa
Nineteenth century

All except Campbell explain the purpose of 'fetish-ism' by either describing the effects of 'fetishes' or discussing the role of their guardians. According to Monteiro: 'These "fetish men" are consulted in all cases of sickness or death, as also to work charms in favour of, and against every imaginable thing, for luck, health, rain, good crops, fecundity; against all illness, storms, fire, surf, and misfortunes and calamities of every kind.'[11]

Dennett writes:

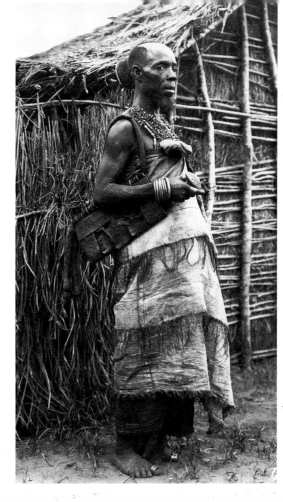

'Fetish' guardian
Teke people, Central Africa
Early twentieth century

Postcard showing power objects
outside a dwelling
Kongo people, Central Africa
Nineteenth century

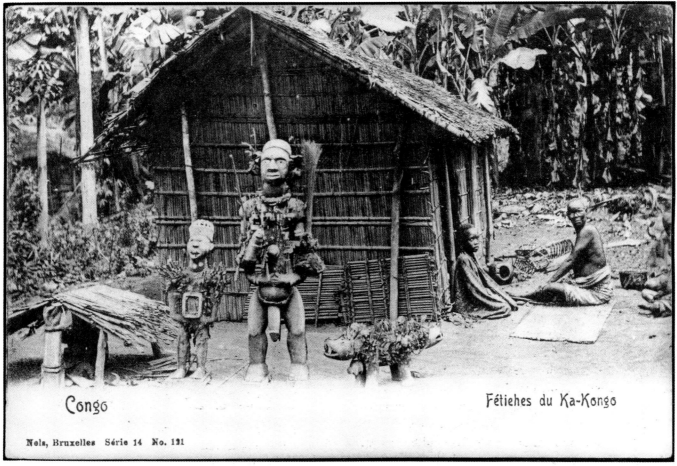

Congo Fétiches du Ka-Kongo

Nels, Bruxelles Série 14 No. 121

13

The evil spirit, Nkiss, pervades all things, and is eternal, invisible, to all save the *nganga*, uncreated, but appears to be especially resident in different large feteiches, each one inflicting, or being the means of avoiding, different evils. They are supposed to punish you with death if you eat forbidden food, if you bewitch anyone, rob, or do anything contrary to their will, prevent rain from falling in its proper season, on the commission of certain indecencies, and for faults of omission cause one to fall sick.[12]

Campbell, on the other hand, affirms: 'The bulk of fetish preparations are preventive and prophylactic, therefore to neglect to provide these, and to consult the oracles in regard to every detail pertaining to Death, Life and Birth, which is frequently a fresh incarnation, is to expose oneself, or one's child, to the displeasure of the departed spirits.'[13] And, according to Claridge: 'There is a fetish for almost every conceivable object within the compass of a negro's mind – for hunting, fishing, trapping, gardening, marketing, travelling, trading, playing, living, or dying; which can make the elements friends or foes, or turn a peaceful citizen into a bird, beast or creeping thing, or stimulate the birth-rate of a clan, or overthrow it with an epidemic, kill, or create as the need arises.'[14]

Monteiro, Dennett, Glave and Bentley mention the authority of the 'fetish' guardian ('witchdoctor', 'priest', 'fetish-man'), but, thereafter, references become fewer. Even Nassau's comprehensive treatment of the subject dedicates only nine lines to discussing the 'fetish doctor'.[15] Lessening European interest in their role seems to correspond with what was thought to be their diminishing ability to oppose missionaries, white settlers and traders, after practitioners went underground.

For these early authors, African belief and adherence to 'fetishism' implied ignorance, leading to an irrational fear of the world around them, and pointed to a basic mental inferiority which was used to justify their tutelage by European powers. Dennett prefaces his description of *Nkis's* [sic] with the thought that

God as we know Him, is quite unknown to poor Fjort, hence his ignorance of all that is good. Though we cannot call him (the Fjort) bad, yet he appears so to us from the absence of what we have learned to consider good qualities in a man, such as love, gratitude, honesty and uprightness, etc. Instead of his actions being prompted by love, duty, etc, all his movements are actuated by selfishness and suspicion, and the avoidance of the evil he is hourly expecting.[16]

The other aforementioned authors were no less ready to draw ill-reasoned moral and intellectual lessons from what, to the European mind, were erroneous and superstitious religious beliefs. Thus Monteiro:

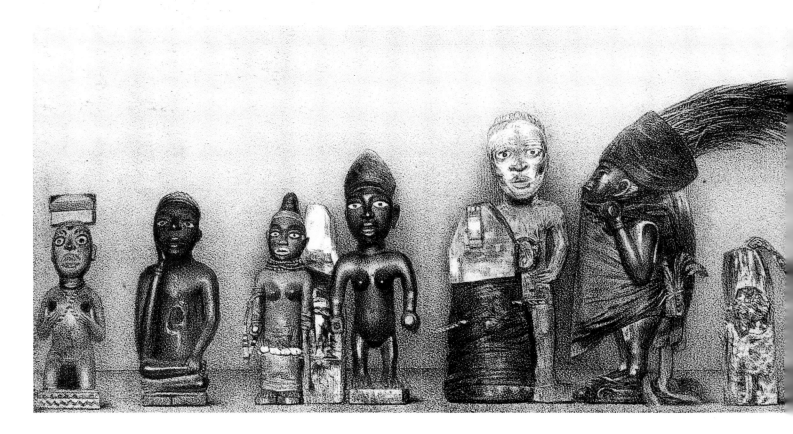

To sum up the negro character, it is deficient in the passions, and in their corresponding virtues, and the life of the negro in his primitive condition, apparently so peaceful and innocent, is not that of an unsophisticated state of existence, but is due to what may be described as an organically rudimentary form of mind, and consequently capable of but little development to a higher type.... His whole belief is in evil spirits, and in charms or 'fetishes'.[17]

Glave observes: 'The native of Central Africa has an inborn dread of evil spirits; he believes that a power unseen by mortal eyes is always present, seeking opportunities to injure mankind; his superstitious mind attributes to this mysterious and malignant influence all reverses and disasters which he may suffer through life.'[18] And Bentley similarly prefaces his chapter on 'fetishism' with the comment: 'Never have we met with anything like a seeking after God on the part of the raw native; indeed, it is a marked characteristic and weakness of the race that an African, Negro or Bantu, does not think, reflect or reason, if he can help it.'[19]

Although Monteiro's views are uncompromising, by the end of the nineteenth century, attitudes were beginning to change. Bentley, for example, argues that superstitious beliefs were not the product of innate mental deficiencies, but of rectifiable ignorance.[20] There was,

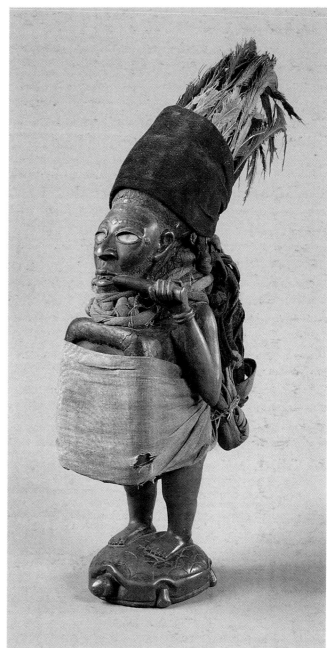

Power figure (*nkisi*)
Kongo people, Central Africa
Museum für Völkerkunde, Berlin

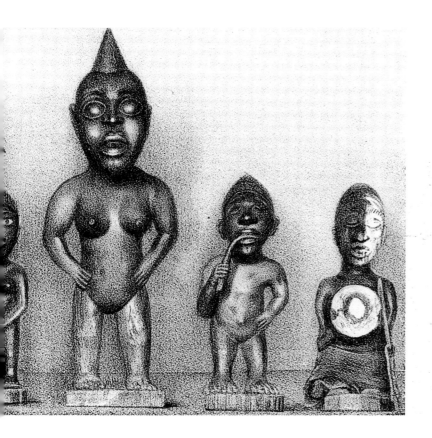

Lithograph showing Kongo power figures in the collection of the Museum für Völkerkunde, Berlin (detail), *c*.1874
From Adolf Bastian, *Die Deutsche Expedition an der Loango-Küste*

therefore, no physiological or neurological difference between the minds of Europeans and Africans, only quantitative and qualitative differences in their knowledge about the world. Such a change helped to justify continued missionary work in Central Africa, and, not surprisingly, this is most clearly expressed in missionary writings. Nevertheless, it was echoed by Campbell who, while still prepared to testify to his own belief of the pervasive sway 'fetishism' continued to exercise, no longer attributes its effects to any innate failure of the mind, noting that 'fetish rites and ceremonies permeate the whole Bantu fabric, beginning at infancy, and more often prior to birth'.[21]

By 1922 Campbell and Claridge are admitting that African beliefs have their counterpart in European superstitions and invite comparison between them. Claridge[22] recounts an Englishman's belief in the luck brought to his family by a horseshoe, but calls this '"high class" fetishism', while Campbell muses about European blind belief in the medical doctor to complain that '… we ourselves are not so very far removed in point of time from the practices of Africa'.[23] While the earliest writers (Monteiro and Dennett), make explicit comment on the amorality and intellectual inferiority of Africans, inferred at least partly through belief in 'fetishism', by the close of the century, 'fetishism' is being seen not so much as being evil, but simply misguided.

Other subjects are approached by these writers more randomly. Bentley gives well-documented examples of the believed efficacy of 'fetish' figures to cure sickness, and alludes to taboos incumbent on their keepers. Monteiro and Glave describe the shelters that housed the figures, Bentley and Campbell discuss their use against witchcraft, and Glave and Bentley the way knowledge was imparted about 'fetishism' through initiation societies. Dennett, Bentley and Campbell contain information as to how the images were activated, while Dennett alone describes the necessary rites performed before an image could be carved.

To one degree or another, all these authors identified 'fetishism', whether as a more or less singular phenomenon or in the form of diverse practices, as the shared religious experience of Africa. Religion throughout the continent was thereby reduced to the common level of spiritual vacuity, a product of fear and superstition bereft of reason and all ethical considerations. These views were contested by some German writers, but the prestige of the most eminent did little to undermine the prejudiced certainties of their British and French contemporaries. The philologist F. M. Müller

doubted the accuracy and relevance of much descriptive material on which the idea was based, while another German, the explorer and inveterate collector of exotic material culture Leo Frobenius, insisted categorically that 'fetishism' reflected the fears and superstitions of a fifteenth-century Europe accustomed to seeing witchcraft and the work of the devil all around them. The term was considered so imprecise and inaccurate that it could equally be applied to many European beliefs and current superstitions such as palmistry. Unlike others who had come to similar conclusions, Frobenius pleaded that the term be abandoned and concluded his criticism with the challenge: 'Show me a people who have not passed through the same experience, and I will cry peccavi, and quietly assent whenever I again hear the negroes addressed in scorn with the words: "You fetish-worshippers, you".'[24]

The Lessons of Images

Even a brief examination of African travel books written between 1875 and 1922 demonstrates the diverse and seemingly unrelated types of objects that the term 'fetish' conjured to the European imagination. Museum classifications up until the mid-twentieth century merely confirmed the stable, if confused, meaning applied to the word since the eighteenth century. A hint of some rational and consistent use of 'fetish' was made in 1909 by Leo Frobenius who suggested that it was used indiscriminately to describe any object that had been decorated with the human figure or head: 'For my collection I have received all imaginable things of the kind, fetish clubs, fetish pickaxes, fetish pipes, fetish goblets, fetish guns, sceptres, bells, masks and, above all, snuff-boxes. If the collector be asked for the reason of this descriptive title, he will usually answer: "Voilà! C'est la figure humaine!".'[25]

Notwithstanding the variety of objects classified by the voyagers, scholars and curators of the fifteenth to twentieth centuries as 'fetish', there is one corpus of images based on the human body which, through their recurrent description and illustration command particular attention. The aforementioned R. E. Dennett, who was trading in Kongo in the latter part of the nineteenth century and who collected[26] and wrote extensively on the subject, observed:

To describe one of these feteiches is to describe them all.

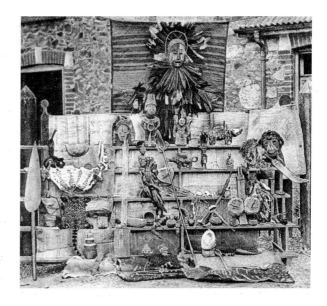

Two power figures (*minkisi*) from the
Congo from the collection of R. E. Dennett
Royal Albert Memorial Museum
and Art Gallery, Exeter

'Feteiches and Curios' (detail)
Photograph by H. J. L. Bennett of
R. E. Dennett's collection
Nineteenth century

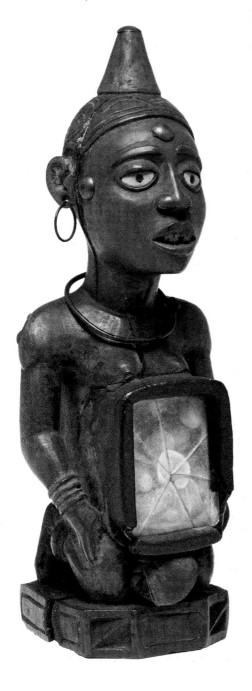

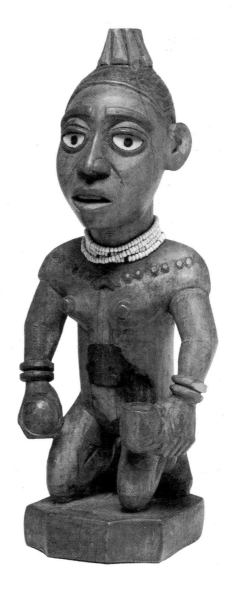

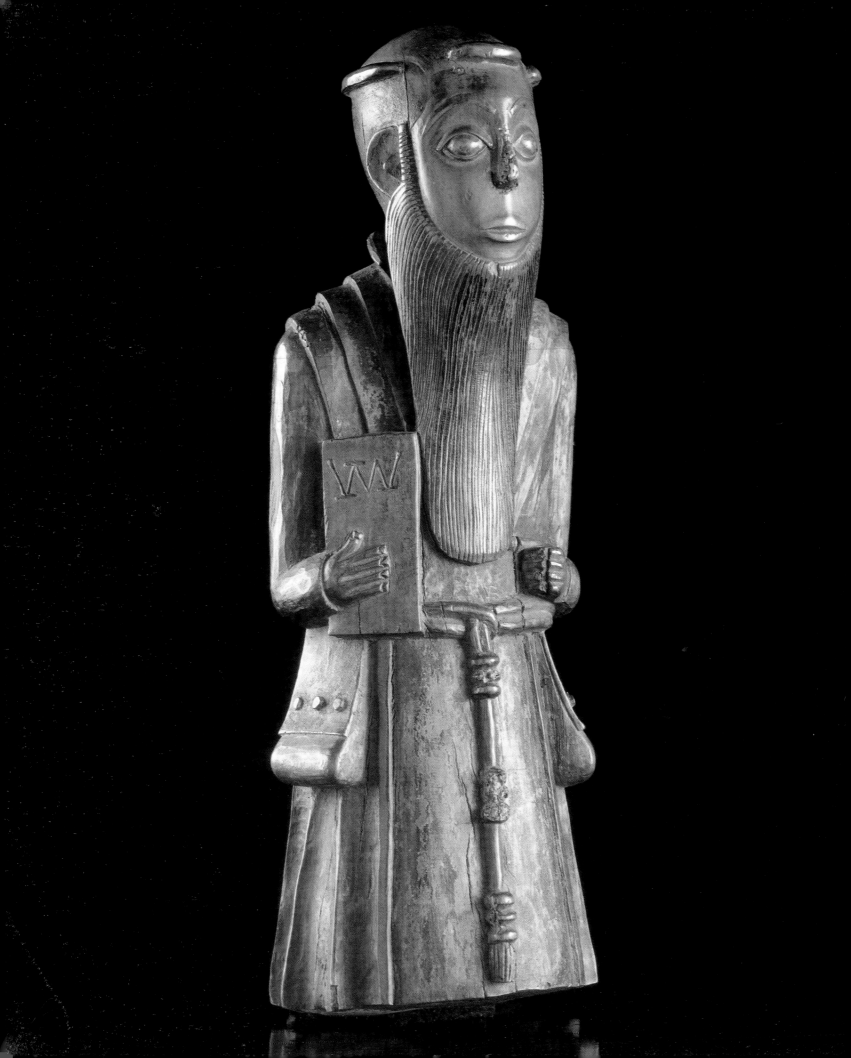

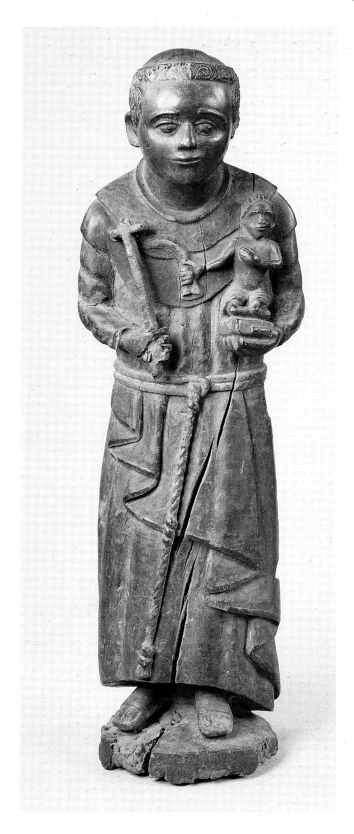

ABOVE: *St Anthony with Christ Child*
Kongo people, Central Africa, nineteenth century
Museum für Völkerkunde, Berlin

LEFT: Figure of a missionary [Cat.30], Kongo people, Central Africa,
nineteenth century, Katholieke Universiteit, Leuven

Imagine, then, a figure of wood, some two or three feet high,
representing a man, a woman, or some animal with a distinct
peculiarity about it, either a long leg or arm, a curious foot, or
other deformity. This figure appears to be one mass of nails,
spear-points, knives, or bits of iron, each of which has some
peculiar significance, known only to the *nganga*, who indeed
must have a marvellous memory since he is supposed to know
by whom each nail was driven into the feteich, and for what
purpose.[27]

Unlike older accounts, which still maintained the
distinction between 'idols' and 'fetishes' and thereby ex-
cluded figurative sculpture from any discussion of 'fetish-
ism', nineteenth-century descriptions were remarkably
consistent in their primary fixation on the human body.

After the discovery of the Kongo in 1482, the
Portuguese contented themselves with overseeing the
native king burn his 'idols' and announce his conversion
to Christianity. They encouraged the replacement of
images by crosses, while charms were substituted by
crucifixes and images of the saints. The first Portuguese
intervention was short-lived. Failing to find precious
metals, Portugal dispatched a consignment of crucifixes
but never sent sufficient missionaries to spread and con-
solidate their faith; 'The Christian religion waxed so cold
in Congo, that it wanted very little to be extinguished.'[28]
Between 1700 and 1720 the Flemish Capuchins estab-
lished missions in the country, but their work was soon
curtailed.[29] Not until 1888, after the Congress of Berlin
(1884-5) when Leopold II of Belgium was acknowledged
as sovereign of the Congo Free State, was evangelisation
renewed by the Scheutist missionaries. Intermittent evan-
gelisation had supported the development of a specifically
Kongolese understanding of Christianity which facilitated
European disparagement. Recalling the state of the
country in June 1879, William Holman Bentley, en-
trusted with establishing a Baptist mission there, wrote:
'When we reached San Salvador in 1879, it was to all
intents and purposes a heathen land. King and people
were wholly given to fetishism and all the superstitions
and cruelties of the Dark Continent.'[30]

But 'fetishism' was not evidenced by inchoate sub-
stances or the veneration of the so-called 'nail fetishes'
(*nkisi nkondi*) portrayed on souvenir postcards and in
travel accounts. Bentley goes on to describe: 'In a house
in the king's compound were kept a large crucifix and
some images of saints, but they were only the king's
fetishes. If the rains were insufficient they were sometimes
brought out and carried around the town.'[31]

Bentley also describes hunting 'fetishes' in the form

of flat wooden crosses, *santu*, daubed with the blood of animals which they had helped to capture. Alfonso I (1509-41), the most powerful of Kongo's Christian kings, presented metal crucifixes to all his clan chiefs and judges in an attempt to appropriate what he understood to be the source of Portuguese power. Christian images were institutionalised within established systems of authority; they were passed on at the investiture of new chiefs and represented the source of an efficacious and potent power that gave them authority to swear oaths, to punish oath-breakers, to dispense wise judgement as well as to cure sickness and free the mortally ill from the torments of evil spirits.[32] The incorporation of Christian imagery had also been commented on by Cavazza who, in 1687, noted 'that the magician-priests of the Congo painted their "idols" with the sign of the cross'.[33]

According to Balandier, Christianity was not understood as a means of personal salvation, but as a supplementary source of power under the control of ancestor and nature spirits.[34] Dennett was of the opinion that 'the old missionaries, before 1670, having taught the Fjort what God is, they have, by their ignorance and idolatry, so mystified them, that only hundreds of years of patient, severe, and strictly truthful teaching can undo the mischief they have done, and bring God clearly to them'.[35]

This view was repeated by other travellers such as Glave.[36] Among the first examples of 'fetish' figures from the Kongo to be described in the modern literature, therefore, were not indigenous styled carvings but appropriations of Christian images.

The origins of the justly renowned *minkisi minkondi* (*minkisi* is plural form of *nkisi*) or 'nail fetishes', remain enigmatic, but it is probable, though historically unproven, that they emerged from a synthesis of Kongo and Christian beliefs. Not only the style, but equally the constellation of beliefs appertaining to the body, mutilation and power may have been derived from the variety of Christian experiences introduced during the intermittent periods of European influence.

The parallels between medieval and Renaissance Christian ritual practices and images, and those found 400 years later in the Kongo are intriguing. Since the Middle Ages the body provided European Christianity an idiom with which to express metaphysical and spiritual concepts. Images of the pierced body resulting from the martyrdom of saints or the crucifixion of Christ have dominated Christian iconography. A painting in the style of the Rhenish school, dated between 1520 and 1530, unusually depicts the body of the Virgin Mary pierced by seven swords. The martyrdom of St Sebastian provided a

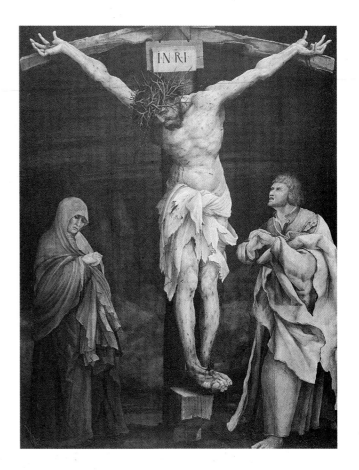

Mathias Grünewald
Christ on the Cross
Date unknown
Staatliche Kunsthalle, Karlsruhe

OPPOSITE:
Artist unknown
Our Lady of the Seven Pains, 1520-30
Staatliche Kunsthalle, Karlsruhe

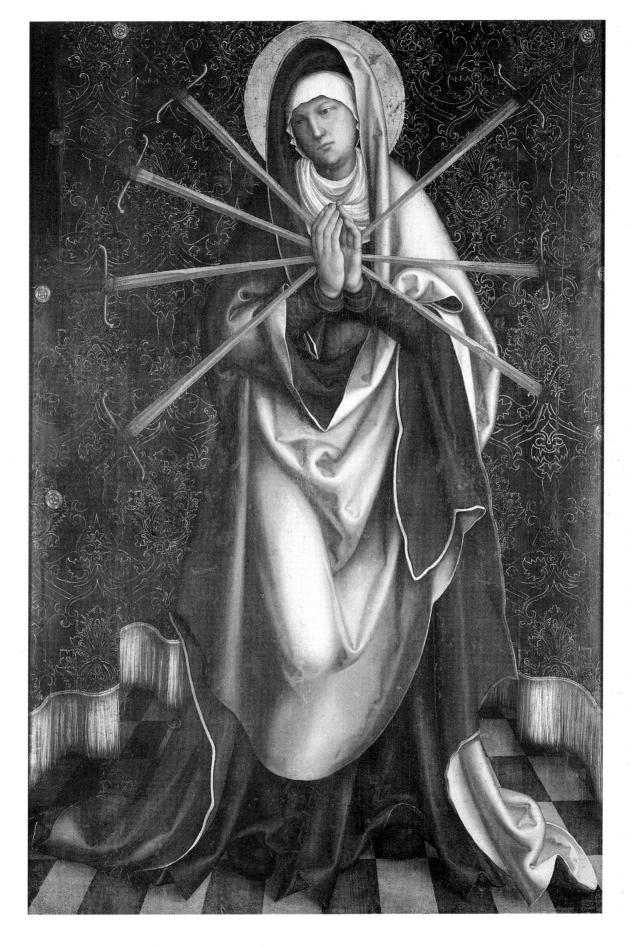

much emulated subject for many artists, such that the portrayal of the saint's body pierced by arrows became a familiar image. The archetypal mutilation of the body by piercing was represented by Christ's crucifixion – one of the most ubiquitous and centralising images of Christianity. Representations of St Sebastian by, for example, Mantegna, or Grünewald's *Crucifixion* provided powerful images, with sado-masochistic overtones which clearly articulated suffering and bodily denial as a path to eternal life and the attainment of supernatural authority.

Christianity also attached particular meanings to objects of torture and martyrdom. The sword was itself frequently incorporated into religious paintings to symbolise martyrdom, arrows were interpreted as divinely sanctioned spiritual weapons, hammers and nails were symbols of the Passion.[37] The blood from the wounds of Christ was itself associated with magical qualities. By the thirteenth and fourteenth centuries, artists were depicting the blood from Christ's wounds to symbolise the food of the soul which sustained the world.[38] The crucifixion as the archetypal sacrifice within Christianity destroyed Christ's ties of subordination to the world, freed him from all utility and restored him to a world of unintelligible caprice.[39] Suffering and death by mutilation not only restored and demonstrated Christ's divinity, but far more importantly provided the efficacious deed that resulted in humanity's salvation. The crucifixion provided a practical demonstration and acknowledgement of a path to power and authority. A particularly cogent image of the supernatural and magically charged body of Christ pictured with the instruments of its consecration is portrayed on the small triptych made for Antonius Tsgrooten in 1507 by the Flemish artist Goossen van der Weyden. In the central panel, behind the figure of Christ, appear the instruments of the Passion, the hammer and nails, the lance used to pierce the side of Christ on the cross, while the whip lying on the floor recalls the flagellation. The painting also makes an explicit parallel between Christ's blood and the milk running from Mary's breast to represent the twin fountainheads of spiritual and bodily food which constitute the irreducible foundation of human life.[40] The stigmata has been retained by Christianity as a sign capable of miraculously impressing itself on the bodies of persons showing extraordinary faith and devotion; that is to say as a sign of authority.[41]

Not only were the fifteenth-century Portuguese heirs to an impressive iconography of macabre bodily imagery which visualised mutilation as a means of achieving power or authority over life, but also of fantasies of the means to imitate the example of Christ through ritu-

alised self-flagellation. So great was the medieval European loathing of the body, that the French historian Jacques Le Goff even accused the age of trying to 'deny the existence of biological man'.[42]

From the mid-twelfth century to the fourteenth century, the Christian hatred of the body was given physical expression through the flagellants, a deeply influential lay movement whose authority and example threatened even the stability of the Catholic church. Given the millenarian fervour in Europe and the desire among some religious orders to return to the example of worldly renunciation given by the church fathers, it is not unlikely that similar dogmas and practices were introduced abroad and fed into the Kongolese construction of Christianity.

Further parallels existed between the prohibitions, behaviour and assumption of supernatural qualities adopted by the European flagellant movement and Kongolese practices concerning knowledge of and the means of activating *minkisi*. The flagellants did not see themselves, nor were they seen by the population, as simple penitents. 'They themselves claimed that through their flagellations they were not only absolved from all sin and assured of heaven but were empowered to drive out devils, to heal the sick, even to raise the dead. There were flagellants who claimed to eat and drink with Christ and to converse with the Virgin; at least one claimed to have risen from the dead.'[43]

The lessons of images that taught that a form of semi-divinity was achievable through the mutilation and denial of the physical body were given practical demonstration through the example of the flagellants who sought the same path as the martyrs.

The ethnographers J. Maes and E. Peschuel-Loesche[44] long suspected that the overtly sexual and threatening *minkisi* figures might have had a European origin. Both their analyses and that of Jongman[45] of *nkondi* point to Christian-derived elements in their usage.

After examining a figure in the Museum voor Volkenkunde at Leiden and comparing the accounts of earlier researchers as to how the figures were rubbed, and not nailed, to activate them, Jongman concludes that the figure of a cross could be seen in the patinas found on a number of pieces – the result of generations of devotees lightly tracing their fingers across the wooden surfaces. Jongman even finds evidence to suggest that customs of pounding nails into images to enlist their supernatural intervention survived well into the twentieth century in parts of Europe. In Flanders, K. Ter Laan described the custom of driving a nail into an image or picture in order

to injure another person; a respondent to a folklore questionnaire recounted a miraculous head of a saint into which pilgrims could hammer nails to cure headaches; while young girls in one part of France stuck pins into the image of a saint to help find their future husbands.[46]

Parallels between images and practices of bodily mutilation and the acquisition of supernatural power both in Europe and the Kongo suggest that the style and perhaps even the modes of usage of Kongolese 'fetishes' may have been influenced by European missionaries. However, it cannot be assumed that similarities between forms or styles of objects from different cultures have any functional correspondence to shared ideologies. The aforementioned missionaries and other writers were Protestant or sectarian and shared an interest in dismissing previous Catholic missionary efforts as much as African beliefs. Rather than describe the significance of *minkisi* in the context of Kongo religion, these writers, in the main, were content to extrapolate and impose their own concepts of 'fetishism' on to the ritual practices and images they encountered. As John Mack argues in the following essay, the European cross probably represented nothing more than a transposition of the indigenous cosmogram and was itself easily incorporated into older beliefs. Nevertheless, it is interesting to speculate that what for many Westerners has been assumed to be the very embodiment of 'savage' art may also contain a reflection of Europe's own former iconographic conventions and beliefs. History comes full circle with the drawing by R. P. Nico Vandenhoudt, *The Crucifixion*, showing an African with nail and hammer, nailing Christ to the Cross.[47]

So persuasive had the imagery and significance of 'fetishism' become by the early twentieth century that it assumed a rhetorical value that could impute the sense of 'savagery' to whatever context it was applied. A year into the First World War, the *Illustrated London News* printed a page showing eight German war memorials, which were to have been erected to raise money for their campaigns by encouraging people to pay for the privilege of hammering a nail into them. In the centre of the page stand two Kongolese *minkisi*. Discussing the statue of Hindenburg erected in Berlin, the writer mused:

… the nails in the Hindenburg statue must be intended as appeals to the national hero to avenge the wrongs of his fellow-countrymen on their hated foes. No doubt the intention is not explicit in the German mind, but rather subconscious. German psychology would seem to be just evolving an idea which the more advanced natives of West Africa had developed into a logical system many years ago, and German *Kultur* would appear

to have a good chance of attaining, eventually, the same plane as the 'civilisation' of negroid Africa.[48]

The British image of Kongo 'fetishism' provided a sense of the fragility even of European civilisation and the barbarous human nature which lay submerged under its thin skin. Clearly, the imagery on which we hang our prejudices of the supposed mental deficiency, amoral behaviour or spiritual lassitude of other cultures, and from which their persecution was justified, is nothing other than an expression of our own 'hearts of darkness'.

Exotic Reveries

In *The History of Sexuality*, Michel Foucault argued that from the seventeenth century onward, Europe embarked on a process to convert sexuality into careful codified and

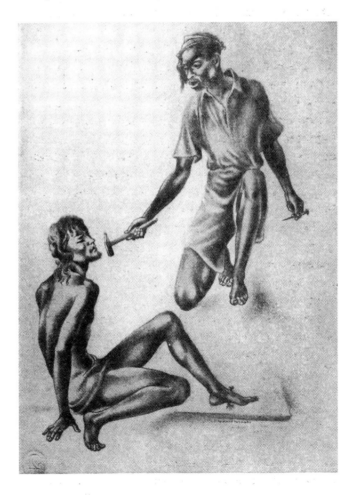

R. P. Nico Vandenhoudt
The Crucifixion, c.1950

142—THE ILLUSTRATED LONDON NEWS, Dec. 25, 1915.

FOR GERMANS TO DRIVE NAILS INTO! ENEMY

WITH regard to the German statues and other monuments here illustrated, the following is an extract, translated, from the article accompanying them in the paper from which they are taken : " Various forms of war memorials have been erected in Germany during the present war—mostly for the purpose of war-charities, money being paid for permission to hammer nails into them. We here give various
[Continued in No. 2.]

statues and other memorials which are in various towns in Germany—erected during the present war. The custom of hammering nails is an old one. In the Middle Ages workmen's apprentices used to stick nails into walls, statues in the market-places, etc., doubtless just to show their friends they had passed there. This custom, but for charitable

STUTTGART'S "OWN PARTICULAR HERO": THE STATUE OF THE BRAVE SWABIAN.

THE adjoining illustration shows a wooden idol, from the region north of the Lower Congo (Chiloango River), now in the British Museum. This figure simply bristles with iron nails and knife-blades driven into it by worshippers. The idol is known as Mangaka, and its aid is sought by men who have suffered from theft, accident, sickness, or misfortune. The victim, on payment of a fee, is permitted to drive a nail or knife-blade into the figure. This is to call the attention of the supernatural power, which the image represents, to the sad case of the worshipper, who believes that his trouble will soon be alleviated, and that divine vengeance will strike the enemy. Indeed, the miscreant can only escape supernatural punishment by paying the priest a still higher fee to extract the nail, and so, as it were, to withdraw the summons."

"GERMANY WAS NEVER DEFEATED WHEN UNITED": THE "IRON" OAK AT HALLE.

WITH NAILS AND KNIVES DRIVEN INTO IT LIKE BERLIN'S HINDENBURG: AN IDOL FROM THE CONGO.

BIELEFELD'S WAR MEMORIAL: A STATUE OF A GERMAN SOLDIER IN FIELD-GREY—FOR NAILING.

A GERMAN SUBMARINE WAR MONUMENT: THE "U" BOAT MODEL AT HÖRNUM, ISLE OF SYLT, WITH A BRITISH SEA-MINE AS BASE.

Considerable comment has been aroused by the craze in Germany for driving nails into large wooden statues of popular heroes, such as Hindenburg at Berlin, and von Tirpitz at Wilhelmshaven—a privilege which can be exercised by all and sundry on payment of a small fee. "The inner meaning of this strange performance," writes a correspondent, "and the nature of the satisfaction derived by the operator, are a trifle obscure. We can hardly see in the new custom a revival of the magical practices of an earlier date, when, to the accompaniment of appropriate incantations, waxen figures were stuck with pins and otherwise maltreated ; for in the latter case it was believed that bodily harm was caused to the individual whom the effigy represented. A possible key to the riddle, however, is furnished by a wooden idol in the British Museum" (the left one of the two shown above). After

'For Germans to drive nails into!
Enemy war memorials and Congo cases of nailing'
The Illustrated London News, December 1915

VAR MEMORIALS—AND CONGO CASES OF NAILING.

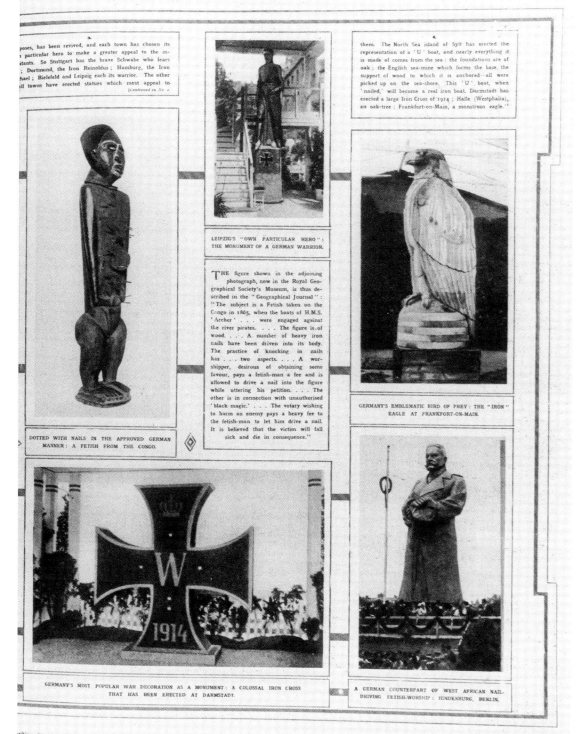

poses, has been revived, and each town has chosen its
particular hero to make a greater appeal to the in-
itants. So Stuttgart has the brave Schwabe who fears
; Dortmund, the Iron Reinoldus ; Hamburg, the Iron
hael ; Bielefeld and Leipzig each its warrior. The other
ill towns have erected statues which most appeal to.

[Continued on No. 2.]

them. The North Sea island of Sylt has erected the
representation of a ' U ' boat, and nearly everything it
is made of comes from the sea : the foundations are of
oak ; the English sea-mine which forms the base, the
support of wood to which it is anchored—all were
picked up on the sea-shore. This ' U ', boat, when
' nailed,' will become a real iron boat. Darmstadt has
erected a large Iron Cross of 1914 ; Halle (Westphalia),
an oak-tree ; Frankfort-on-Main, a monstrous eagle.''

LEIPZIG'S ''OWN PARTICULAR HERO'':
THE MONUMENT OF A GERMAN WARRIOR.

THE figure shown in the adjoining
photograph, now in the Royal Geo-
graphical Society's Museum, is thus de-
scribed in the ''Geographical Journal'' :
''The subject is a Fetish taken on the
Congo in 1865, when the boats of H.M.S.
' Archer ' . . . were engaged against
the river pirates. . . . The figure is of
wood. . . . A number of heavy iron
nails have been driven into its body.
The practice of knocking in nails
has two aspects. . . . A wor-
shipper, desirous of obtaining some
favour, pays a fetish-man a fee and is
allowed to drive a nail into the figure
while uttering his petition. . . . The
other is in connection with unauthorised
' black magic.' . . . The votary wishing
to harm an enemy pays a heavy fee to
the fetish-man to let him drive a nail.
It is believed that the victim will fall
sick and die in consequence.''

DOTTED WITH NAILS IN THE APPROVED GERMAN
MANNER : A FETISH FROM THE CONGO.

GERMANY'S EMBLEMATIC BIRD OF PREY : THE ''IRON''
EAGLE AT FRANKFORT-ON-MAIN.

GERMANY'S MOST POPULAR WAR DECORATION AS A MONUMENT : A COLOSSAL IRON CROSS
THAT HAS BEEN ERECTED AT DARMSTADT.

A GERMAN COUNTERPART OF WEST AFRICAN NAIL-
DRIVING FETISH-WORSHIP : HINDENBURG, BERLIN.

cribing it, as above, he continues :—''This seems to fit the German case ; the nails in the Hindenburg statue must be intended as appeals to the national hero to avenge the
ngs of his fellow-countrymen on their hated foes. No doubt the intention is not explicit in the German mind, but rather subconscious. German psychology would seem to be just
lving an idea which the more advanced natives of West Africa had developed into a logical system many years ago, and German Kultur would appear to have a good chance of attaining
tually the same plane as the ' civilisation ' of negroid Africa.'' With regard to the epithet '' iron '' applied to some of the German monuments, it does not appear to mean to these
s that they are made of iron [as it is applied in the German original to the wooden statue of Hindenburg], but that they have iron nails knocked into them.

specialist discourses whose legitimacy it guaranteed by their then-emergent scientific status. Far from Western society censoring discussion on sexuality, it encouraged and channelled such discussions, building an extensive archive of case studies which enabled sexual norms to be defined and a pathology and corresponding etiology of sexual behaviour to be constructed.

The emergence of psychiatry, psychoanalysis, modern medicine and biological sociology defined and restricted 'normal' legitimate sexual practice to the conjugal family. Sex was given an entirely functional procreative role from which even the most minor deviations were mapped, described and classified with such rigour and ardour that, Foucault believed, the central subject itself was mostly evaded. 'Aberrations, perversions, exceptional oddities, pathological abatements, and morbid aggravations'[49] were isolated, defined and categorised in order to produce an inclusive repertoire of evils from which the individual, the family, even society itself had to be protected. At the heart of the analysis of sexual deviations was 'fetishism', what Foucault called the 'model perversion'[50] which provided the framework for the isolation, description and explanation of other so-called psychiatric disturbances. Alongside the medical and psychiatric etiology, other fields of knowledge emerged which provided additional interdictions against a debasement of sexuality's reproductive function. Discourses on demography, statistics, eugenics and political economy redefined individuals and communities as 'populations' to be counted and classified by age, sex, class, occupation, education and location to enable the establishment of centralised national planning through which the future economic and cultural vigour, and political identity of a nation, could be guaranteed.[51] It is not for nothing, as Robert Nye[52] reminds us, that anxiety about the size and condition of the French population, male impotence, sexual exhaustion and reproductive fertility, coincided with increased interest in fetishistic deflections of the sexual act. Sexuality denuded of eroticism was acknowledged as vital to the health of the social body as well as of the individual.

The de-eroticisation of sex at home[53] coincided with the objectification and eroticisation of the non-European female body.[54] The construction of the erotic Other, while embodying different 'natures', followed an essentially similar strategy and created like effects in all the lands that succumbed to European domination. During the eighteenth and nineteenth centuries eroticism was conflated with an exoticised Orient producing an image of Eastern women as mute and fecund – tainted by

the motivation of mysterious emotions that gave reign to 'untiring sexuality' and 'unlimited desire'.[55]

The South Seas version is notable for its idealisation of woman living in a state of nature in a sexually promiscuous paradise untainted by the conventions of civilisation. In contrast to these views, Africa remained the 'Dark Continent', impenetrable both territorially and intellectually, medically and morally deleterious, menacing, both on the mind and the body. Within such 'wasteland', the archetypal woman was degenerate, untamed and promiscuous, represented in popular imagery by the Hottentot with her short stature and protruding buttocks.[56] Whereas in orientalism, the sexual submission and possession of the foreign female body mirrored the subordinate and dominant position between East and West,[57] African exoticism transcribed near-identical power relations between the geography of South and North. It was European men who explored, invaded, administered and worked Africa. Some historians have even argued that the propelling force of colonialism was a redirected male sexual energy,[58] away from hearth, home and country to the impenetrable and dark heart of distant continents.[59] As Patrick Brantlinger sardonically remarks: 'Africa was a setting where British boys could become men but also where British men could behave like boys with impunity.'[60] It is noteworthy that in neither novels nor memoirs were European women the subject of the sexual fantasies of colonial men.[61]

Much of the discourse on the exploration and establishment of European rule in Africa was permeated with sexual allegories. Since Hegel, Africa has been described as a mysterious sensual virgin waiting to be conquered. It is timeless, ahistorical, waiting: passive and yielding to the events visited on it. In the eighteenth century this attitude was still ambiguous. Mungo Park, writing in 1799, on the one hand insisted that physiological differences did not detract from 'the genuine sympathies and characteristic feelings of our common nature'.[62] Nevertheless, while Park found generous, sympathetic and kindly qualities in what, in the majority, were elderly women or slaves, he slandered young women as avaricious, rude, troublesome, demonstrative, wanton, lacking in sexual propriety, and prone to ungovernable curiosity. Bizarre forms of female behaviour, at least in European eyes, almost always attracted the attention of later writers. Ellis (1883)[63] mentioned a contingent of Amazons, 'beautiful' scarred female warriors, in West Africa; and Gorer (1935)[64] after similarly describing the female warriors of Dahomey, remarked how, in his opinion, the number of women reserved for the king had caused shortages in

their ranks, leading to unusual levels of 'perversion and neurotic curiosity'.[65] Such views were multiplied and elaborated during the heyday of colonialism as a result of greater contact with African women and their representation in the burgeoning travel literature and works of fiction.[66]

The European fascination with African women is not only evident in the literature of the period, but in the illustrations included in travel books and memoirs, and, to an impressive degree, in the picture postcards that by 1900 were being produced on a large scale. 'Sexual pleasure begins with the privilege of sight'[67] and the picture postcard and printed illustration were primary in fixing and codifying African women to the European gaze.[68] One of the most common poses, under the alibi of illustrating '*les types indigènes*' were scantily dressed young women poised in a rigid upright position, arms by their side, looking directly at the camera. Other postcards show files of up to twenty women with naked breasts abjectly staring into the lens, pairs of girls turned away from each other to show back and fronts of the body, and single women with hands clasped coquettishly behind their heads. Such illustrations were highly selective; in the main, they were of well-developed young women. Girls, older women and men were more usually shown at work and were not the subject of portraiture. The subjects were anonymous, unnamed, blending in easily to form a stereotype of the eroticised African.

What is found in the illustrations of photographers is equally explicit in the writing of the period.[69] In his fictitious account of the essence of the continent, *Impressions of Africa* (1910), Raymond Roussel employed highly syncretic images to model African women on easily recognisable and explicit sexually perverse and erotic roles. The emperors' young wives combine wild, undomesticated temperament with charm and beauty. Proud Rul in her torn red velvet corset that she wears over her loincloth provides the reluctant but defiant victim of sadistic torture, and Louise Montalescot, a European woman who, in the tropics, fell victim to Europe's preoccupying fear of degeneration, is described as a female transvestite with a penchant for military costumes.

Less perverse, but none the less sexualised female images are used in William Seabrook's *Jungle Ways* (1931).[70] For Seabrook, 'Wamba' is the embodiment of all African womanhood: 'She was not only a true sorceress, but a true Negress, true to type and true to the genius of her race – light-minded, sensual, a luxurious, pleasure-loving animal, comic at times, gaily insolent, yet good-

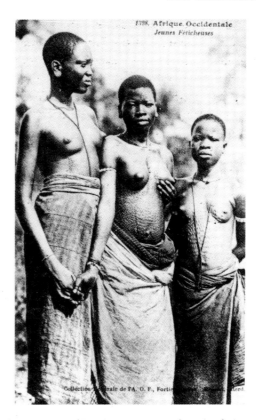

'Jeunes Féticheuses', nineteenth-century postcard
From R. Corbey, 'Alterity: The Colonial Nude'
Critique of Anthropology, VIII, No.3, 1988, p.90

Photograph by René Jacques of Guillaume Apollinaire's studio and library, Paris 1952-3

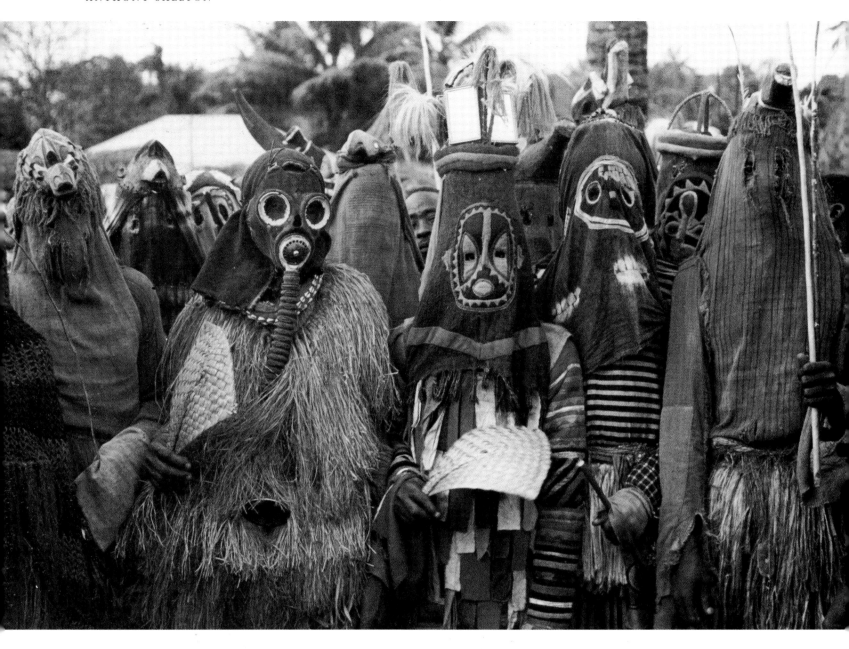

Photograph (1959) showing the African adoption
of a Western mask for traditional masquerades
Ugwuoba village, Ibo people, Nigeria

hearted – but with another side, another soul, dark and
primordial, in continual unconscious deep communica-
tion with old, nameless things, demoniac and holy.'[71]

The conflation of eroticism with mysticism tied
Seabrook to his more scholarly friend, the French anthro-
pologist and writer, Michel Leiris. Apparently happy to
accept similar characterisations of African womanhood,
Leiris readily extended them to Afro-Americans, thereby
locating a source of undiluted sexuality right in the heart-
land of America and Europe. His excitement on first
seeing Josephine Baker, during one of her early perform-
ances in Paris, which he recounted years later, was in-
fectious: 'Like the music, profane or religious, that
seemed like a faint breeze wafted from distant Africa into
the midst of our industrial civilisation, so the image of a
Josephine Baker, abandoning herself to the rhythm of the
Charleston, evoked something primitive akin to the
Christ inférieur des obscures espérances of Apollinaire.'[72]

Neither Surrealist literature, such as Aragon's *Paris
Peasant* with its exoticised, defamiliarised Parisian land-
scape, nor the peculiar subjects and strangely angled
photographs they made of their surrounds succeeded so
much in creating awareness of the exotic and erotic as
did jazz and the black cabarets. Ideas and feelings of the

exotic and eroticism were reaffirmed in Europe, not only threatening firmly held beliefs and prejudices, but offering the possibilities of new sexualities previously repressed at home.

The wild, dangerous, potentially polluting and exotic qualities that European writers, travellers and colonial servants ascribed to African female sexuality were not dissimilar to the distillation of their religious, intellectual or moral beliefs in the 'fetish' figure – perhaps not surprising given that religious 'fetishism' provided the intellectual model through which sexual behaviour could be related. In both cases what was important was not the figure or body itself, but the prejudices about motivations and understanding, intolerance and the redeflection of sexual, aggressive and emotional instincts that had been denied and exiled from Europe to foreign territories. This proximity between religious and sexual fetishism was recognised by anthropologists, psychologists and psychiatrists alike. Alfred Binet, who adopted the psychiatric use of 'fetishism', noted the intellectual and moral weaknesses shared by 'savages' and the 'sick' which were sufficient to label them 'deviants'. 'The term fetishism suits quite well, we think, this type of sexual perversion. The adoration, in these illnesses, for inanimate objects such as night caps or high heels corresponds in every respect to the adoration of the savage or negro for fish bones or shiny pebbles, with the fundamental difference, that in the first case religious adoration is replaced by sexual appetite.'[73]

Freud also acknowledged similarities between African religious and erotic 'fetishes' and noted the acceptance by some authors of the view that sadism and masochism were the remnants of cannibalistic desire.[74] So close was the association between European notions of religious fetishism and African sexuality in the popular mind of the period, that one picture postcard, under a portrait of a partly-nude African girl, could meaningfully bear the caption 'Jeunes féticheuses'.

A Change of Skin

Leiris's essay 'Le caput mortuum ou la femme de l'alchimiste' is among the first indications of European reaffirmation of the possibility of creating the sexually exoticised woman at home,[75] and 'fetishising' her body. As for Binet, so too for Leiris, sexual 'fetishism' was tied to religious 'fetishism'. In both cases, a part or substitute object assumes the identity of the whole or person. The experience of the object of fetishistic desire is intensified, leading to the illusion of metamorphosis. The twin themes of disguise and transformation were central in connecting the Other and the erotic in a general theory of 'fetishism' that drew freely on Freud's concept of disavowal to account for the suspension of belief in the quotidean world. In 'Le caput mortuum', Leiris discusses the effects and sensations aroused by William Seabrook's collection of leather masks.[76] The tightness of these masks created a heightened appearance of intimacy between the skin and the artificial epidermis that enveloped it, while, paradoxically, erasing the identity of the wearer. The masked person lost all personhood. Social indexes, race, class, age, gender, profession, were eradicated as was any sense of temporal succession. The image became a blank creation, form without consciousness, potentiality without objective, existence without determination – in short, a primordial archetype that escaped identification and transcended subjectivity.

Nancy Grossman
Untitled, 1968

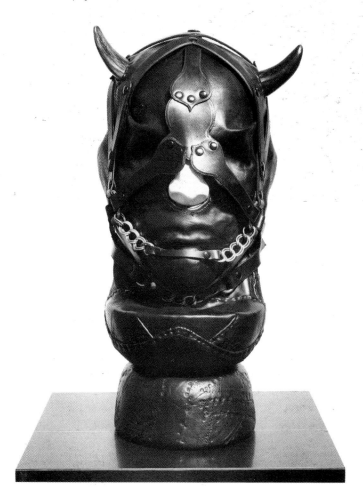

The hoods did more than obliterate identity, they cancelled out the head and brain, thereby annulling reason and intelligence while refocusing the gaze on the remainder of the body. The experience of unmasked bodily imagery was intensified, promoting a shift in normal attention. The obliteration of the subject, the erasure of the physical head and the refocusing of the gaze elsewhere set up multiple paradoxes contradicting the functional hierarchy of the biological body while creating the conditions for its transformation. Human subjectivity becomes metamorphosed into bestiality, culture into wild nature awaiting domination and exploitation. Given the correct technology, the European woman could be endowed with the same mysterious and desirable qualities previously attributed only to her foreign sisters.

Nancy Grossman's *Male Heads* (1969–70) work in a similar manner and also reveal much about the effect of contemporary 'fetish' dress. Like Seabrook's hoods, sheathed in constrictive leather, the heads create their particular anxiety by their closure and displacement from the rest of the body. The bound head and neck is silenced, the eyes are blinded, the face obscured from communicating emotion by its enclosed epidermis of leather; enclosure transforms the subject into an object that can only suggest the missing body by parodying the phallus. The body of her *Male Figure* is tightly bound in a second skin of leather which perfectly traces the muscles and sinews concealed under its surface. Bodily senses (but not necessarily functions) are suspended; smell is overpowered by the pungent odour of leather, zips black out vision, silence speech and deafen sound. We are made to feel suspense as to whether the deprivation of senses of smell, sight and hearing are in any way compensated by the greater awareness of tactile sensations, but the blows or caresses that the posture of the body appears to anticipate never fall and our voyeuristic inquisitiveness is denied fulfilment. The leather skin creates a being that is culturally ungendered, though corsets are thought highly symbolic in the transformation of male into she-male. Even the body's anatomical features are ambiguous for, not only are its penis and testicles cradled in a leather sack, but the effect of the corset is to gather in the waist, while the posture pushes out the torso to suggest breasts.

Grossman's *Male Figure* conveys none of the ironic parodies of her head series. Its gender is challenging, and intimates both the male in bondage – powerless, vulnerable and silenced – and the feminised male struggling to escape its macho chrysalis. The power of the figure lies in its unresolved arbitration of the contradiction between

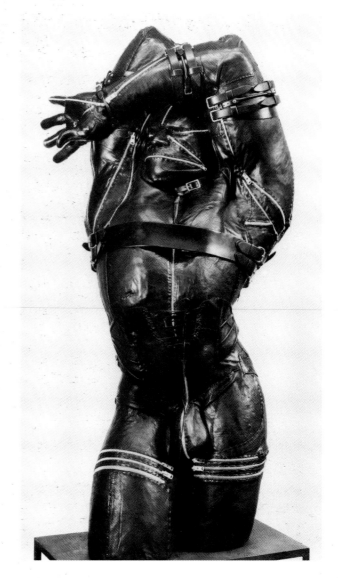

Nancy Grossman
Male Figure, 1971
Israel Museum, Jerusalem

the threat of death and castration and the rebirth of a new sex.

Masks or hoods are not the only means of defamiliarising and exoticising the body. According to the influential French critic, Jean Baudrillard, clothes, cosmetics, tattoos, scarification or piercings can all refocus and halt the gaze to enable any part of the body to assume fetishistic significance:[77]

The entire contemporary history of the body is the history of its demarcation, the network of marks and signs that have since covered it, divided it up, annihilated its difference and its radical ambivalence in order to organise it into a structural material for sign-exchange, equal to the sphere of objects, to resolve its playful virtuality and its symbolic exchange … into sexuality

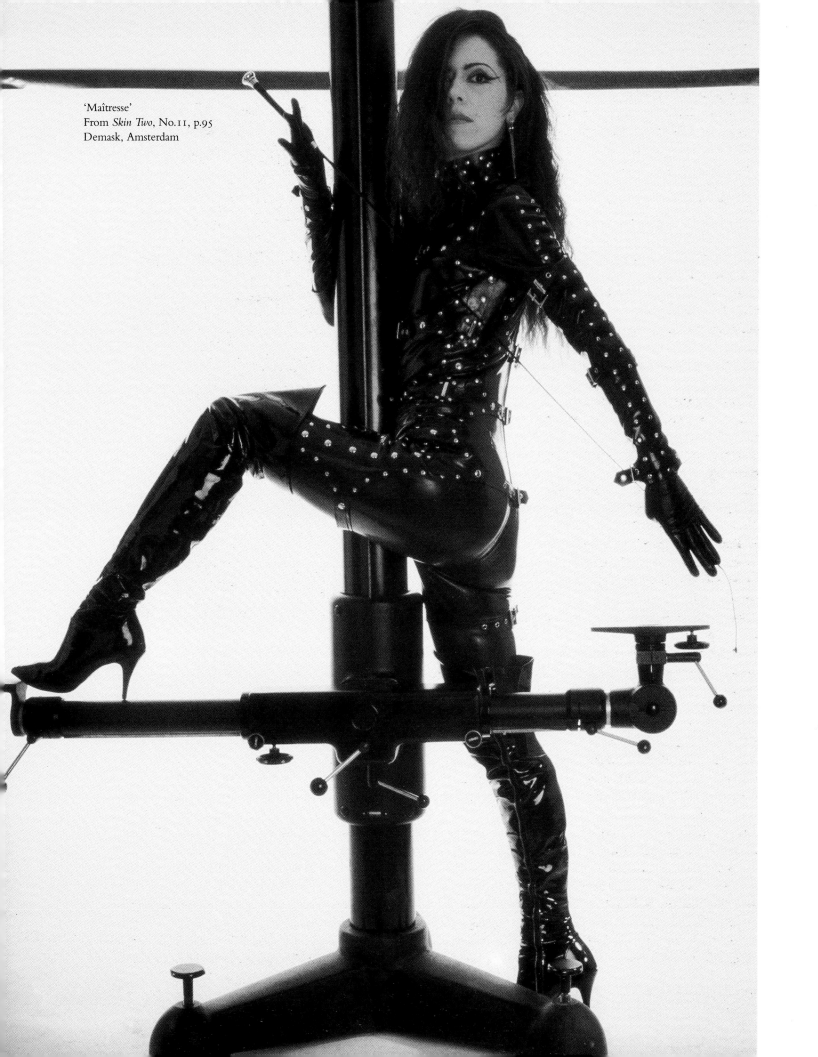

'Maîtresse'
From *Skin Two*, No.11, p.95
Demask, Amsterdam

taken as a determining agency, a phallic agency entirely organised around the fetishisation of the phallus as the general equivalent.[78]

Contemporary notions of the body dismiss any necessary 'naturalness' about its qualities. Instead it is seen as a medium capable of assuming multiple values and meanings which can be created and recreated, and whose interpretation is limited only by the unconscious anxiety of castration. Dress, whether sado-masochistic, leather, rubber, PVC cyberpunk, etc, divide it into erectile areas by creating boundaries with the skin on which the gaze can rest before succumbing to the apprehension surrounding phallic castration. The object of desire becomes displaced elsewhere on the body as the subject imputes to it sexual significance in struggling to deny his imminent confrontation with castration. For Baudrillard, unlike Freud, it is the mark that divides and imposes limits on the body; discrete areas defined by scars, piercings, boots, rips and loosely stitched clothes, become seen as erectile and surrogates of the disavowed phallus. The body, even in its entirety and especially when upright, can be fetishised as the phallus:

Ankle boots and thigh boots, a short coat under a long coat, over the elbow gloves and stocking tops on the thigh, hair over the eyes or the stripper's G-string, but also bracelets, necklaces, rings, belts, jewels and chains: … a mark that takes on the force of a sign and thereby even a perverse erotic function, a boundary to figure castration which parodies castration as the symbolic articulation of lack.[79]

In the case of Grossman's heads and male body, it is not necklaces, bracelets or chains, but zips, straps and belts that dissect the body to create strongly felt erectile areas of the calves, torso, upper and lower arms and fingers that demonstrate the effectiveness, that Baudrillard notes, of the equivalence between 'the marks of "fetishism"' and 'the marks of sado-masochism (mutilations, wounds, cuts)'.[80]

The same appearance of erectility is used to produce the most psychologically effective images of the female *maîtresse* – the thin calves, legs, torso and arms stretched tall or long, suggesting a power analogous to the masculine penetrative force of the penis. The recognition of the body's plastic qualities attracts the attention of couturiers such as Jean-Paul Gaultier and Versace, as well as equally inventive 'fetish' designers like Pam Hogg or Erisian Garbs whose success stems from their effective creation and manipulation of the marks to move, arrest and re-

focus the gaze to displace sexualisation. Examples abound in anti-heroines such as Barbarella, Catwoman, Madonna and Andrea in Pedro Almodóvar's film *Kika*, which use clothes to fetishise parts of the body. In *Kika*, Andrea's 'otherness' is signified by a slashed black dress revealing artificial breasts dripping bright red blood, while her hair is covered in shiny black rubber wiring. Elsewhere, her costumes include torn and stitched black-sequined dresses, rubber jackets and bras, glass heels, fish-net stockings, and the video camera attached to her helmet or searchlight in place of her bra cups. The blood, thigh belts, zips, gloves, and open stitched, slashed dresses, that mark and divide Andrea's body create multiple sites for staged disavowal and fetishistic substitution.

'Andrea', from *Kika*, directed by Pedro Almodóvar
Costume by Jean-Paul Gaultier

Foucault observed that 300 years of sexual discourse could not help but stimulate non-productive desire which sought to play, subvert or travesty approved sexuality through scandal, exhibitionism and resistance. These counter-incitements against channelling sexuality into reproductive functions have pre-empted the fixation of intransigent boundaries around sex and bodies to create 'perpetual spirals of power and pleasure'[81] seen in art, cinema and the contemporary fetish scene.

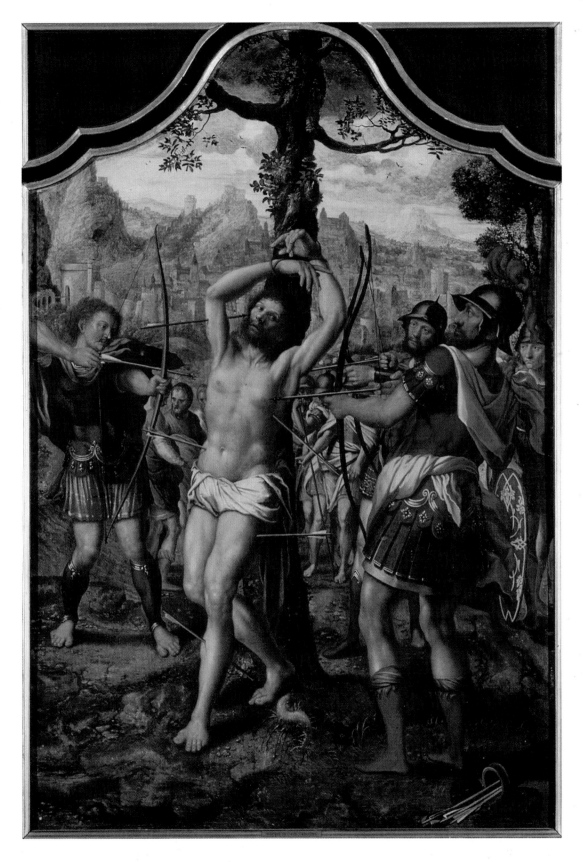

COLOUR PLATE I
Jan Sanders van Hemessen, *Saint Sebastian*
Triptych (central panel), 1530
Musée du Petit Palais, Paris

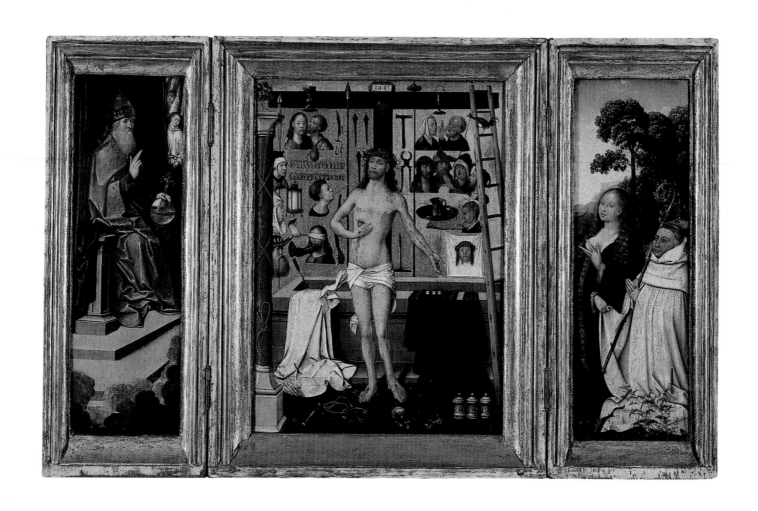

COLOUR PLATE 2
Goossen van der Weyden
Antonius Tsgrooten Triptych, 1507
Koninklijk Museum voor Schone Kunsten,
Antwerp

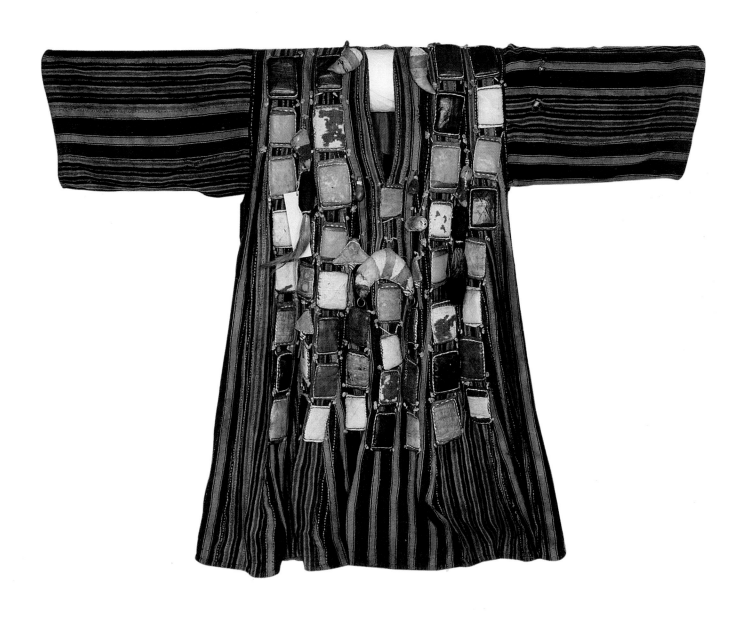

COLOUR PLATE 3
Charm gown [Cat.26]
Asante people, Ghana
Nineteenth century
The Royal Pavilion, Art Gallery and Museums,
Brighton

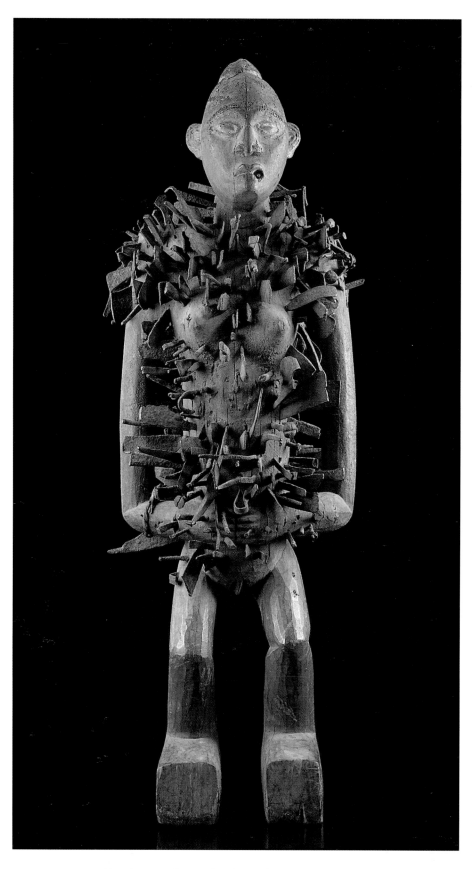

COLOUR PLATE 4 Female power figure (*nkisi*) [Cat.12]
Kongo people (Manyanga), Central Africa
Collection Marc Leo Felix

OPPOSITE:
COLOUR PLATE 5
Power figure (*nkisi*)
with plumed headdress [Cat.11]
Kongo people (Vili), Central Africa
Collection Marc Leo Felix

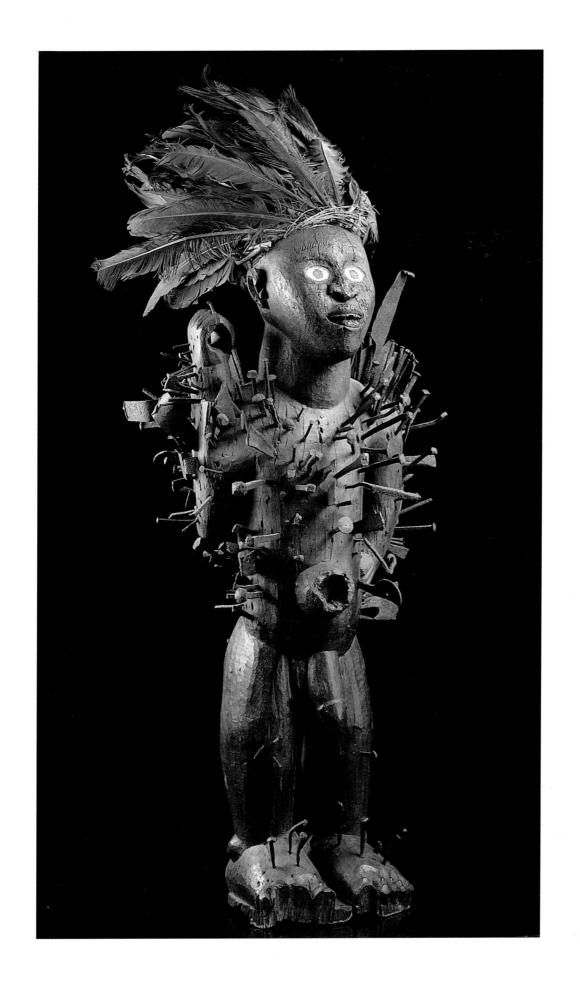

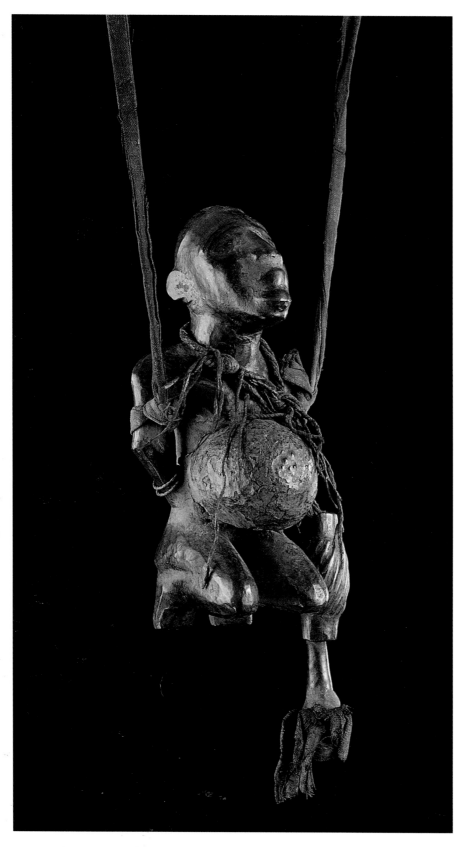

COLOUR PLATE 6
Power figure tied to necklace [Cat.25]
Kongo people (Yombe), Central Africa
Collection Marc Leo Felix

OPPOSITE:
COLOUR PLATE 7
Power figure tied to necklace [Cat.24]
Kongo people, Central Africa
Collection Marc Leo Felix

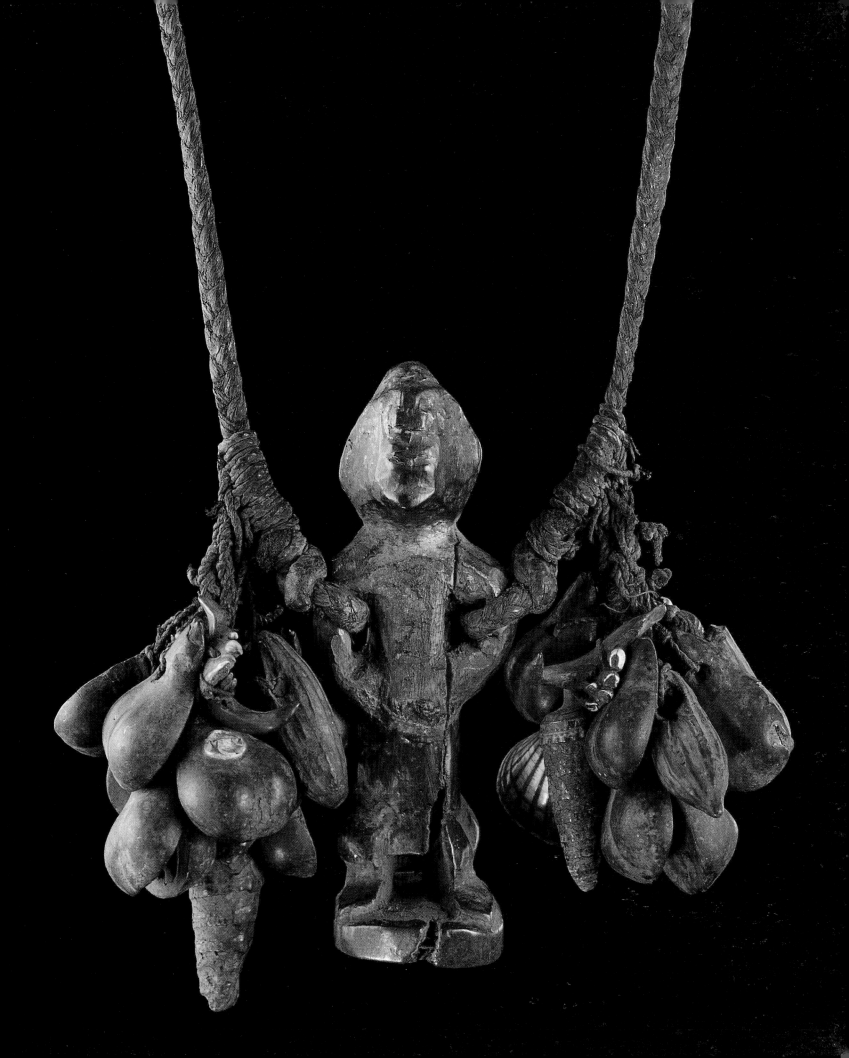

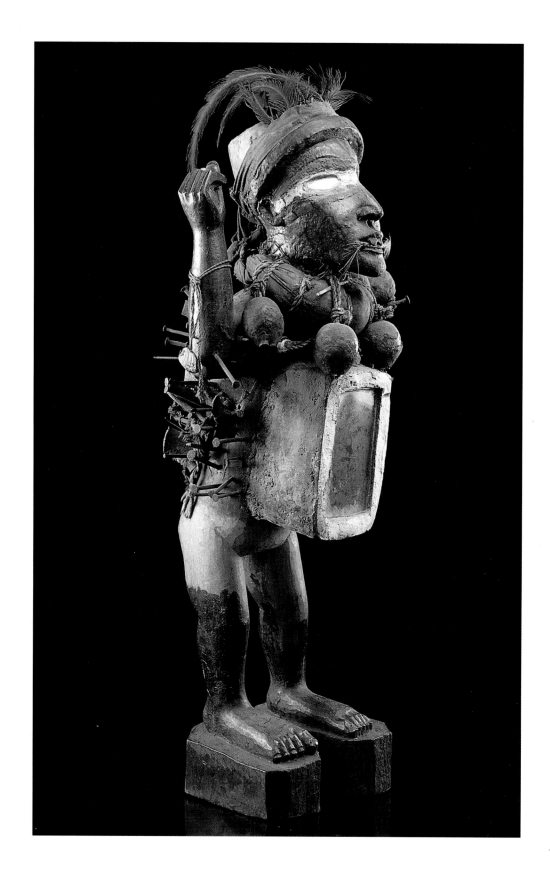

COLOUR PLATE 8
Power figure (*nkisi*) [Cat.27]
Kongo people (Yombe), Central Africa
Katholieke Universiteit, Leuven

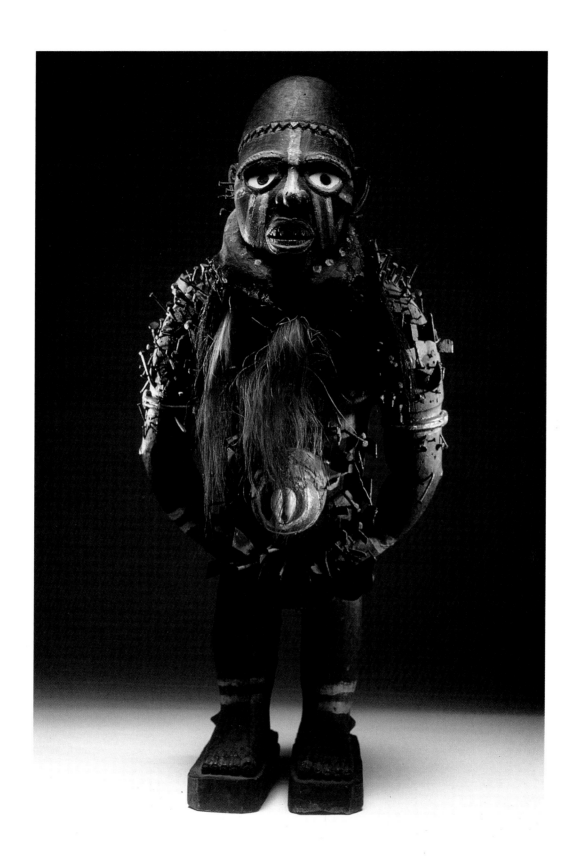

COLOUR PLATE 9
Power figure (*nkisi*)
Kongo people, Central Africa
Museum voor Volkenkunde, Rotterdam

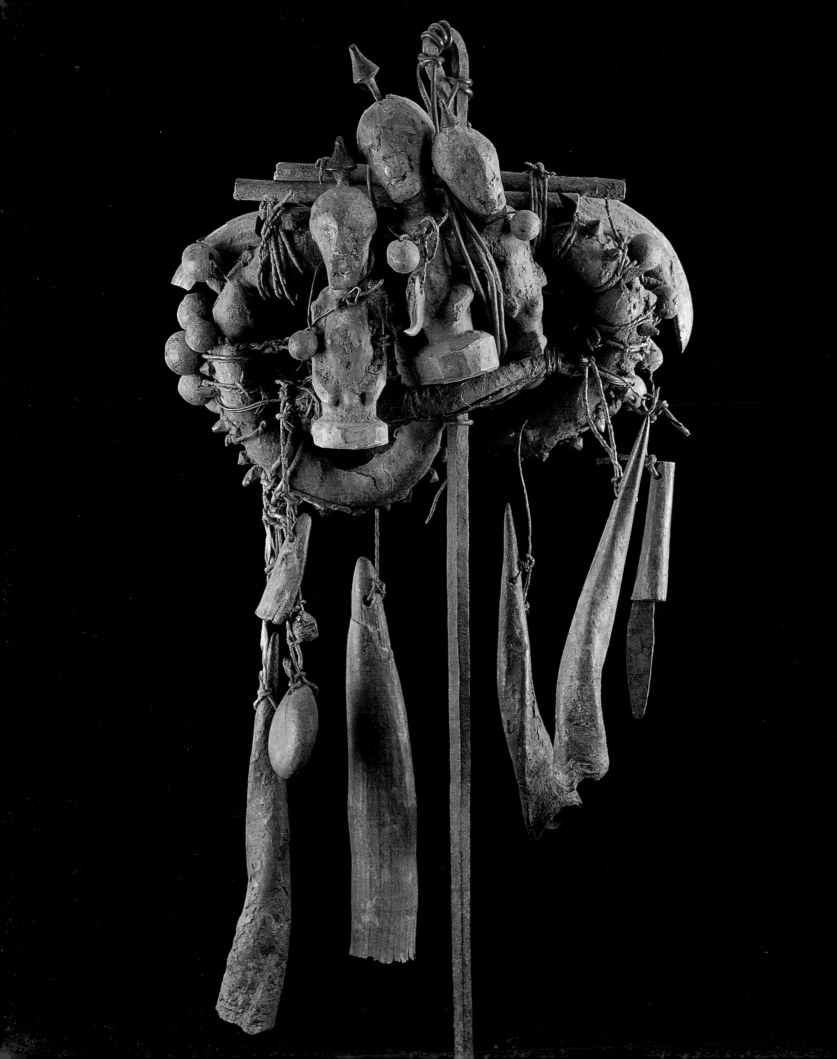

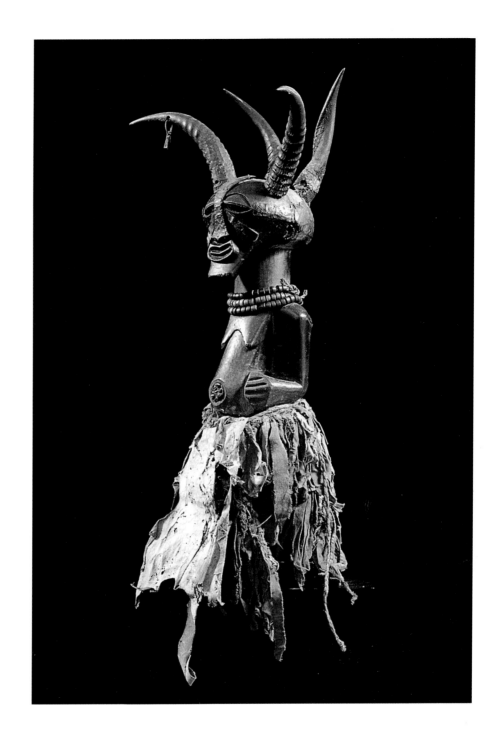

LEFT:

COLOUR PLATE 10
'Altar' with three figures [Cat.22]
Songye people, Central Africa
Collection Marc Leo Felix

COLOUR PLATE 11
Power figure
Songye people, Central Africa
Museum for African Art, New York

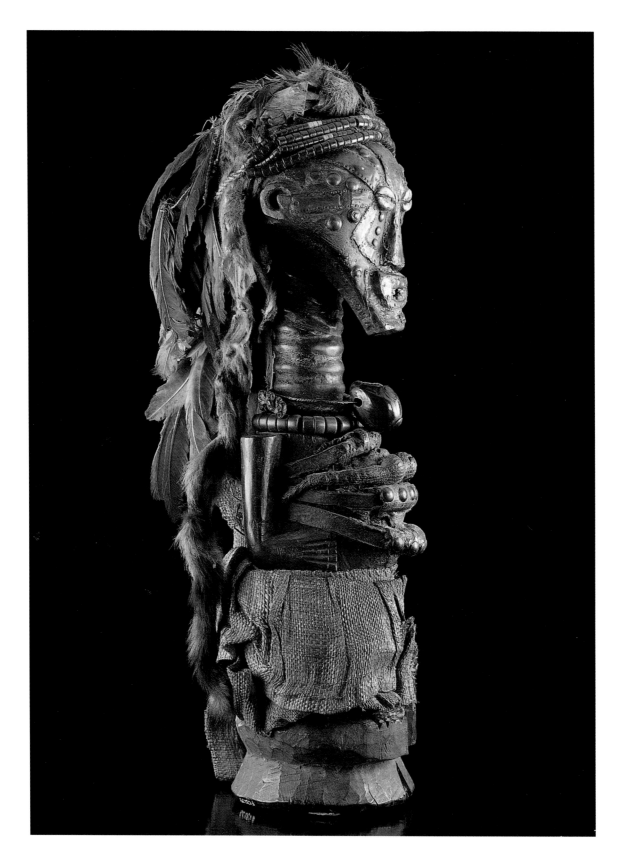

COLOUR PLATE 12
Power figure [Cat.18]
Songye people, Central Africa
Collection Marc Leo Felix

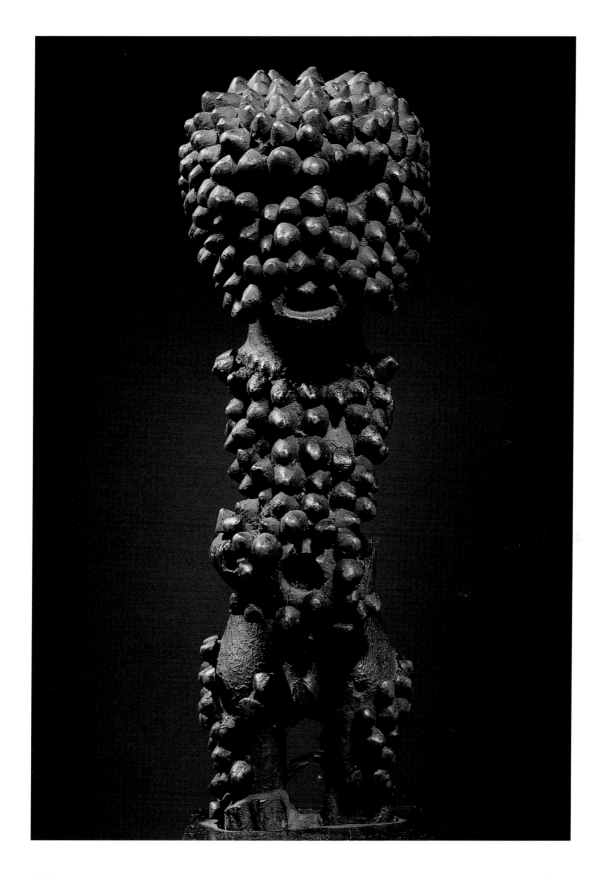

COLOUR PLATE 13
Power figure
Songye people, Central Africa
Museum for African Art, New York

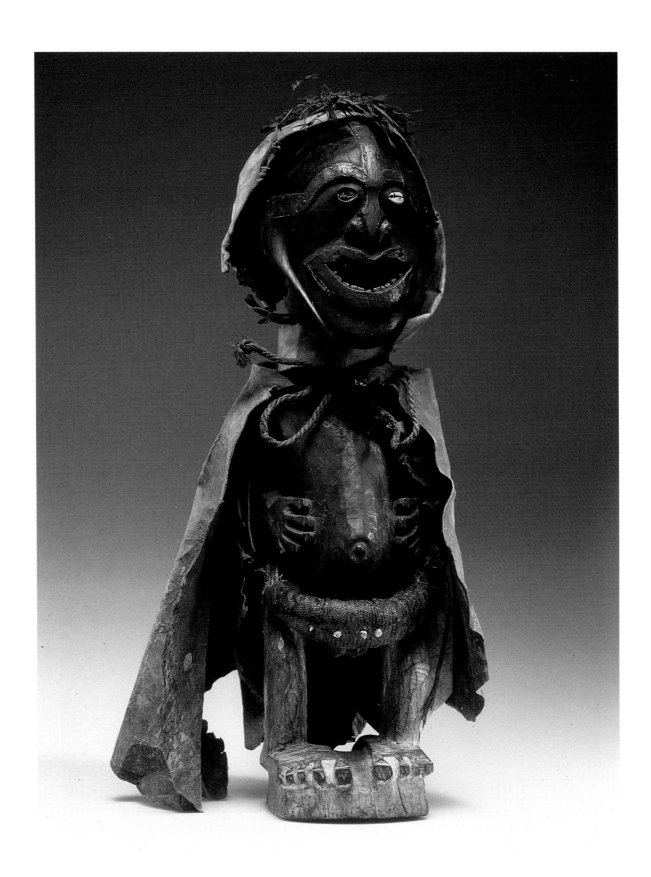

COLOUR PLATE 14
Power figure
Songye people, Central Africa
Museum voor Volkenkunde, Rotterdam

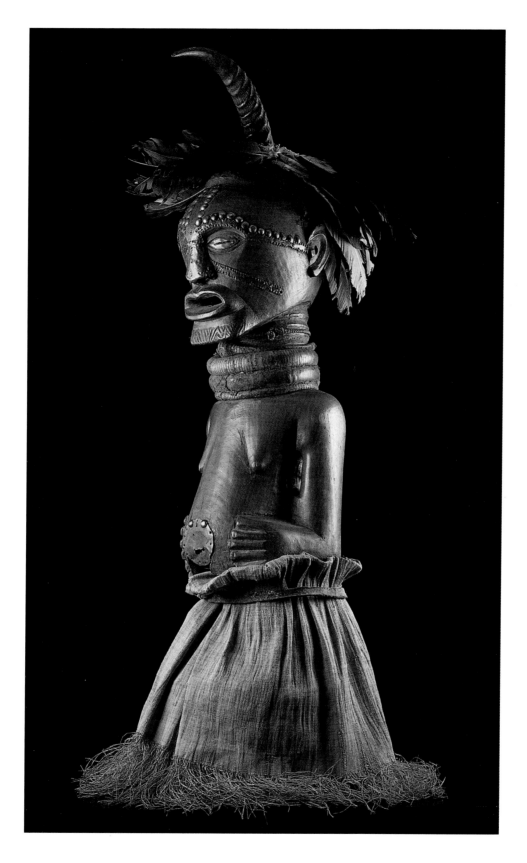

COLOUR PLATE 15
Power figure [Cat.13]
Songye people, Central Africa
Collection Marc Leo Felix

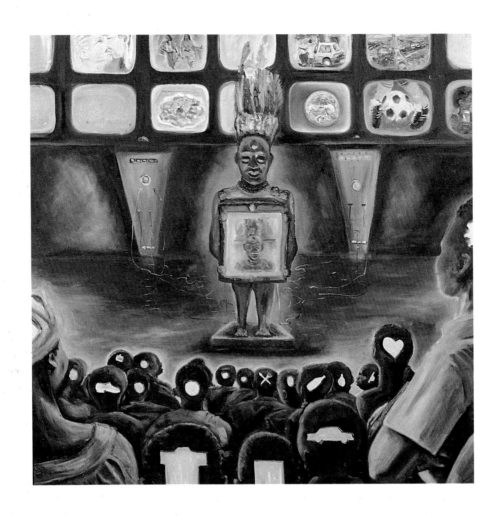

COLOUR PLATE 16
Trigo Piula (Congolese artist)
Ta Tele, 1988
Museum for African Art, New York

The contemporary fetish scene with its fashion designers, stylists, literature, clubs and life-style, as heir to many of those previously exiled forms of colonised eroticism discussed previously, has constructed a Western Other, modelled on archetypal scenarios but performed by a community which has displaced racism and sexual exploitation by consent and respect among its members. From the *bricolage* of disparate psychological traits, literary scenarios, pictorial scenes and theatrical styles, 'fetishism' has constructed its own ritualised forms of behaviour, embodied images of power and legitimising genealogies of origin that together have created a captivating world whose form and motivation are often ascribed a transcendental power. Its highly structured forms, rules and use of religious metaphor are acknowledged by its contemporary practitioners, as they were by von Masoch when he compared his mistress to Titian's *Venus with a Mirror* and the predicament of Severin, her enamoured slave, with that of the Christian martyrs. The sexualisation of religion is well remarked in much of the literature. Terence Sellers, New York's Angel Stern, clearly articulates the erotic fetish as a form of religious sacrament. 'A fetish is an object that radiates a "magical" field. It has no qualities of its own, or rather, its essential reality is held in abeyance, during which time it acts as the vehicle for the essence of the Superior. Whatever belongs to a Superior is not merely a shoe, a scarf, a garter, a letter – it is the Superior for the fetishist.'[82]

Sellers's book also illustrates the degree to which ritual absolutions and prescriptions governing the relationship between slave and dominant have been formalised. 'The Superior finds the body of the slave more or less repulsive until it has been hygienically prepared to come into contact with her. A thorough cleansing, inside and out, the shaving of at least the pubic region, and bondage are the three preliminaries for the imposition of servitude.'[83]

As Gilles Deleuze observes, the relationship between *maîtresse* and slave is one of coldness, described by Anthony Graham as 'embodying the double edged attributes of unobtainable beauty and irresistible power'.[84] The power of the formal coherence found in contemporary 'fetishism' can, to a large extent, be explained by the recognisability and established history of its constituent parts and images.

While part of contemporary Europe has reclaimed what is again a highly syncretic form of 'fetishism' as a significant part of its cultural identity, some African American artists, realising its radical and powerful figurative qualities, have used the images and paradoxical discourse of 'fetishism' to provide a critique of the society which created and disavowed it. The painting *Ta Tele* (1988) by the Congolese artist, Trigo Piula, cleverly appropriates Western images of the 'fetish', by depicting a mesmerised African audience looking into the abdomen of a traditional Kongo *nkisi*. However, in place of the medicinal substance usually concealed there, there is a television screen, while on the back of the heads of the viewers are painted the desires it generates. Commodity 'fetishism' is shown to be the real template to which religious 'fetishism' was subordinate. Other Black artists, like Renée Stout and David Hammons, have consciously reclaimed the Kongo idea of *minkisi* to construct palliative objects: 'Art is a way to keep from getting damaged by the outside world. To keep the negative energy away. Otherwise, if you didn't have a shield to let it bounce off then you start to really go crazy.'[85] Form, material and – in the case of Hammons and Stout who direct their objects at the community rather than the art market – significance, aim to re-establish a uniquely African concept and genre of art.

While the 'fetishisms' discussed in this essay share certain common internal characteristics, partly due to the unresolved ambiguity between the different contexts in which they have been devised and partly because of their rhetorical use to designate pathological or degenerative aspects of subject peoples, sexually excessive women or the insane, each is a distinct refraction of the basic trope.

'Fetishism', as a category, has gone through successive reinventions, combining distinct images, discourses and genres that, at different times and under distinct epistemological, cultural and political circumstances, have been disavowed or embraced. 'Fetishism' has come full circle, from a European invention, disavowed by the West and projected to disparage subject peoples, to a reclaimed and acknowledged form of cultural existence with its own Western community of followers. In other contexts its torturous paradoxes are providing a rich vein of critical and ironic guile for the groups it previously dispossessed.

NOTE. I would like to thank John Mack (Museum of Mankind), John Jarvis and David Reason (University of Kent), and David Mellor (University of Sussex) who kindly read and commented on an early version of this essay.

NOTES

1. Wyatt Macgaffey, *Astonishment and Power*, Smithsonian Institution Press, Washington and London, 1973, p.32

2. William Pietz, 'The Problem of the Fetish 1', *Res*, No.13, Spring 1987, p.37

3. W. Holman Bentley, *Pioneering on the Congo*, Religious Tract Society, London, 1900, p.256

4. W. Holman Bentley, *Dictionary and Grammar of the Kongo Language*, 1895, p.888

5. G. Cyril Claridge, *Wild Bush Tribes of Tropical Africa*, Seeley, Service, London, 1922, p.115

6. Dugald Campbell, *In the Heart of Bantuland*, Seeley, Service, London, 1922, p.240

7. Usually reserved for unorthodox sects and popular beliefs

8. R. E. Dennett, *Seven Years Among the Fjort*, Sampson Low, Marston, Searle and Rivington, London, 1887, p.50. The author's use of the term *nkissism* refers to 'fetish religion' and is derived from *nkisi*. See also his *At the Back of the Black Man's Mind or Notes on the Kingly Office in West Africa*, Macmillan, London, 1906

9. E. J. Glave, *Six Years of Adventure in Congo-Land*, Sampson Low, Marston, London, 1893, p.85

10. Bentley, *Pioneering on the Congo*, p.256

11. Joachim Monteiro, *Angola and the River Congo*, Macmillan, London, 1875, p.248

12. Dennett, op.cit. pp.49-50

13. Campbell, op.cit. p.234

14. Claridge, op.cit. p.119

15. R. H. Nassau, *Fetishism in West Africa*, Duckworth, London, 1904, p.14

16. Dennett, op.cit. p.49

17. Monteiro, op.cit. p.247

18. Glave, op.cit. p.77

19. Bentley, op.cit. p.256

20. ibid. p.293

21. Campbell, op.cit. p.234

22. Claridge, op.cit. p.121

23. Campbell, op.cit. p.243

24. Leo Frobenius, *The Childhood of Man*, Seeley, London, 1909, p.197

25. ibid. p.189

26. At least part of Dennett's own collection is illustrated in the plate on p.48 of his book on the Fjort. A number of the objects illustrated are now in the Royal Albert Museum, Exeter

27. Dennett, op.cit. p.66

28. Philippo Pigafetta, *A Report on the Kingdom of Congo, a Region of Africa*, quoted by Pietz, op.cit. p.38. But see the article by John Mack in this volume

29. Douglas E. Bradley, *Christian Imagery in African Art: The Britt Family Collection*, Snite Museum of Art, University of Notre Dame, p.6

30. As quoted by Sir Harry Johnson, *George Grenfell and the Congo*, Hutchinson, London, 1908, p.85

31. ibid.

32. Wannijn and Balandier, quoted in Bradley, op.cit. p.5

33. D. G. Jongman, 'Nail Fetish and Crucifix', *The Wonder of Man's Ingenuity*, E. J. Brill, Leiden, 1962, p.59

34. Bradley, op.cit.

35. Dennett, op.cit. pp.48-9

36. Glave, op.cit. p.82

37. George Ferguson, *Signs and Symbols in Christian Art*, Oxford University Press, London and Oxford, 1954

38. Carolyne W. Bynum, *Holy Feast and Holy Fast. The Religious Significance of Food to Medieval Women*, University of California Press, Berkeley and Los Angeles, 1987, pp.270-1

39. This interpretation of sacrifice is taken from Georges Bataille, *Theory of Religion*, Zone Books, New York, 1989, p.43

40. cf. Bynum, op.cit. plate 30. See also colour illustration in catalogue (plate 2)

41. The bodies of St Catherine of Siena and St Francis of Assisi were both reported to be marked by the stigmata (Ferguson, op.cit. p.50)

42. Jacques Le Goff, *The Medieval Imagination*, University of Chicago Press, Chicago, 1988, pp.83-4

43. Norman Cohn, *The Pursuit of the Millennium*, Paladin, London, 1970, p.135

44. Quoted in Jongman, op.cit.

45. ibid.

46. ibid. p.61

47. *Les Arts au Congo Belge et au Ruanda-Urundi*, CID, Brussels, 1950, plate 87

48. *Illustrated London News*, 18 September 1915, pp.842-3

49. Michel Foucault, *The History of Sexuality*, Penguin Books, Harmondsworth, 1987, p.53

50. ibid. p.154

51. Ann Laura Stoler, 'Carnal Knowledge and Imperial Power. Gender, Race and Morality in Colonial Asia', in Micaela de Leonardo (ed), *Gender at the Crossroads of Knowledge. Feminist Anthropology in the Postmodern Era*, University of California Press, Berkeley and Los Angeles, 1991

52. Robert Nye, 'The Medical Origins of Sexual Fetishism', in E. Apter and W. Pietz (eds), *Fetishism as Cultural Discourse*, Cornell University Press, Ithaca and London, 1993, p.14

53. Foucault notes that the working classes escaped the imposition of close sexual prescriptions for a much longer period than the middle classes (op.cit. p.121). Working class women were also the victims of the projection of eroticism outside of the middle-class family, coarseness

and animality forming a powerful lure (Mort, in *Formations of Pleasure*, Routledge and Kegan Paul, London, 1983, pp.37-8)

54. See E. Said, *Orientalism*, Penguin Books, Harmondsworth, 1985, p.190

55. ibid. p.188. Said finds that the trope of the oriental woman in Flaubert's Kuchuk Hanem, who never spoke of herself, represented her emotions or presence. 'The oriental woman is no more than a machine. She makes no distinction between one man and another' (ibid. p.187)

56. After death, various of their bodies were dissected by authorities no less renowned than Cuvier to ascertain whether any gynaecological abnormality could be found to explain such a presumption. The investigation was extended to promiscuous European women and led to an association being made between Africans and prostitutes. See Sander Gilman, 'Black Bodies, White Bodies: Toward an Iconography of Female Sexuality in Late Nineteenth-Century Art, Medicine and Literature', Henry Louis Gates, Jr (ed), *'Race', Writing and Difference*, University of Chicago Press, Chicago and London, 1985

57. Said, op.cit. p.6

58. Stoler, op.cit. p.54

59. See also Said, op.cit. p.219

60. Patrick Brantlinger, 'Victorians and Africans: The Genealogy of the Myth of the Dark Continent', in Henry Louis Gates, Jr (ed), *'Race', Writing and Difference*, p.209

61. Stoler, op.cit. p.67

62. Mungo Park, *Travels in Africa* (1799), Dent Dutton, London and New York, 1969, p.61

63. A. B. Ellis, *The Land of the Fetish*, Chapman and Hall, London, 1883

64. Geoffrey Gorer, *Africa Dances*, Faber and Faber, London, 1935, pp.54-5

65. ibid. p.153

66. In the main, fiction writers imitated the structure of travel literature, centring their stories around the themes of quest and adventure, much beloved by the Gothic romance (Brantlinger, op.cit. p.207)

67. Raymond Corbey, 'Alterity: The Colonial Nude (1900-1930)', *Critique of Anthropology*, VIII, No.3, 1988, pp.75-92

68. There already existed a convention whereby Africans were juxtaposed with white women to convey a sense of the sexual impropriety of the scene. Fanny von Pistor, Masoch's 'Venus in Furs', was often accompanied by African maids when disciplining her lover. In Manet's *Olympia*, the model becomes sexualised both by the pose and her juxtaposition with her African servant, Laura. The convention was used by Picasso in his celebrated *Les Demoiselles d'Avignon* (1907) which linked the women of the brothel with negritude by the use of African masks (Gilman, op.cit. pp.250-3)

69. Because of the later part of our argument we shall concentrate on Seabrook and Roussel, but many other writers also disclose these traits. Brantlinger (op.cit. p.213) mentions Rider Haggard, Joseph Thompson and Richard Burton. See also Brian Street's discussion of E.R. Burroughs's Tarzan stories (B. Street, *The Savage in Literature*, Routledge and Kegan Paul, London, 1975)

70. Also important are Alfred Jarry, the anarchist, playwright and author of *Ubu-Roi*, and André Salmon. The colonial Ubu and the black slave dancer in Salmon's *La Négresse du Sacré-Cœur* both combine elements of nudity, uncontrolled sexuality and lack of sexual propriety (Patricia Leighen, 'The White Peril' and 'L'Art nègre: Picasso, Primitivism and Anticolonialism'. *Arts Bulletin*, 722, 4, 1990, pp.609-30)

71. William Seabrook, *Jungle Ways*, Harrap, London, 1931, p.58

72. M. Leiris and J. Delange, *African Art*, Thames and Hudson, London, 1968, p.33. It was not until after the First World War that 'négrophilie' really began to engulf Paris. Gendron attributes the fad at least partly to the influence of foreign soldiers stationed in France. There were 163,952 Africans stationed in Europe under the French flag during the war and a large percentage of the 370,000 Afro-Americans serving in the United States Army were also encamped there. (Bernard Gendron, 'Fetishes and Motorcars: Negrophilia in French Modernism', *Cultural Studies*, 4, 2, 1990, p.145)

73. Quoted in Alasdair Pettinger, 'Why Fetish?', *New Formations. A Journal of Culture/Theory/Politics*, 19, 1993, p.85. Pettinger explores the conflation of religious and sexual fetishism in anthropological, psychiatric and psychoanalytical discourse

74. Anne McClintock, 'The Return of Female Fetishism and the Fiction of the Phallus', *New Formations*, 19, p.3

75. It is perhaps worth noting that the collusion of the erotic with the exotic and their incorporation into the heart of Western society coincided with the demise of direct personalised power as colonialism became more subject to rationalised administration. At the same time, opposition to colonial rule was growing, creating more restricted access to colonies. In the early twentieth century, Europe's image of Africa was heavily influenced by reports of atrocities committed in the Belgian and French Congo which probably contributed to demystifying romantic images of 'savage' life

76. These leather hoods were commissioned by Seabrook for his wife. Later they were photographed by Boiffard and illustrated in Leiris's article. See Rosalind Krauss and Jane Livingston, *L'amour fou. Photography and Surrealism*, Abbeville Press, New York, 1985. Also Dawn Ades in this volume

77. The connection between body-piercing, tattoos and mutilation to produce ecstatic states and former practices of non-Western cultures is acknowledged by many in the New Primitives movement

78. Jean Baudrillard, *Symbolic Exchange and Death*, Sage Publications, London and New Delhi, 1993, p.101

79. ibid. p.101

80. ibid. p.121

81. Foucault, op.cit. p.45

82. Terence Sellers, *The Correct Sadist*, Temple Press, London, 1990, p.69

83. ibid. p.19

84. Anthony Graham, 'Primal Therapy', in Tim Woodward (ed), *The Best of Skin Two*, Masquerade Books, New York, 1993, p.119

85. Dawoud Bey, *In the Spirit of Minkisi. The Art of David Hammons. Third Text*, Third World Perspectives on Art and Culture, London, 1994, p.48

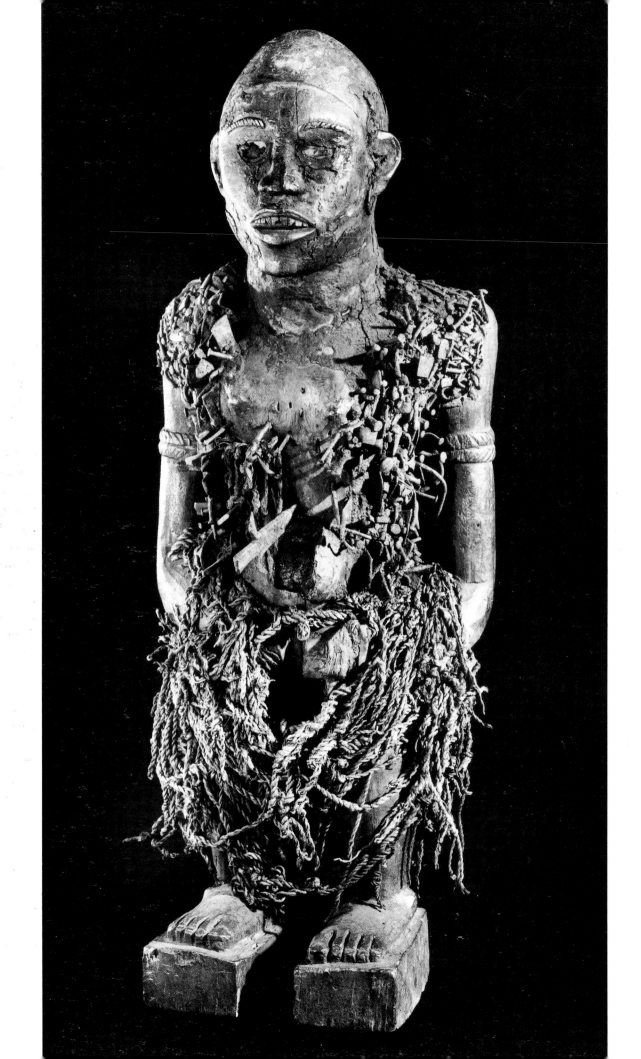

Fetish?

Magic Figures in Central Africa John Mack

At the time of writing the late autumn sales are taking place in London's auction houses. In a number of the catalogues presented by the 'Tribal' or 'Primitive' Departments a familiar vocabulary is on parade. Objects of a certain character are unfailingly described as 'fetishes'.

There are several puzzles here. First, the same catalogues are otherwise at pains to display a panoply of scholarly references, quotations from noted authorities, and native terminology, often rendered with commendable attention to contemporary orthography. The names of indigenous groups are likewise knowledgeably presented. Yet so vague and nebulous a term as 'fetish' persists, endorsed by continuing auction house usage (and no doubt that of many of their clients) in the face of alternative scholarly and native description. Indeed, it is used as if it were a technical term of clear and uncontested pedigree.

A second peculiarity is that the term appears to be deployed principally with reference to objects from sub-Saharan Africa. 'Fetish' seems to adhere most tenaciously to what might be called accumulative objects, be they sculptural or natural in origin. We are not here talking of objects which have been clothed or dressed in some way so as to refine their representational qualities. Rather it is used of objects covered with a whole variety of natural and manufactured materials in a way that suggests aesthetic enhancement has not played a prominent part in their placement. Of course, sub-Saharan Africa is not alone in the production of such images. Yet, it would seem distinctly odd to talk of broadly similar objects from the Pacific Islanders, Native Americans, Asians and Europeans, let alone North African Muslims, Jews and Christians in the same terms. They, it is implied, do not have 'fetish'.

There are, no doubt, obvious enough historical and psychological cupboards that can be (and have been) rummaged in search of a context, if not exactly an explanation, of this practice. One is the whole history of the exploration of Africa itself and the associated perceptions that have been fostered in literature, travellers' reports and some of the earlier anthropological monographs. The negativity of the term 'fetish' and the negativity of the discourse about Darkest Africa are closely akin. Both come with a baggage of other dirty washing lingering on from the nineteenth century and before: 'idolatry', 'devil-worship', 'witchcraft', 'evil-doing', and so forth. The moralistic tone of the thesaurus no doubt owes something to the involvement of Christianising mission in the exploratory process. However inappropriate, the caricature of fetishistic Africa has secure enough historical foundations – though we are still left to wonder why there was not in quite the same way any Darkest Mexico or Alaska, no Darkest Samoa or Fiji.

A second, more erudite, route towards some kind of explanation is by way of the etymology of the term itself. 'Fetish' has an origin in the early confrontations between Europe and Africa. The first Portuguese narratives talked of *feitiço*. This later transmuted into the West African pidgin term *fetisso*. In gaining thereby local currency it had some claim to refer to a recognisable category of object or pattern of thought. Even so, we may still wonder if it was understood in the same way by all its culturally distinct African users, let alone as between African and European users. At any rate its context in medieval European culture was supplanted by an African application which remains (for all that the term *ju-ju* is now more generally used in many places). And it remains despite the more recent reappropriation of the term into Western psychoanalytical description.

The Myth of the Fetish

All of this suggests, then, that 'the fetish' is firmly anchored in the space between cultures, one of the most potent zones of mutual misunderstanding. The most characteristic of the objects referred to as 'fetish' come from Central Africa. Indeed there is a complex of magical objects and practices which involves masquerade, and the use of various devices for healing and other purposes which, with local variation, is common to peoples from the Atlantic Coast right across Central Africa and into Zambia and beyond. The term *nkisi* is the shared Bantu word for aspects of this complex and is found in use in very widely distant parts of the region. Thus in terms of most of the objects illustrated here, and found in the African section of the exhibition which the volume accompanies, *nkisi* refers both to the nailed images from the Kongo on the continent's western shores, and to the magical figures of the Songye deep into central Zaire.

The most familiar of so-called 'fetishes', however, come from the peoples clustered round the mouth of what was then the River Congo (and is now the River Zaire). It is important to recall that here there is a history of contact with Europe that extends back over 500 years. The first Portuguese ships arrived off the coast in 1482. Within a decade the sparse Portuguese settlements were reinforced by a significant group of new settlers from Europe including representatives of a variety of Catholic Orders. And by Easter 1491 the first baptism of a local Kongo chief had taken place. By May the Kongo king and several local aristocrats had followed suit; and by July that same year the first church was already approaching completion.[1] The first catechism was written down in the local Kikongo dialect in 1556, and a dictionary had been prepared by 1652.

We do not know for sure the origin of the fetish figures of the Kongo, nor indeed is it at all likely that there could be a single knowable source. Various of these objects were destroyed with the conversion to Christianity of the famous Kongo king Alfonso I, and so certainly predated the late fifteenth-century encounter of Kongo with the Portuguese. Yet it has been suggested that at least one form of so-called fetish figure, that which incorporates nails, is in fact related to certain nailed images as they appear in Western culture. The Kongo objects in question are carved and usually figurative. In addition to nails, various other bits of hardware have often been driven into them. They are discussed in more detail below. If of Christian or, more generally, European inspiration, such images would represent an evolution of local forms encouraged by acquaintance with what was interpreted locally as an equivalent European practice.

Several possible links have been canvassed. As long ago as 1907 it was suggested by the ethnographer Peschuel-Loesche that nail fetishes were related to crucifixes.[2] It is in fact the case that images of Christ on the Cross entered Kongo culture in part as an insignia of chiefly office rather than in specifically evangelising contexts. Locally cast brass crucifixes are a familiar part of the iconography of more recent Kongo art. Whether the same inspiration lies behind the creation of nailed figures among the Kongo is very far from certain. Despite a considerable attention to archival sources on the history of missionary activity in the Lower Congo area, no solid support for this speculation has emerged.

A second link is the possible connection with a practice of sticking pins into images, which in Europe is best known as a means of inflicting injury on others.[3] Again, there is no supporting evidence of any association. Yet some expectation based on vague notions of the functioning of European witchcraft has been a significant part of the impression cultivated about the use of nail figures in Central Africa. All the negativity of the term 'fetish' has seemed appropriate to these 'ferocious', 'frankly obscene', 'indecent' 'scarecrows'.[4]

In the end, the perception of these objects as 'fetish' is an entirely spurious external view which classifies objects regardless of indigenous understanding. Indeed it has been in situations where an alternative system of understanding, that based on Christian doctrine, was making significant inroads among the Kongo that they

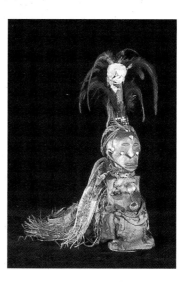

Power figure
Songye people, Central Africa
Trustees of the British Museum, London

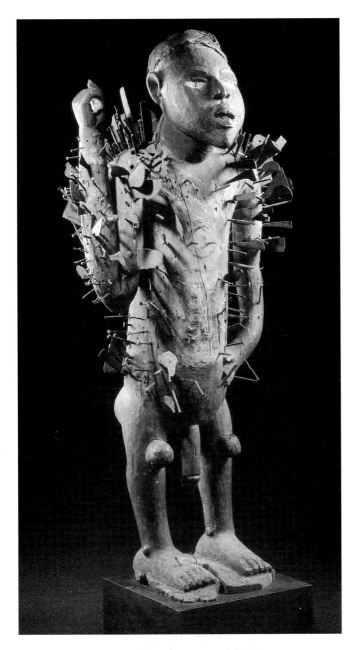

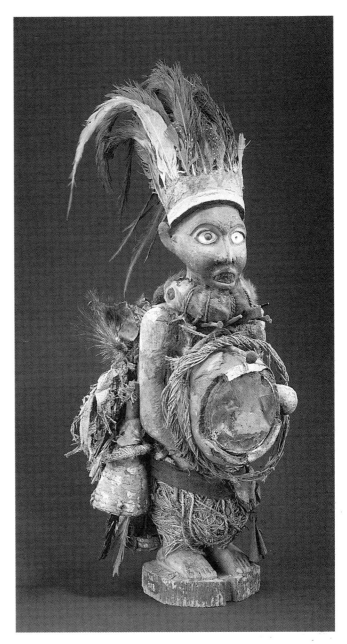

Power figure (*nkisi*) Kongo people, Central Africa
Biblioteca do Museu Antropológico, Universidade de Coimbra,
Portugal

Power figure (*nkisi*)
Kongo people (Vili), Central Africa
Museum für Völkerkunde, Berlin

were encouraged to attribute to these images quite a different symbolic meaning. The next act followed as the inevitable condition of Christian conversion: the harvest of souls was paralleled by the harvest of fetish. Disavowal of all belief in the efficacy of such objects implied their destruction – or, at any rate, their disposal to missionaries or other outsiders. The fact they are preserved today in the museums of Europe and elsewhere is often a direct result of such acts of disavowal. The use of such objects has diminished today and the ritual that once surrounded their operation has disappeared. Yet, if they are not

rescued by reinterpretation, they are destined to remain, in public perception at least, the quintessential 'fetish'.

The following observations are a reflection on what has already been achieved in unravelling an essentially complex set of images. Much has been gained from a re-examination of native texts about the objects recorded in the early years of the century and recently rediscovered.[5] A short pamphlet dating from 1969 and written by a Kongo commentator, Fu-Kiau Kia Bunseki, has also proved a suggestive resource.

The Object and its Function

The images themselves are in a variety of forms: the most familiar in ethnographical collections are a series of human figures carved from a solid block of wood. They display a wide variety of gestures – with one hand raised in an apparently threatening manner, hanging by the side, behind the head, or placed on the hips or the abdomen; female figures sometimes have the hands supporting the breasts; there are composite images of mother and child; teeth may be bared, tongue hanging out; eyes may be of white porcelain or other material imparting a staring appearance. Sometimes the image may be of an animal, a monkey or, more especially, a dog. Frequently male figures are encrusted with nails, blades, hooks, chains or other strips of metal. Most have a pack of substances attached to the abdomen, often with a mirror or occasionally a large cowrie shell embedded in the middle.

Some of these objects are of distinguishable types to which specific names appear to have been applied. In general, however, all such objects are referred to under the common term *nkisi* (or plural *minkisi*) and are thought of as containers.[6] Thus, in addition to carved figures, natural objects or other containing devices may also be used – objects such as a large shell or gourd, or a cloth bag, a pot or a box made from bark, may also function as the *nkisi*. What is contained is, in a narrow physical sense, a series of elements which collectively act as medicines or magically charged substances. These include chalk, white kaolin, charcoal, earth from graves, seeds, resin and so forth.

Without these elements the *nkisi* is neutralised. With them, however, the object is imbued with an empowering spirit also known as *nkisi*. The object therefore 'is' *nkisi* in the more profound sense that *nkisi* is contained within it by virtue of the substances assembled on the object. *Nkisi* is conceived as a power emanating from the unseen world of the dead, an omniscient force which is otherwise inaccessible to human perception. In being persuaded into taking up residence in a particular contained space, however, it has somehow emerged manipulable by human agency. Those who control the object are the *nganga*, a class of what might be called priests, who effect the ritual sequences in which the powers of the *nkisi* are activated on behalf of individual clients or communities as a whole. The powers, however, are not general but personalised and specific to individual objects which often bear their own name. Indeed they may acquire a reputation for their own pre-eminence.

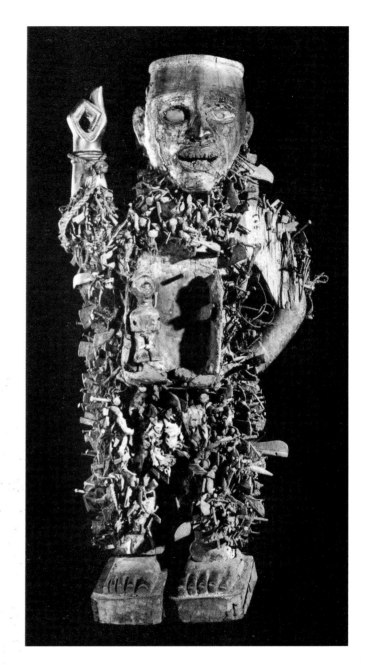

Power figure (*nkisi*) [Cat.4]
Kongo people, Central Africa
Trustees of the British Museum, London

Nkisi, then, are dynamic animated objects. They function at the behest of human operators; and their range of activity is extensive. They may be used in magico-medical contexts to promote healing; and they can have a detective function in identifying thieves or catching adulterers. Some have a juridical aspect and may provide judgement or punishment. They link in to systems of divination and assist in identifying the perpetrators of witchcraft. They may be consulted to enhance one's own chances of good fortune or to curse others.

Admittedly the purposes of *nkisi* are ambiguous.

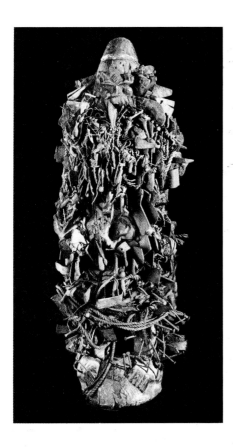

Power figure (*nkisi*) [Cat.5]
Kongo people, Central Africa
Trustees of the British Museum, London

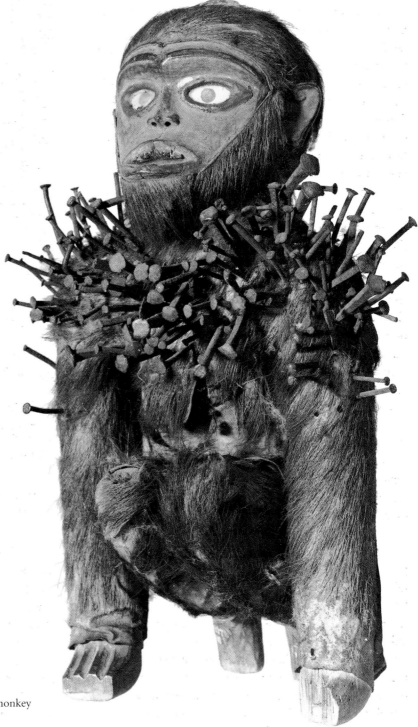

Power figure (*nkisi*) in the form of a monkey
Kongo people, Central Africa
Rijksmuseum voor Volkenkunde, Leiden

57

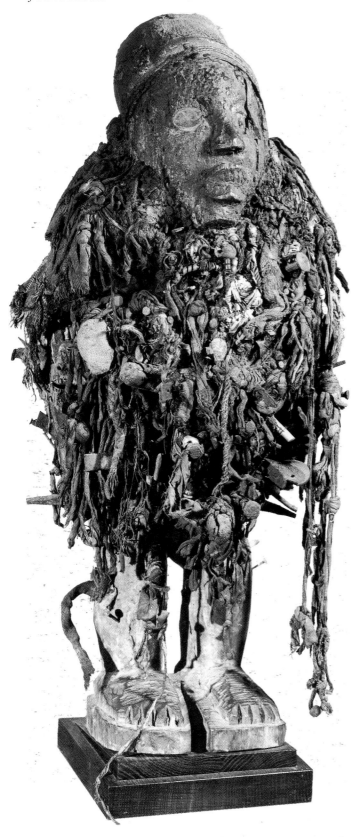

Power figure (*nkisi*)
Kongo people, Central Africa
Rautenstrauch-Joest-Museum für Völkerkunde,
Cologne

They are a locus of ritual activity, and an animated, em-powered object. Are they, then, really to be regarded as that restricted, impulsive kind of construction which the appellation 'fetish' implies in a European context? Dis-cussion of this phenomenon in relation to African art has generally proceeded by way of a distinction between two types of object. Thus William Fagg, for instance, in discussing Teke sculpture from the People's Republic of Congo, wrote: 'Some of these figures are ancestor figures but others are true fetishes, that is they are not made in honour of any particular spirit but are powerful in them-selves and made for a particular purpose, good or bad.'[7] Generally, this contrast between positive, often person-alised ancestor sculpture, and the negative impersonal type of image associated with magical projection is taken to be coherent with a broad distinction between the more overtly aesthetic carving of the ancestor figure and the accumulative character of the 'fetish'.

In Central Africa the division is most readily justi-fied in the apparent contrast between the *nkisi* festooned with its accompaniment of nails, blades, fragments of cloth and mirror glass, and the smooth sublime sculpture, often shiny as if varnished, and produced, for example, by the Kuba and the Hemba deeper into Zaire. Bluntly, the one appears to be the product of an ill-considered, vaguely magical process where aesthetic factors are en-tirely secondary; the other looks to have been deliberately treated to enhance its aesthetic qualities, a result of the affectionate approach to a fabled ancestor commemorated in sculpture.

Here I want to argue that in concentrating on outer appearance without asking how and why these effects have come about, we miss the point. Contrary to expec-tation, what we see on the surface is not the essence of the object but rather the interface between the hidden inner world of the animating spirit and the outer fragile world of the human supplicant. This is a critical relation-ship whose immediate field of operation is the surface of the object, but whose context is what happens invisible to perception within the object and that whole sequence of ritual action which surrounds the approach to the world of the spirits. In this respect they are much like the mask whose external appearance is often as important for what it hides (the masker, but also the spirit or other entity which by definition is unseeable) as for what it expresses.

Let us examine the extremes of this distinction: the Kongo nail fetish and the king figures of the Kuba. The Kuba kingdom is another of the elaborate historical poli-ties of Zaire and one sharing certain artistic preoccupa-

tions with the Kongo. It is possible that Kongo and Kuba have mutually influenced each other in the distant past, or at least that they have shared a common set of artistic assumptions. Both, for instance, have a developed interest in pursuing the possibilities of geometric patterning on objects, as is evident in the earliest examples of their arts. Yet nothing could be further removed in terms of appearance and apparent use than the bristling nail figures and the composed rounded forms of the dignified seated Kuba kings. The one is described historically as the ultimate example of an engine of magical fantasy – 'devil images'[8] – the other as refined portraiture, the very embodiment of the confident legitimacy of royal power.

There is some initial indication that, despite appearances, both images share some common conceptual features. Thus, the type of *nkisi* which is dominated by nails is known as *nkondi* (plural *minkondi*). MacGaffey tells us[9] that *nkondi* means 'hunter', the term deriving from the word *konda* which has the sense of someone who hunts alone rather than a participant in an organised game hunt. So, too, one of the more important praise names of the Kuba king associates him to the leopard, 'the animal that hunts alone'.[10] In this aspect the king is by extension likened to the witch who moves alone and unseen and who possesses an exceptional clairvoyant vision. This is threatening – an aspect not of the visual appearance of the king figure perhaps, but of the whole verbal context of kingship. In the case of the *minkondi* a deliberately aggressive aspect is a part of its conception as an object. Both are, then, at one level an assertion of a power which exceeds normal human capacity, and which to that extent contains an underlying menace.

Of the two, the *nkondi* is certainly the more intimidating, but it is not for all that the unremittingly vengeful image it is sometimes made out to be. Truth is stranger than fiction. *Minkondi* have a variety of identified functions; however, as early indications (mainly those resulting from the research of the Swedish missionary Karl Edward Laman) suggested, the principal approach to *minkondi* is to render oaths and undertakings authoritative and binding – hardly the conventional expectation of a 'fetish'. As such they are called upon to ratify treaties between opposed communities, to endorse attestations of innocence where someone asserts their wrongful accusation, to confirm initiation vows, and other such oath-taking.[11] The method of binding or fixing an individual intention or affirming an undertaking is by the driving in of a blade or nail. To this is attached some identifying element – cloth, hair or perhaps saliva. This personalises the approach to the *nkondi* and, in the event that a vow is

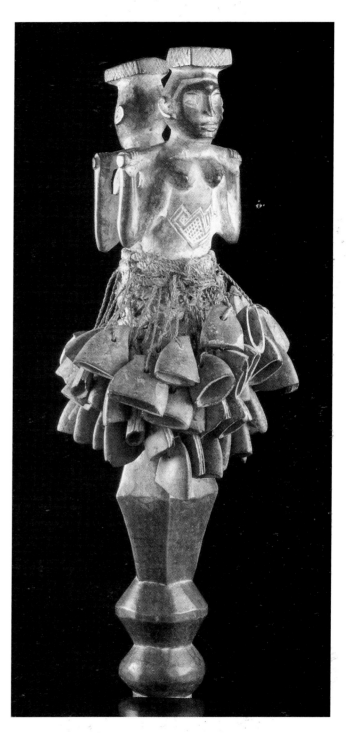

Priest's (*nganga*'s) rattle [Cat.29]
Kongo people, Central Africa
Katholieke Universiteit, Leuven

broken or a guilty supplicant wrongfully protests his or her innocence, unerringly identifies the impostor. In such cases the *nkondi* enacts retribution. Similarly the power of the figure may also be used for forensic purposes. Thieves may be identified by driving in a nail with the remains of stolen goods attached. The driving in of the nail in the first place is conceived as activating, angering the *nkisi*-spirit – hence the threat which underwrites its power and its appearance when unjust or fraudulent causes are brought to it.

More private affairs may also be revealed to *min-kondi*. Thus, where someone anticipates that their own success may cause disruptive and envious response in others, the fear may be allayed by fixing it through the driving in of a nail. In such matters the *nkondi* affords personal moral protection. Likewise it may right wrongs. Someone unjustly accused may draw out a nail placed in the figure on their behalf as proof of their innocence. Such an act undertaken by the guilty would have fatal results.

Despite the rhetoric, the blades are often placed on the image so as to create a symmetrical effect. There is some suggestion that this arrangement coheres with Kongo notions of completeness. It has the effect, of course, of making the task of the ritual specialist in remembering the cause represented by each inserted blade or nail much more difficult than would an eccentric disposition. Even so, such a feat of memory is required of the *nganga*. The method of annulling a vow or of reversing an affair wrongfully presented is to withdraw the appropriate nail. On the more heavily used of images this may involve a selection amongst upwards of 200 blades and their associated causes. Should the wrong one be extracted the power of the *nkisi*-spirit thus released would recoil upon the operator to dire effect.

Symmetry is also a feature of those types of nailed image which, instead of humans, portray animals. The most familiar is that of the dog, *kozo*. Here the medicine pack is placed in the centre of the back, and each half of the object is conceived as the image of the other resulting in a double-headed sculpture. The dog is an important category of animal in the symbolic systems of the Kongo and other Central African peoples. Its capacity for being at home in both a domestic village context and at finding its way through the forest makes it an apt vehicle for expressing relationships between the living and the dead or other spirits. Just as they can by their sense of smell track down game, so they can hunt out evil-doing. And, standing as they do at this conceptual divide between the human and ancestral realms, it is sometimes said that they

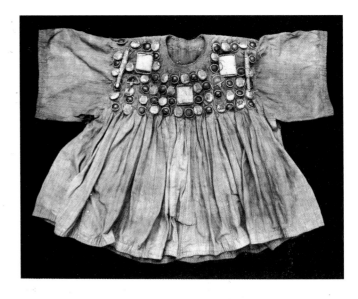

Charm gown [Cat.7]
Asante people, Ghana
Trustees of the British Museum, London

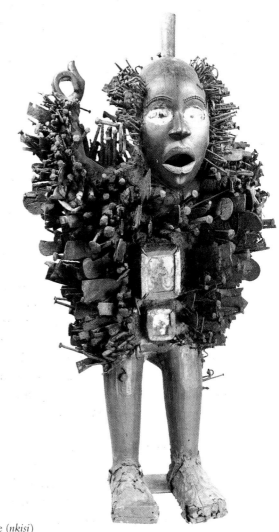

Power figure (*nkisi*)
Kongo people, Central Africa
Pitt Rivers Museum, University of Oxford

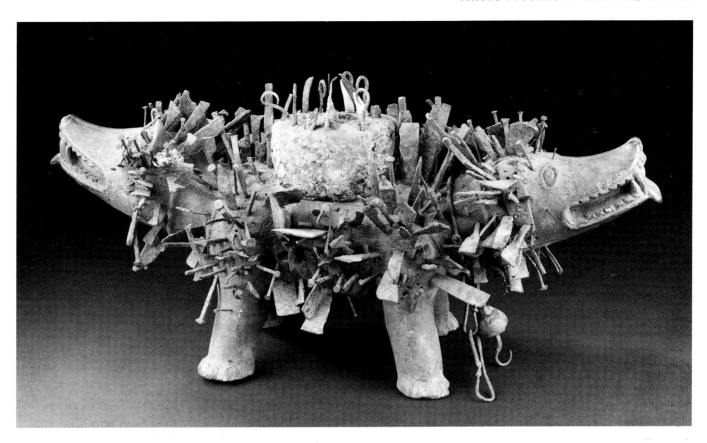

Power figure (*nkisi kozo*) in the form
of a double-headed dog [Cat.3]
Kongo people, Central Africa
Trustees of the British Museum, London

have four eyes, two for this world and two for the world
of the dead.[12] Hence the symmetrical divide in the
middle of the object and the heads that face in both
directions.

The other prominent visual and conceptual element
in the construction of the *minkondi* is the mirror attached
by its medicine pack to the abdomen (or, less commonly,
the forehead) of the figure. The ambiguous character of
mirrors makes them a common device of symbolic and
mythological constructions in many cultures. In reflecting
back the gaze of the viewer, they completely reveal what
is in front of them at the same time as they completely
conceal what lies behind. Surrealist programmes have
played around with these characteristics in a variety of
ways, producing images where the mirror reveals what is
behind the viewer rather than what is in front, or where
moving through a mirror gives access to the underworld.
Deployed on *minkondi* the mirror asserts, and is perhaps
held to be an instrument of, that all-encompassing ocular
vision of the *nkisi*-spirit contained within, its window on
the human world.

Mirrors are also considered as white, like water. This
links them to other white objects associated with *min-
kondi* figures, to the white porcelain which is sometimes
shaped and used as eyes, or the white pigment which is
painted principally on the head of the object, and which
indeed the *nganga* also applies to his own body. White
clay is an element in the composition of the medicine
bundle which activates *nkisi*. The Kikongo word for
white (*mpemba*) also means 'cemetery', 'land of the dead'.
The dead, however, are not thought of as residing
uniquely in burial places, but as living in or under water.
They themselves are also thought of as being white.[13]

The association with the dead, with ancestors, is
further elaborated in other conceptual ways both mythic
and cosmological. The Kongo speak of their arrival in
their present lands as the crossing of a great river. This
great river in its turn divides the land of the living and
that of the dead. Thus the Kongo see the universe as a
composition of two halves with water as the line of div-
ision. There is a succession of activity between the two
universes such that when one world sleeps the other
awakens: as the sun moves across the sky and sets beyond
the horizon, it begins to illuminate the world of the
dead. As it rises in the morning, the dead rest and the
living are awakened. By extension, the process of birth
and death is seen as a similar passage from one world to
the next.

Thus, the use of the mirror appears, additionally, to recall elements of this cosmogram. The water that lies between the two universes may be a river, the Atlantic Ocean, or simply a pool. In fact, certain deep pools provide one point of entry into the world of the dead. The mirrors on *minkondi* appear to function as a similar conduit.

Even this necessarily abbreviated account of Kongo ideas suggests that so complex an object as the *nkondi* is anything but the impulsive product of a self-regarding obsession. What we see on the surface of the object, and what is so absurdly misrepresented in the lingering discussion of 'fetish', is a stage in a whole series of on-going transactions between the living and the dead, assembled, contained in one powerful image. The driving in of the nails is not, then, a casual act of magical fantasy but a dramatic, presumptive and inherently dangerous act which pierces the surface that lies between the two domains. From the reading of the various ethnographical and historical accounts of Kongo, the *nkondi* emerges as a kind of progressive archive of complex spiritual interactions played out on the surface of the object so as to give shape to human experience.

The Sharp and the Shiny

Surface is no less important to the treatment, and thus the understanding, of *ndop*, the king figures of the Kuba. They have never been thought of as in any sense fetish objects. Yet there are significant areas of comparability between what are conventionally presented as two diametrically opposed types of African image.

Just as the Kongo spirits of the dead are identified with an underwater realm, so, too, the Kuba associate a category of nature spirits, the *ngesh*, with marshy, watery places, the sources of streams and deep forest pools. These spirits are fickle; they survey and influence affairs in the villages of the living often in unexpected directions. They remain unseen and inherently dangerous. But they can be approached and consulted in divination.

The king himself is regarded as such a being: an *ngesh*, a spiritual figure with the power over life and death. King figures are carved for each successive holder of royal office and portray them, not in the sense of creating a physical likeness, but by incorporating an emblem on the front of the sculpture which recalls some innovation with which the king has been associated – the introduction of a game board, skill at metal-working, and so

forth. Over time they acquire a deep, shiny, heavily varnished appearance. This is the result of them being oiled regularly by the royal wives in the course of use. Such applications occur on two particular occasions. The first is during the installation of kings when the new incumbent sleeps in a room with all the figures representing his predecessors. This procedure is seen as a method of incubating in him the spirit of kingship, those extra-human capacities which, among the living, kings uniquely possess. The second is to ensure the continuing presence of such kingly powers even when the king himself is absent on a journey outside his capital.

The action of rubbing, then, is not the sentimental practice of an owner in relation to a much-treasured object. It is, rather, a process intended to activate the object, to wake up and thus release its inherent powers. This idea of massaging as a method of activating is found elsewhere in Kuba culture. Thus, like the Kongo, the Kuba also identify the dog's facility for finding its way in the forests, the domain of spirits, with a forensic ability equivalent to that spirits themselves possess. Small images of dogs (among other appropriate animals) are carved and used in divination.[14] The method is to rub a disc, dipped in oil or saliva (as the nails driven into *minkondi*), across the back of the image. It stops once the answer being sought has been identified from a list of possible solutions spoken out by the operator. Again a well-rubbed shiny surface results.

Women likewise rub a mixture of oil and powdered red wood (which is also applied to king figures) on their bodies. The exposed stomach is the most usual site, and the stomach is also often carefully incised with the patterns which Kuba otherwise apply to certain types of textile, and to carved images. To describe the action as one of beautification is to miss part of the point; rubbing with oil also encourages fecundity.

It is notable that the Kuba, in addition to shining up certain kinds of object, also deliberately dull others. At night ceremonies intended to promote fertility, and associated with the phases of the moon, special wooden versions of ceremonial swords and knives are used. No doubt this is in part for the very practical reason that it averts the possibility of accidental injury in the semi-darkness. Women, however, also cover their heads to avoid the moon from shining directly on them. If they were to be exposed to moonlight on these ceremonial occasions they would risk infertility. Likewise the avoidance of shiny, metal-bladed weaponry seems to have an additional motivation, that of affording protection against spiritual dangers. A general association of reflective sur-

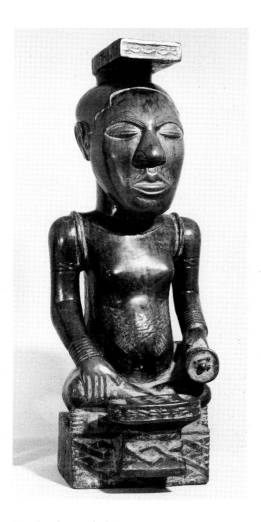

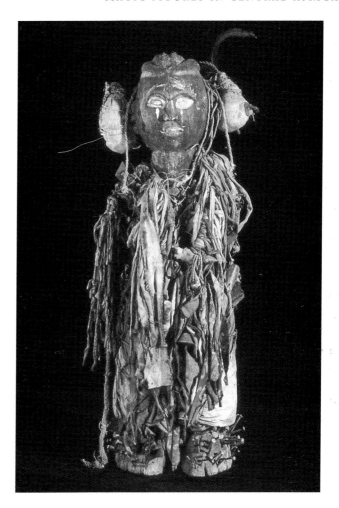

Wooden figure of a king
Kuba people, Central Africa
Trustees of the British Museum, London

Power figure (*nkisi*)
Kongo people, Central Africa
Trustees of the British Museum, London

faces with ritually empowered objects, of which the king figures are the prime example, seems to pervade Kuba cultural perceptions.

Of course, the association with royalty gives Kuba king figures a different context to that of *minkondi*, for all that they are conceived as deriving their power from the domain of spirits. The divination implements are perhaps closer in general function to the Kongo conception of the functioning of *nkisi*. But, from the point of view of the appearance of the objects themselves we have here not two divergent traditions but two parallel ones. What we see when we look at the pieces is not the result of creating an intentional visual impression on a passive sculpted subject; it is rather the end-product of a complex series of meaningful cultural processes applied to objects that are themselves regarded as intrinsically dynamic.

Finally, although we have identified two stereotyped kinds of object with two different cultures, in practice oiled or rubbed objects and accumulative or assembled

sculpture are found in both. Thus, in addition to their nailed images, the Kongo have highly polished figurative sculpture. Indeed they also lightly rub the backs and foreheads of *nkondi* in activating them, making a sign which is often compared to the cross. The ritual specialist, the *nganga*, makes a similar sign on his own body. This has led to speculation of a Christian inspiration to the practice. The cross, however, also has meaning as a representation of the Kongo cosmogram just discussed. The horizontal line of the cross corresponds to the great river of Kongo cosmology, and the vertical line to the links between the worlds of the living and the dead which it divides. Thus nailing, though inevitably attracting the greatest attention, has to an extent obscured the fact that rubbing is also an aspect of the Kongo approach to directing the forces held within objects.

In the case of the Kuba, it is interesting that at the turn of the century they had themselves collected or acquired magical figures from the Songye, distant neigh-

63

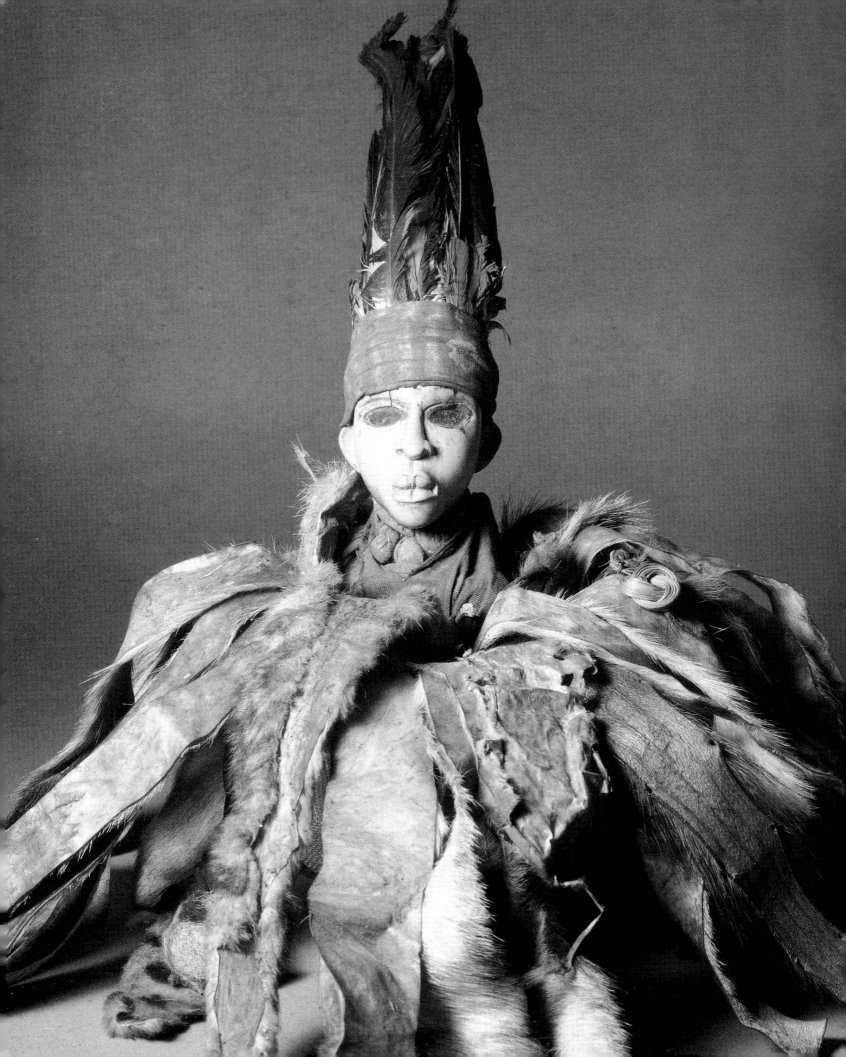

bours to their south-east. As noted earlier, these images, used by the Songye as a form of so-called white magic, are also known as *nkisi*.[15] The objects appear in a photograph of the Kuba king Kot aPe taken in the opening decade of the century. It would appear that possession of these exotic magical devices from outside the orbit of Kuba culture was an aspect of general royal control over magic coherent with the king's personal status as a spirit. The Kuba and the Kongo both had *nkisi*.

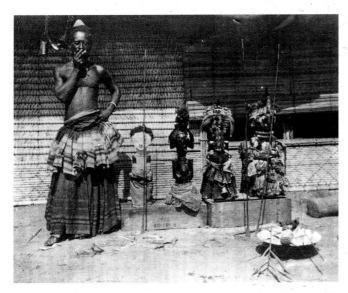

The Kuba king with his four
Songye power figures, Central Africa, 1908
Trustees of the British Museum, London

 The sharp and the shiny – the *nkondi* and the *ndop* – do not encode widely different approaches to objects, let alone opposed mentalities. In the end, it is we who have constructed the world of the fetish, not the original makers, priests or clients of such figures in Central Africa.

NOTES

1. George Balandier, *Daily Life in the Kingdom of the Kongo, From the Sixteenth to the Eighteenth Century*, Meridian Books, New York and Cleveland, 1969, chapter 2

2. D. G. Jongmans, 'Nail Fetish and Crucifix', *The Wonder of Man's Ingenuity*, E. J. Brill, Leiden, 1962, pp.55ff

3. ibid. p.61

4. H. M. Stanley, A. J. Wauters, W. H. Bentley, Lt J. K. Tuckey; all as quoted in Zdenka Volavkova, 'Nkisi Figures of the Lower Congo', *African Arts*, 4, 1972, p.52

5. Wyatt MacGaffey, *Art and Healing of the Bakongo commented by themselves*, Folkens Museum-etnografiska, Stockholm, 1991

6. Wyatt MacGaffey, 'Complexity, Astonishment and Power: The Visual Vocabulary of Kongo Minkisi', *Journal of Southern African Studies*, 14 (2), 1988, pp.191–2; also MacGaffey, *Art and Healing*, op.cit. p.5

7. William Fagg, *The Tribal Image*, British Museum Publications, 1970, p.35

8. Dapper, 1676; as quoted in Volavkova, op.cit. p.52

9. MacGaffey, 'Complexity, Astonishment and Power', p.199

10. Conrad Wharton, *The Leopard Hunts Alone*, New York, 1927

11. Robert Farris Thompson, 'Zinkondi: Moral Philosophy Coded in Blades and Nails', *Bulletin du Musée Barbier-Mueller*, 31, 1986

12. Wyatt MacGaffey, 'The Eyes of Understanding: Kongo *Minkisi*', *Astonishment and Power*, National Museum of African Art, Smithsonian Institution Press, Washington, 1993, p.43

13. Wyatt MacGaffey, 'Fetishism Revisited: Kongo *Nkisi* in sociological perspective', *Africa*, 47 (2), 1977, p.173

14. John Mack, 'Animal representation in Kuba Art', *The Oxford Art Journal*, Vol.4, 2, 1981, pp.50–6

15. Dunja Hersak, *Songye Masks and Figure Sculpture*, Ethnographica, London 1986

LEFT:
Power figure (*nkisi*)
Kongo people, Central Africa
Staatliches Museum für Völkerkunde, Munich

Surrealism: Fetishism's Job

Dawn Ades

GEORGES BATAILLE once proposed that the proper scope of a dictionary should not be the passive act of defining the meaning of a word, but that of addressing the job of work it had to do: 'A dictionary's job would begin from the moment that it stopped giving the meaning, but rather the tasks, of words.'[1]

The word 'fetishism', of obscure origins and disputed etymology, has worked its way through the rationalising discourses of the European Enlightenment; connoting over-valuation and displacement, its job was to signal error, excess, difference and deviation. Perhaps one of the key phantoms of the dream of reason, it helped to structure and enforce distinctions between the rational and irrational, civilised and primitive, normal and abnormal, natural and artificial. Thus the adoption of the term successively by Marx, and nineteenth-century psychologists, to refer to forms of irrational valuation within their own society, had a satirical edge. In Surrealism, however, there is a change in its fortunes. Having served to affirm the powerlessness of mind and body to act rationally, fetishism was to intervene in the Surrealist subversion of utilitarian and positivist values, or, as Carl Einstein put it, 'to change the hierarchies of the values of the real'.[2]

The peculiar capacity of the word both to adapt to and resist change may be a function of the very obscurity of its origins – which has prompted an obsessive interest in its etymology. A contrast might be drawn with the word 'taboo', which could be seen as belonging to the same type of mysteries relating to power, desire and superstition as those to which 'fetishism' was initially attached. The difference lies in the fact that 'taboo', how-

ever its meanings may have developed, was a word that belonged to the same cultural space as those concepts to which it referred. 'Taboo' is a Polynesian word. As Freud said in *Totem and Taboo*: 'It is difficult for us to find a translation for it, since the concept connoted by it is one we no longer possess. It was still current among the ancient Romans, whose "sacer" was the same as the Polynesian "taboo"...'[3] Unlike 'fetish', taboo was a term internal to the culture whose beliefs it connoted. The term fetish evolved in the course of encounters between Africans and Europeans on the coast of West Africa from the sixteenth century on, but, as William Pietz has argued, 'These cross-cultural spaces were not societies or cultures in any conventional sense. From this standpoint, the fetish must be viewed as proper to no historical field other than that of the history of the word itself, and to no discrete society or culture, but to a cross-cultural situation formed by the ongoing encounter of the value codes of radically different social orders.'[4]

Our idea in this exhibition was to assemble objects to which the term 'fetish' has been applied, in some of its disparate arenas, tracing the history of the word's activities and investigating continuities and discontinuities. We divided the exhibition into three parts: first, those things described as 'fetishes' by European traders and explorers in West Africa; second, a room devoted to Surrealism; and finally, a section including both street culture and fashion that has been dubbed fetish, and works by contemporary artists which could be related to any of the usages of the term. These are divisions that could correspond roughly to the concerns of ethnography, psychoanalysis and sexual politics. They were, though, intended to be porous, not watertight.

An obvious reason for the centrality of Surrealism in this exhibition is its involvement in both ethnography

and psychoanalysis, in which notions of fetishism have played such a crucial role. Surrealism was constituted in an awareness of what Foucault later called the 'confrontation, in a fundamental correlation', of ethnology and psychoanalysis. 'Since *Totem and Taboo*, the establishment of a common field for these two, the possibility of a discourse that could move from one to the other without discontinuity, the double articulation of the history of individuals upon the unconscious of culture, and of the historicity of those cultures upon the unconscious of individuals, has opened up, without doubt, the most general problems that can be posed with regard to man.'[5]

The Surrealists' embrace of other cultures was defined by their rejection of the values of their own. 'Latin civilisation has passed its zenith, and for my part I demand that we forgo, unanimously, any attempt to save it. It seems just now to be the last rampart of bad faith, senility and cowardice ...'[6] Their attitudes, though not wholly escaping the primitivising stance of the colonial world, are more complex than is sometimes admitted. Recent critiques of the Surrealists' attitudes to non-Western cultures are a useful corrective to a romanticisation of their position, but do not necessarily take into account the full complexity of this position historically.[7]

The pejorative character of the term was put to subversive effect in the counter exhibition organised by the Surrealists and the French Communist Party at the time of the huge Colonial Exhibition in Paris in 1931, which celebrated the extent of French territorial colonisation. African and Oceanic art were exhibited, and mural paintings by French artists allegorised the supposedly harmonious and patriotic relations between France and its colonies.[8] The Surrealists joined the anti-colonial campaign to expose these as myths and protest against exploitation and repression in the colonies, preparing and distributing a tract, 'Ne visitez pas l'exposition coloniale!', and helping devise an exhibition entitled *La Vérité sur les Colonies* (The truth about the colonies). A photograph reproduced in *Le Surréalisme au Service de la Révolution* shows a vitrine of exhibits labelled 'European Fetishes' containing three statues including a Catholic image of the Virgin and Child, and a charity collecting box in the form of a black child. The use of the term 'fetish' is doubly provocative. To describe these European objects as fetishes exposes the Western ideological assumptions behind the term, and by redirecting its object backwards, as it were, to Western things, serves to defamiliarise and denude them. Moreover, to juxtapose the Virgin with the black child begging-bowl was to make comparisons between religious and economic 'fetishism', a complex

relationship which precisely inheres within the term itself. Whether or not the organisers of the Anti-Colonial Exhibition were aware of it, the term did initially contain the Protestant viewpoint that Catholic idols compared in a number of ways with African *fetissos*.

The Surrealists were inveterate collectors of things from all over the world, from Paris flea market detritus to grand sculptures from Oceania or Pre-Columbian America. Photographs of Breton in his studio show him surrounded by objects of all kinds, massed like charms to protect him from things modern and utilitarian. However, only a few of these are actually described as 'fetishes'.[9]

The 'correlation through confrontation' of ethnology and psychoanalysis is especially vivid in the review *Documents* (1929-30); edited by Georges Bataille, this gathered many dissident Surrealists, like Michel Leiris, Robert Desnos and André Masson, in its pages. Although the juxtaposition of cultures characterises all Surrealist reviews, in *Documents* – and partly because, unlike the official Surrealist reviews, it was never the organ of a movement with its own project – contrasts, contradictions and comparisons force a radical revision of the hierarchies and values created by man and his artefacts, from whatever culture.

Documents represents a reaction against treating ethnographic objects as art; this serves, not to enforce a distinction between them and 'Western art', with only the latter properly entitled to such 'elevated' concepts as 'beauty', but to propose a similar process of addressing art as part of a specific cultural continuum among other artefacts. But there is also, in *Documents*, a strong sense of loss in much of the writing about modern art; as Bataille says in a key text in the last issue of *Documents*, 'L'esprit moderne et le jeu des transpositions', even the best of modern art belongs more to the history of art, emasculated and academic, than to human urgencies. It lacks the capacity to express either admissable or inadmissable experiences or needs. 'I defy,' he writes, 'any lover of modern art to adore a painting as a fetishist adores a shoe.'[10] By 'play of transpositions' Bataille means, as Denis Hollier points out, the symbolism of psychoanalysis, especially dream symbolism, targeting thereby the Surrealists.[11] The opposition Bataille sets up between symbolic transpositions and the fetish is clear, and this points to a crucial issue in relation to the Surrealist object. Bataille's polemic also throws into relief two important earlier pieces of critical writing in *Documents*: Carl Einstein's 'André Masson: Étude ethnologique', and Michel Leiris's 'Alberto Giacometti'.[12] Under pressure from similar preoccupations each chooses a term from outside

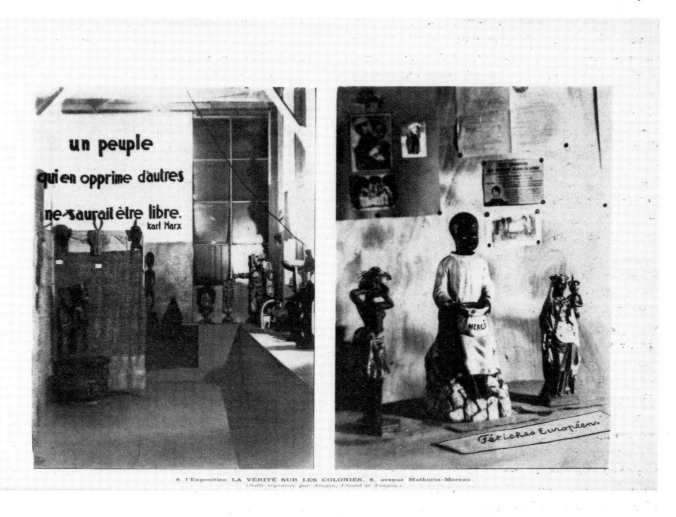

A l'Exposition LA VÉRITÉ SUR LES COLONIES, 8, avenue Mathurin-Moreau.
(Salle organisée par Aragon, Éluard et Tanguy.)

traditional aesthetic rhetoric, both of which in different ways are implicated in the drawing together of psycho-analysis and ethnology: Einstein takes the term totem, while Leiris places fetishism at the heart of his short piece on Giacometti. Each centres on issues of identity, the relation between self and the external world and the problem of creativity, which the words *totem* and *fetish* focus in quite different ways.

There is a somewhat contradictory character to this section on Surrealism. While ideas and themes that can be seen to correspond to various usages of the word fetish abound in Surrealist writing and visual manifestations – above all, as we shall see, in the Surrealist object – there is a certain reserve in the use of the term itself. The reasons for this are probably rooted in a new awareness, itself a consequence of the opening of ethnology into psycho-analysis, of the prejudicial character and the nature of the power relations that fetishism had signified.

The prevalence of 'fetishism' as an explanatory tool in the study of 'primitive religion' came under attack from Marcel Mauss by the end of the nineteenth century. He pointed out that the term should only ever be ad-

Two photographs from *Le Surréalisme au Service de la Révolution*, No.4, December 1931, showing the room organised by Aragon, Éluard and Tanguy at the exhibition *La Vérité sur les Colonies*

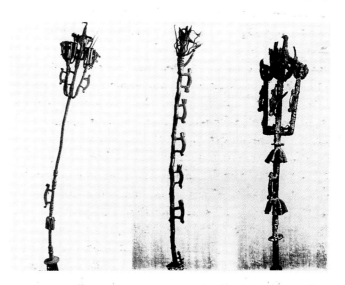

Tree fetishes from Benin in the Stuttgart Museum für Länder und Völkerkunde, reproduced in *Documents*, No.4, Paris, 1929

dressed to the thing itself, and not to a spirit distinct from it; in his 1898 review of Mary Kingsley's *Travels in West Africa* he argued that 'fetish' should designate at most certain amulets, and subsequently rejected it altogether, on the grounds that it prejudiced the understanding of the specific conceptions of magic within a given society.[13] Effectively, he was banning the word; 'so-called fetish-objects,' he argued, 'are never any old things chosen at random; this could only be true for the superficial eye of an outsider. On closer inspection it should be obvious that such objects are "always defined by the code of magic or religion" in question.'[14] Mauss's ideas were a powerful influence on the Surrealists and on that overlapping group that included Georges Bataille, centred on the review *Documents*. It was the apparently arbitrary character attached to the notion of the fetish that persuaded Mauss to drop the term as a dangerous caricature: a caricature with its roots in such notorious travellers' accounts as that of the Dutch merchant William Bosman in 1703. Bosman's African informant (significantly, an educated man, aware of the gulf between different social, religious and economic structures) told him that:

... the number of their Gods was endless and innumerable. For (said he) any of us being resolved to undertake anything of importance, we first of all search out a God to prosper our designed Undertaking; and going out of doors with this Design, take the first creature that presents itself to our Eyes, whether Dog, Cat, or the most contemptible Animal in the World, for our God; or perhaps instead of that any inanimate that falls in our way, whether a stone, a piece of Wood, or any thing else of the same Nature.[15]

Peitz comments on the puzzlement of early travellers and traders at exchange practices which operated so massively in the Europeans' favour: 'Gold is much prized among them, in my opinion more than by us, for they regard it as very precious: nevertheless they traded it very cheaply, taking in exchange articles of little value in our eyes.'[16]

It was precisely this radical disjunction, this gap between estimations of the value of a material object signalled by fetishism as a key term in the study of primitive religions that had led to its 'figurative' adoption by Marx and then by nineteenth-century psychologists. In the fourth section of the first chapter of *Capital*, 'The mystery of the fetishistic character of commodities', Marx's use of the term is, as Peitz has argued, both 'theoretically serious and polemically satirical':[17]

The mercantilists (the champions of the monetary system) regarded gold and silver, not simply as substances which, when functioning as money, represented a social relation of production, but as substances which were endowed by nature with peculiar social properties. Later economists, who look back on the mercantilists with contempt, are manifestly subject to the very same fetishistic illusion as soon as they come to contemplate capital. It is not so very long since the dispelling of the physiocratic illusion that land-rents are a growth of the soil, instead of being a product of social activity!'[18]

The fetishisation of capital, not less than the fetishisation of commodities, which Marx argues was a simpler form of bourgeois economic production, is an illusion, whose mysterious origins are analogous to

the nebulous world of religion. In that world, the products of the human mind become independent shapes, endowed with lives of their own, and able to enter into relations with men and women. The products of the human hand do the same thing in the world of commodities. I speak of this as the *fetishistic character* which attaches to the products of labour, so soon as they are produced in the form of commodities.[19]

What is striking about these passages in which the notion of fetish is used as a satirical weapon to attack the value systems of bourgeois society is the way in which distinctions between what is natural and what is produced by human labour seem almost fortuitously to reverberate with the etymological complexity of the term itself. Whether or not Marx bore this in mind, the proposed derivation of fetish via the pidgin *fetisso*, from the Portuguese *feitiço*, meaning witchcraft or charm, which derived from the Latin *factitius*, meaning 'made' or 'manufactured', gives the adoption of this term an interest exceeding that of the surface or foreground satirical analogy with the superstitious overestimations of primitive religious forms of belief. Although apparently buried deep beneath the sense of witchcraft, the Latin and then early Christian meaning of *factitius* as 'man-made', as opposed to the God-made natural world, often therefore with the sense of something fabricated, artificial or deceptive as opposed to genuine, further thickens the value-constructions loading the word.

Like Marx, the nineteenth-century psychologists of sexuality adopted the term fetishism from the study of religions. They show a fascination characteristic of the nineteenth century with its etymology. Alfred Binet, for instance, who first proposed it in his 'Le Fétichisme dans l'amour' (*Revue Philosophique*, 1887) as an appropriate

term for a particular sexual deviation within psycho-sexual research, gave alternative derivations. To his own etymology of the word, 'from Portuguese *fetisso*, enchanted, magic thing ("*chose fée*"); *fetisso* from *fatum*, fate', he adds a footnote to the effect that Max Müller attached the word *fetisso* to the Latin *factitius*, '*chose factice, sans importance*', rather than *fatum*.[20]

Binet is confident that it has a real object within the scientific study of religions. Fetishism, he argues, which was disdainfully called by Max Müller the '*culte des brimborions*', played a capital role in the development of religions, and even if they did not start with it, all were involved with it in some way and some ended there. The great battle of images, that has raged since the early Christian era, 'sufficiently proves the universality and the power of our tendency to confound the divinity with the material, palpable sign which represents it. Fetishism holds no less a place in love …'[21]

There is an interesting stress here on the importance of the material sign, the embodied character of the amorous illusion. Binet's analysis of fetishism quickly spread in the growing literature on the psychology of sex, and it was in this context rather than in the sense that Freud was to give the term, that we should begin to examine Surrealism's use of it.

Binet emphasised that what was described was not a 'psychological monstrosity'; 'everybody is more or less fetishist in love.' He defined a *grand* and a *petit* fetishism, of which only the former could be described as a form of 'genital madness'. The fetish object could be an inanimate object or any fraction of the body. Some parts of the body, though, were more likely to become fetishes than others: hand, foot, hair and eye. Binet's examples, many of which are taken from Charcot and Magnan's clinical studies, do include cases of women fetishists. Krafft-Ebing, however, who extensively revised his *Psychopathia Sexualis* to incorporate fetishism, notes that cases where fetishism assumes pathological importance have so far only been observed in men.[22] He does not rule out the possibility of female instances, although such, he says, have not yet been the object of study. Krafft-Ebing's purpose in classifying pathological forms of sexuality was, unlike Binet, in large measure forensic: he was concerned with its potentially criminal extensions, ranging from theft (of handkerchiefs, hair etc) to violence on the body. But he agrees with Binet on the crucial point that fetishism is proof of the intimate connection between mind and body. Fetishism, Krafft-Ebing argued, can only be acquired; it cannot be congenital. 'Every case requires an event which affords the ground for the perversion.'[23]

It can only be individual, and he quotes Binet: 'In the life of every fetishist there may be assumed to have been some event which determined the association of lustful feeling with the single impression.'[24] Almost certainly this was an event in early youth, connected with the first awakenings of the *vita sexualis*, whose circumstances were usually forgotten, although the result of the association was retained.

Here we are obviously on the threshold of Freud's discovery, or claim, as to what that event invariably was (for the male child): shock at the discovery of the lacking maternal penis. However, the conditions for that discovery – that is the existence of the castration complex – were still absent. There was agreement that the associations were subjective, probably not wholly accidental, that the imagination was a key ingredient, and above all that the fetish object took on an independent value – that it was, in terms of normal sexuality, irrationally overvalued.

The fetish-object may be articles of female attire, as in the case of the nursemaid's costume, frequently boots and shoes (Mirbeau's *Diary of a Chambermaid*, on which Buñuel's film was based, could well have been drawn from one of these case studies), gloves or underclothing.[25] Attachment to such inanimate objects should not be confused with the normal love of man for a handkerchief, shoe or glove etc which 'represented the mnemonic symbol of the beloved person – absent or dead – whose whole personality is reproduced by them. The pathological fetishist has no such relations. The fetish constitutes the entire content of his idea.'[26] Only the presence of the fetish could allow for erotic experience with a person, and often the presence of another was unnecessary for erotic stimulation. Merely the sight of such an object could be enough, though other senses were often involved – smell, touch and hearing.

Parts of the body particularly likely to become the object of fetish worship were hair, foot, hand and eyes. Binet gives the case of a young man whose sexual interest was displaced on to the eye, and imagined the nostrils as the seat of the female sexual organs – a case which seems to involve a double displacement. Another example in Krafft-Ebing was the young man who loved the foot of a lame woman. His ambition was to marry a chaste, lame girl who would free him of his crime by 'transferring his love for the sole of her foot to the foot of her soul'.[27] This attraction to the base which is often a part of the fetish's attraction formed an important part of Bataille's analysis of seduction, whose relation to the fetish we shall examine below.

The power of the word is rooted in a certain set of constants, which William Peitz argues provide a continuity despite the variability of the arenas in which it operates.[28] He defines these as follows: first, its irreducible materiality; the fetish is not identical with an idol, which is an acknowledged stand-in. Second, it is characterised by what Peitz calls 'singularity and repetition'; 'The fetish has an ordering power derived from its status as the fixation or inscription of a unique originating event that has brought together previously heterogeneous elements into a novel identity.'[29] This apparently is characteristic of African culture of the fetish, where Peitz quotes McGaffey's statement that 'a "fetish" is always a composite fabrication'. We need to distinguish two aspects to this 'ordering power of the fetish' in the context of Surrealism: there is both the unique and singular event which invested a material object or body-part with special power, which in psychoanalytic terms was compulsively repeated, and also the notion of heterogeneity, which was endowed with an illusion of unity or meaning (social, religious, psychological) through the operation of desire. The third constant is the notion of value: the displacement, reversal or overestimation of value, which is attached to the term 'fetish' and is perhaps its clearest and most consistent feature. Finally, the relation between fetish and the human body, whose functions and health the former may control and order.

As what Michel Foucault called the 'model perversion', fetishism had become, in the move to classify and control the deployment of sexuality, 'the guiding thread for analysing all the other deviations'.[30] The Surrealists, whose emphasis on pleasure and the body deliberately flouted the 'socialisation of procreative behaviour', were nonetheless ambivalent about sexual fetishism. The fact that fetishism had been so obsessively studied as a type of pathological sexual aberration in the context of a France paranoid about falling birth rates, and insistent on reproduction as a moral and patriotic duty and the only proper aim of sexual activity, invested it for the Surrealists with a positive value.[31] Their insistence on erotic pleasure as an aim in itself quite unmarked by any sense of patriotic or familial duty takes on in this light a clearly oppositional quality to the pathologisation of deviance. However, the Surrealists – above all, Breton himself – were bound to the idea of the reciprocity of heterosexual love; although there is some debate in the 'Recherches sur la sexualité', limits to the free discussion of the body exist although they are different from those imposed by the notion of normality.[32] Fetishism is in effect pressed into service in different ways by Surrealism, the very ambivalence of the

Joseph Cornell *Untitled*, *c.*1940 [Cat.54]
Private collection, courtesy Faggionato Fine Arts, London
© The Joseph and Robert Cornell Memorial Foundation

term, occupying a kind of *terrain vague* between public and private spaces, dream and waking, the interior and the exterior, Europe and its others, matching Surrealism's own situation.

Surrealism's relationship with the fetish depends crucially on the latter's materiality, and was closely bound up with the emergence of the Surrealist object. As Dalí put it:

What matters is the way in which the [Surrealist] experiments revealed the *desire for the object*, the tangible object. The desire was to get the object at all costs out of the dark and into the light, to bear it all winking and flickering into the full daylight. That is how the *dream objects* Breton first called for in his 'Introduction to the discourse on the paucity of reality' were first met with.[33]

Breton's 'Introduction to the discourse on the paucity of reality' contains one of his rare usages of the term 'fetish', and also, not by chance, the first formulation of the idea of the Surrealist object:

Do not forget if for no other reason the belief in a certain practical necessity prevents us from ascribing to poetic testimony an equal value to that given, for instance, to the testimony of an explorer. Human fetishism, which must try on the white helmet, or caress the fur bonnet, listens with an entirely different ear to the recital of our expeditions. It must believe

thoroughly that it *really has happened*. To satisfy this desire for perpetual verification, I recently proposed to fabricate, in so far as possible, certain objects which are approached only in dreams and which seem no more useful than enjoyable. Thus recently, while I was asleep, I came across a rather curious book in an open-air market in Saint-Malo. The back of the book was formed by a wooden gnome whose white beard, clipped in the Assyrian manner, reached to his feet. The statue was of ordinary thickness, but did not prevent me from turning the pages, which were of heavy black cloth. I was anxious to buy it and, upon waking, was sorry not to find it near me. It is comparatively easy to recall it. I would like to put into circulation certain objects of this kind, which appear eminently problematical and intriguing. I would accompany each of my books with a copy, in order to make a present to certain persons. Perhaps in that way I should help to demolish these concrete trophies which are so odious, to throw further discredit on those creatures and things of 'reason'.[34]

Breton is interested in the fetishist not, in the first instance, because of his sexual obsessions *per se*, but as someone who is convinced by his imagination. This can best be illustrated with reference to the almost contemporary and much better known *Manifesto of Surrealism*, where Breton outlines the two types of being who do not suffer from sclerosis of the imagination: children and the insane. For them, the world is not restricted to the purely utilitarian and functional. Things outside the immediate reach of the waking senses can be experienced as real. In his example of the fetishist who must touch the white helmet or the fur, it is the conjunction of the actual material substance, the 'irreducible materiality' of the fetish object, and the imaginative leap at a moment of intense experience that has given it such power, whatever its psychological roots. That which had been bracketed as outside rational behaviour and activity became almost by definition the arena of Surrealist exploration. The fetishist offered a supreme example of the reconciliation of imagination and reality. The fetish object – fur, bonnet, apron; the examples from the case studies are numerous and specific – was an undeniable material substance, but at the same time could not register in the world of utilitarian reality. It had individual psychological value but no social value. As Breton put it: 'Must poetic creations assume that tangible character of extending, strangely, the limits of so-called reality?'[35] In this sense, then, the fetishist, as Breton said in the passage quoted above, could understand the Surrealist poet, exploring the tangible inventions of language, loosened from its utilitarian function. 'What is to prevent me from throwing disorder into

this order of words, to attack murderously this obvious aspect of things? Language can and should be torn from this servitude. No more descriptions from nature, no more sociological studies …'[36] Since conviction of the reality of social conventions is riveted in us through its clichés, for 'it is from them we have acquired this taste for money, these constraining fears, this feeling for the native land, this horror of our destiny', to destabilise language is to shake these convictions, and also to question the assumed border between real and imaginary.

Breton's attack on the despised objects of utility sets the Surrealist object in direct confrontation with Le Corbusier's 'type-objects', hygienic and prosthetic.[37] Dalí's proposal for the construction of Surrealist objects, as a new form of communal activity for the movement, was directly prompted by Breton's dream object. Dalí, however, reforges the direct link with psycho-sexual concerns which was marginal to Breton's invocation of the fetish, through his notion of the 'Surrealist object functioning symbolically'.[38] These composite, elaborate constructions touch at several points the themes noted above for the fetish, although they should not be simply collapsed into it. The very fact that Dalí describes them as 'symbolically' functioning objects opens up some distance between them and the classical fetish, pulling them into relation with dreamwork. Dalí divorces these objects from any formal considerations, and they have nothing in common with the early constructivist experiments in kineticism.

OBJECTS OF SYMBOLIC FUNCTION:
These objects, which have a minimal mechanical function, are based on phantasms and representations susceptible of being provoked by the realisation of unconscious acts …

The incarnation of these desires, their manner of objectivising themselves by substitution and metaphor, their symbolic realisation constitute the typical process of sexual perversion, which resembles in every respect the process of poetic fact.

Dalí simultaneously sets up a psychoanalytical context through the classificatory terminology of 'normal' and 'perverted' sexuality, and then subverts it, by equating the object with Surrealism's poetic aims, thereby bringing into question the scientific aims of the psychologists: 'the object itself and the phantasms that its functioning can unleash always constitute a new and absolutely unknown series of perversions, and consequently of poetic facts'. The idea of an almost endless inventiveness at the service of a perverse erotic imagination,

73

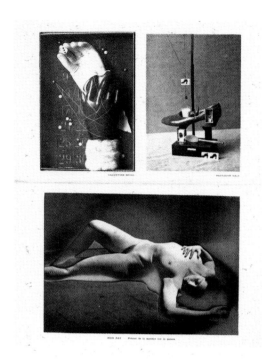

Valentine Hugo's and Salvador Dalí's objects reproduced
opposite Man Ray's *The Primacy of Matter over Thought* in *Le
Surréalisme au Service de la Révolution*, No.3, December 1931

Two Surrealist objects by Gala Éluard and André Breton
reproduced opposite Salvador Dalí's *Paranoiac Face* in *Le
Surréalisme au Service de la Révolution*, No.3, December 1931

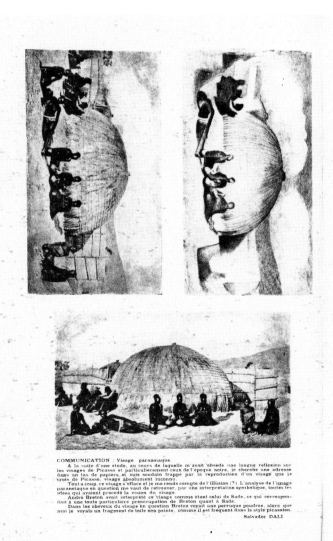

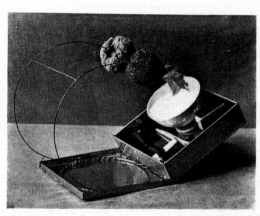

GALA ÉLUARD.

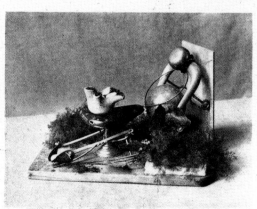

ANDRÉ BRETON.

Roland Penrose's *Dew Machine* at the exhibition
Surrealist Objects and Poems, London Gallery Ltd,
London, 1937

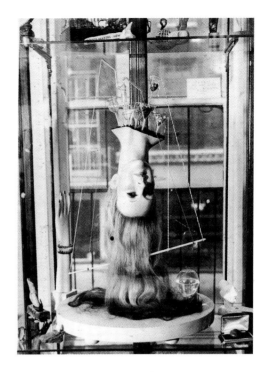

Roland Penrose and friend wearing masks from
Roland Penrose's collection, London, *c*.1940

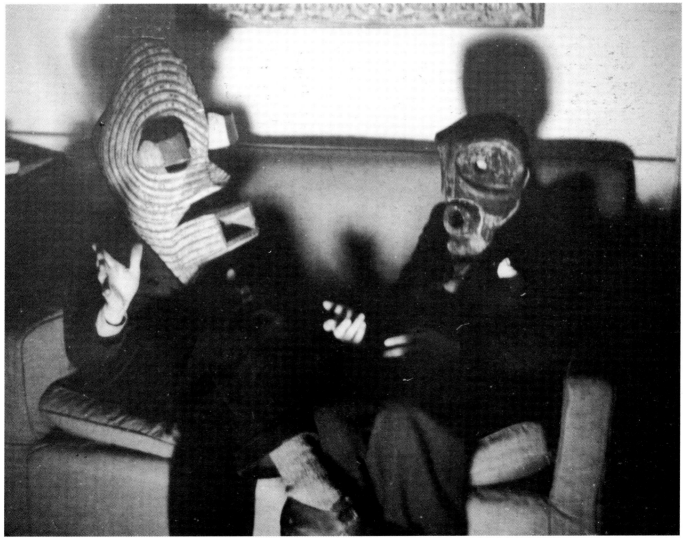

the categorising psychologist's nightmare, serves to underline the gap between the Surrealists' interests in the research and experimentation in sexuality and that of the 'scientists'. It was part of the project of the Surrealist object in the early 1930s that it should be 'practised by all'. Coming closer to fetishism than to dream symbolism, Dalí proposes that everyone should produce their own, given the irreducible individuality of the erotic imagination. 'The objects depend only on the amorous imagination of each person and are extraplastic' – that is, outside formal and aesthetic considerations. Of the four objects reproduced, two are by men, two by women (André Breton, Valentine Hugo, Dalí and his companion Gala). As far as Dalí was concerned, there was no gender bar to the realisation of these desires.

Dalí's 'Objets Surréalistes' concluded with accounts of these four objects which are basically descriptive rather than analytical, and were necessitated by the very complexity of the objects, the details of whose materials, construction and mobility were quite hard to determine from the photographs. He described his own 'article' as follows:

Inside a woman's shoe is placed a glass of warm milk in the centre of a soft paste coloured to look like excrement.

A lump of sugar on which there is a drawing of the shoe has to be dipped in the milk, so that the dissolving of the sugar, and consequently of the image of the shoe, may be watched. Several extras (pubic hairs glued to a lump of sugar, an erotic little photograph, etc) make up the article, which has to be accompanied by a box of spare sugar and a special spoon used for stirring leaden pellets inside the shoe.[39]

Dalí's comments on an object by the poet Paul Éluard are intriguing in the very direct link he sets up with the ethnographic objects. Éluard had included a wax taper in his object, and Dalí says 'wax was almost the only material which was employed in the making of sorcery effigies which were pricked with pins, this allowing us to suppose that they are the true precursors of articles operating symbolically …'[40] Herbert Read's comment in the 'Foreword' to the 1937 exhibition *Surrealist Objects and Poems* at the London Gallery makes a more general link between the Surrealist object – whether found, made or chosen – and ethnographic objects. He does so in terms that unintentionally highlight the contradiction that lies at the heart of Surrealism's embrace of the other – the 'savage': 'Imagine, therefore, that you have for a moment shed the neuroses and psychoses of civilisation: enter and contemplate with wonder the objects which civilisation

has rejected, but which the savage and the Surrealist still worship.'[41]

The Surrealist object has a rich ancestry; apart from Breton's dreamed object, the bearded book dwarf mentioned above, there were other both verbal and visual sources: the classic Surrealist image based upon the conjunction of two or more dissimilar realities on a plane foreign to them ('beautiful as the chance encounter of the sewing machine and umbrella on a dissecting table'); collages governed by a similar principle of displacement and disorientation; the game of the *cadavre exquis*; a variety of Dada objects and constructions, and Duchamp's 'assisted readymades'. Its immediate origin, though, was Giacometti's *Suspended Ball*, a source Dalí acknowledges but distinguishes from his own proposal of the symbolically functioning object on the grounds that it was still a sculpture, while the Surrealist object was exclusively made from found or readymade materials, and had nothing to do with aesthetics.

A drawing of *Suspended Ball* is included among the 'dumb, mobile objects' by Giacometti reproduced in SASDLR. *Suspended Ball*, which exists in both the original plaster form and in a wooden version, shockingly links violence to desire; the cleft pendant ball seems to hover over a curved wedge, which is waiting to slice further into the ball, but is also perhaps a magnified segment of it. Analogies between the ball and both eye and genitals point to a long obsession of the Surrealists, and most immediately to Buñuel and Dalí's 1929 film *Un Chien Andalou*, whose opening scene of the slitting of the young woman's eye was celebrated in *Documents* by Georges Bataille: 'The eye could be brought closer to the cutting edge, whose appearance provokes at the same time acute and contradictory reactions: precisely what the makers of *Un Chien Andalou* must horribly and obscurely have experienced when in the first images of the film they determined the bloody loves of the two protagonists …'[42] *Suspended Ball*, as has often been noted, confuses gender in its analogies with the human body and the motions of sex.[43]

A comic-horror sequence in *Un Chien Andalou* also plays on fetishistic displacements and substitutions across gender. A young man and young woman confront each other; the man suddenly clasps his hand to his mouth as though his teeth were about to fall out, and then removes it to reveal the lower part of his face as though wiped clean, as if he has no mouth. The girl reacts by furiously applying lipstick to her own mouth; however, hairs now grow on the man's face. The young woman claps her hand to her mouth in dismay, and quickly examines her

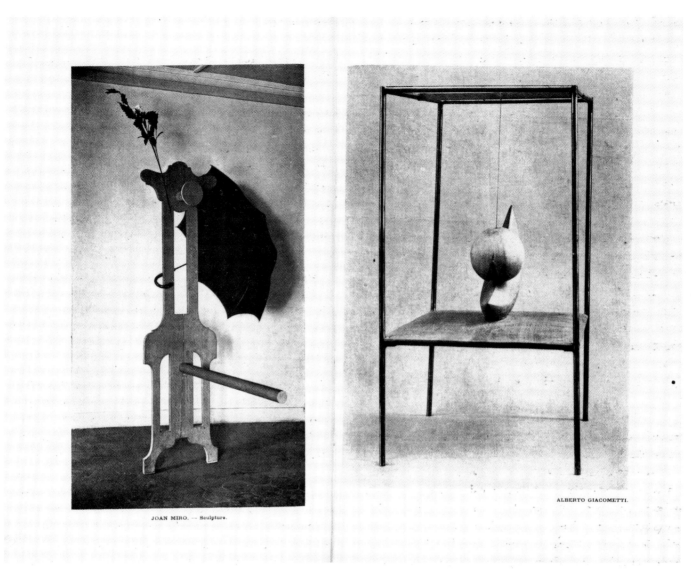

JOAN MIRO. — Sculpture.

ALBERTO GIACOMETTI.

Joan Miró's *Sculpture* and Alberto Giacometti's *Untitled (Suspended Ball)* reproduced in *Le Surréalisme au Service de la Révolution*, No.3, December 1931

Alberto Giacometti's *Dumb, Mobile Objects* reproduced in *Le Surréalisme au Service de la Révolution*, No.3, December 1931

armpit, which is now completely hairless. The man continues to look at her with hair growing on his mouth; she puts her tongue out at the man, and leaves the room, returning to put her tongue out once again at the hairy-mouthed man. This hilarious sequence compresses an extraordinary range of sexual signifiers into a dance between genders, starting with the horror-provoking castration symbol of the empty face (the original film direction was that the man should pucker his mouth until it appeared like a slit), through the masquerade as the woman frantically applies lipstick, to the final display by the woman of a comically waving phallic tongue.

Breton's 'L'Objet Fantôme', (the Phantom Object), published in the same issue of SASDLR as Dalí's 'Objets Surréalistes' and later incorporated into Les Vases Communicants, included a critique of these elaborate constructions.[44] Breton begins by drawing a sharp distinction between fantasy prompted by religious fear and modern monsters of the imagination like Picasso's Clarinet Player, Duchamp's Bride or Dalí's Great Masturbator. He opens with a quotation from Engels: 'The beings outside time and space created by the clergy and nourished by the imagination of ignorant and oppressed crowds are only the creation of a morbid fantasy, the subterfuges of philosophical idealism, the bad products of a bad social regime.' Breton wants to refute charges brought against the Surrealists by the dissident group centred on Documents, which had been leading a campaign to discredit the Surrealists by implicating them as idealists.

The deviation of works such as those by Duchamp or Dalí, modern monsters, which at first sight appear 're-pellent and indecipherable', should not be confused with the metaphysical imaginary of Bosch or Blake. 'The variable theory which presides over the birth of this work … shouldn't let us forget that preoccupations rigorously personal to the artist, but essentially linked to all people, here find a means of expression through a form of deviation.' Breton argues that such works can be analysed for their latent content, and then proceeds to do so for his drawing of an envelope with eye-lashes and a handle – the phantom object. Favourable though he is to the idea of the Surrealist object, whose adoption, he says, he recently insisted upon, he nonetheless finds it loses in power through being too systematically determined.

They offer to interpretation a less vast scope … than objects less systematically determined. The voluntary incorporation of latent content – filleted in advance – into the manifest content serves here to weaken the tendency to dramatisation and magnification used in the opposite case by censorship. Without

doubt such objects, too particular and too personal in conception, will always lack the astonishing power of suggestion enjoyed by chance by certain quite ordinary objects, for example the gold-leaf electroscope …

Out of Breton's objection to the symbolically functioning objects – his own as well as Dalí's – emerged the simpler type of Surrealist object, such as Oppenheim's Fur Breakfast (plate 32). Here there is an elision between fetish and dream object, in which the condensation and displacements typical of dream work take on material form.

Michel Leiris's 'Alberto Giacometti', published in Documents in 1929, continues the challenge to Surrealism posed by that review, which took the form of contesting value and meaning across a similar field of objects. Facing the problem of the 'private and particular' – the relation between individual expression and communicability – Leiris eschews the idea of the universalising function of the symbolic dreamwork. Fetishism alone occupies the central place in his argument.

Fetishism, for Leiris, now as in ancient times, 're-mains at the basis of our human existence'.[45] He distinguishes, however, between a true fetishism, and a counterfeit version to which too much of our lives is devoted, in the form of the worship of 'our moral, logical and social imperatives'. True fetishism is a different order of relation between the self and the outer world altogether. It is desire in its true form – love which demands another pole, external to itself, and is projected from the interior, 'clad in a solid carapace which imprisons it within the limits of a precise thing … into the vast strange chamber called space'. Few works made by

Alberto Giacometti
Pointe à l'œil, c.1932
Alberto Giacometti-Stiftung, Kunsthaus Zürich

the human hand respond to the exigencies of this true fetishism; most art is deeply boring. The reason that certain moments, objects or events stand out with inexplicable force and clarity in our memory is that they witnessed this sudden confirmation of desire from the outside, in what could be truly called a crisis. 'It is a matter of moments when the outside seems brusquely to respond to the summation that we launch towards it from the inside, when the external world opens up for our heart to enter into it and establish with it a sudden communication.' Leiris delicately builds up a framework for perceiving Giacometti's *Man and Woman, Reclining Woman* or *Personnages* (1929) as material traces of such moments of intense experience. They are essentially autonomous, and unjustifiable from any logical or rational perspective

which may demand of art a comfortable copy or ideal model of the external world. Leiris's description of the figure and its fetish alone in space closely corresponds to the open cage-like tracery of Giacometti's sculptures and the mysterious interpenetration of their forms.

The memory traces left by these moments of crisis are often embodied in events that appear in themselves 'futile, denuded of symbolic value and in some way gratuitous', like the fetish object. Leiris instances some of his own memories of this order: 'In a luminous street in Montmartre, a negress from the Black Birds troupe hold-

Alberto Giacometti
Man and Woman, 1929
From Michel Leiris, 'Alberto Giacometti', *Documents*,
No.4, Paris, 1929

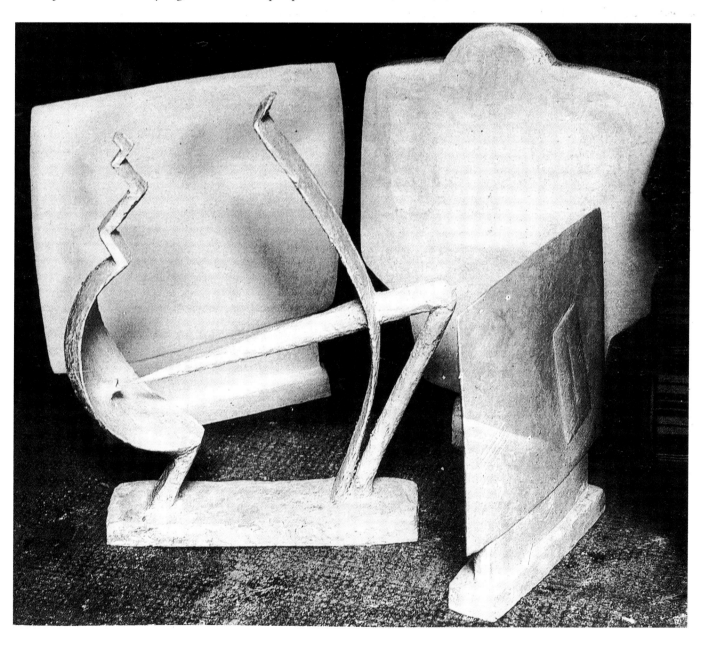

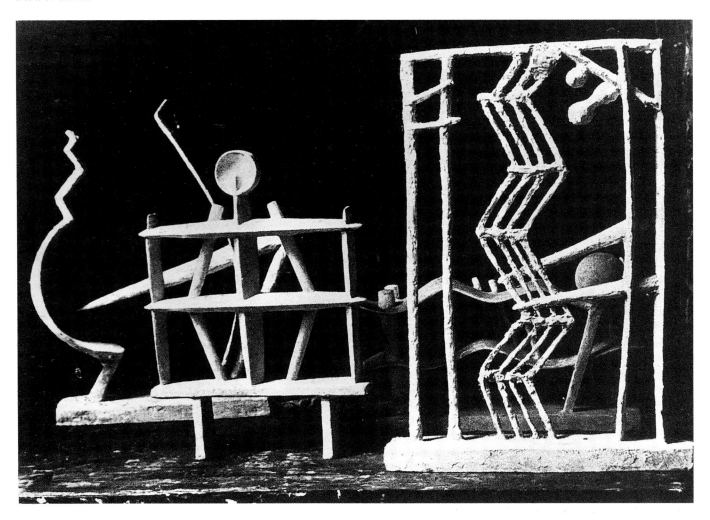

Alberto Giacometti
Personnages, 1929
From Michel Leiris, 'Alberto Giacometti', *Documents*,
No.4, Paris, 1929

ing a bunch of roses in her two hands, a steamer I was aboard moving slowly away from the quay ... meeting in a Greek ruin a strange animal which must have been a kind of giant lizard ...' Leiris finds Giacometti's sculptures, like *Man and Woman* or *Reclining Woman*, the precise equivalents of this type of memory – records of a psychical crisis, a confirmation of one's existence in a space not bounded by the imperatives of false fetishism but outlined rather by the operation of our own desire, which can be nothing other than 'l'amour – réellement amoureux – de nous-mêmes ...'.

And yet – what price should we give the capricious character of Leiris's own memories? They seem in effect to be almost too perfectly structured, corresponding to three of his – and Bataille's – preoccupations at the time: with the implications of 'negrophilia' in Paris (Black Birds), with the overturning of old notions of 'the primitive mind' (travel from here to there), and finally with the collapse of Latin civilisation (dinosaur in the ruins of Greece). Perhaps it should be enough to note that they operate in this text as a hint of another layer behind the

psychoanalytical discourse of the fetish. Leiris was reading Freud's *Totem and Taboo* at the time, and comments in his diary a couple of months before finishing the Giacometti article:

The theories of contemporary psychologists and sociologists (Freud, Durkheim, Lévy-Bruhl) on primitive mentality are necessarily subject to caution, these scholars having made no direct observations but worked from materials provided by the ethnographers. As far as totemism is concerned, for example, the different observers bring out very different forms, depending upon the country ... Moreover, these observations cannot have been made in an absolutely objective frame of mind; they are tendentious, and falsified in origin by the interpretation whose germ they already contain.

It seems that to explain the life of primitives most of these people have invented '*robinsonnades*' which represent in their

field the equivalent of those that Marx mocked in the classical economists.[46]

Leiris was evidently aware of the tainted nature of the term fetishism within ethnographic discourse, whose shadow he nonetheless invokes.

Dalí once referred to Feuerbach's 'conception of the object as being primitively only the concept of the second self … Accordingly it must be the "you" which acts as "medium of communication", and it may be asked if what at the present moment haunts Surrealism is not the possible body which can be incarnated in this communication.'[47]

Bellmer's object-sculptures are haunted by this idea of the 'possible body'. They have their origins both in the 'little fetishism' that Binet described as inseparable from all human love, but also undeniably in the sadism that Krafft-Ebing argued could be closely related to fetishism. In 'L'Anatomie de l'Amour', Bellmer claims that desire has its point of departure not in the whole, but in the detail. The body fragment isolated and compulsively repeated also points to male anxiety about lack in the Freudian sense of the fetish. In Bellmer, this overlaps with the earlier type of sexual fetishism – desire takes the fragment 'fatally' for the whole: its efficacity relies above all on the fact that it has an independent identity. Only thus, Bellmer writes, can it be doubled, multiplied, displaced in the realisation of the image of desire:

From the moment that the woman reaches the level of her experimental vocation, accessible to permutations, algebraic promises, susceptible of yielding to transubstantial caprices, from the moment that she is extendible, retractible … – we shall be better instructed as to the anatomy of desire, than the practice of love itself could do.[48]

Bellmer imagines removing the barrier between woman and her image. He gives a fearful example of this: a photographic document of a female victim who had been wrapped in wire 'provoquant des saillants boursoufflés de chair, des triangles sphériques irréguliers, allongeant des plis, des lèvres malpropres, multipliant des seins jamais vus d'emplacement inavouable',[49] which Bellmer compares with the multi-breasted Diana of Ephesus. This document prompted Bellmer's own experiments of photographing the body wrapped in string, one example of which was used for the cover of *Le Surréalisme, même* (Spring 1958). Comparisons have been made between Bellmer's 'monstrous dictionary of analogies/antagonisms' of body parts and the decadent

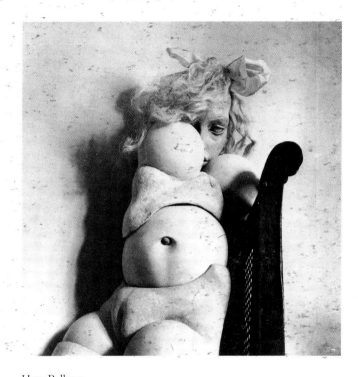

Hans Bellmer
Doll, 1936-49
The Mayor Gallery, London

le surréalisme, même 4

directeur : André Breton

revue trimestrielle printemps 1958

Cover of *Le Surréalisme, même*, 4, Spring 1958

dream-fantasy of one of the male lovers in Rémy de Gourmont's *Le Songe d'une femme*. However, there is a crucial difference. Paul Pelasge dreams of plants and bodies that metamorphose into one another in a cinematic slow motion of inflated fragments: 'now her two small sharp breasts become irritated and tremble; they become balloons; they stifle the naked woman who was offering herself; they settle down on their short stem; they are two large white mushrooms topped with a pink shell'.[50] Bellmer's body parts multiply and are displaced, but never metamorphose into something else. The leg, for example, 'perceived in isolation and in isolation appropriated by memory, should go forth to live its own life in triumph, free to double itself, to attach itself to a head, to sit down, cephalopod, on its open breasts while straightening the back that is its thighs';[51] but it remains, essentially and irreducibly, like the fetish, itself.

Parallels have often been drawn between the Surrealist object and photographs – parallels that are clearly laid out in SASDLR when the objects were reproduced facing Man Ray's photograph *The Primacy of Matter over Thought*. But if we draw in the idea of fetishism, some intriguing differences emerge. The body is the site for much of Surrealist photography, usually the female body. Brassaï's nudes, acephalous and phallicised, themselves seem to symbolise the fetish as Freud defined it. The Surrealist object – especially in its first incarnation as Dalí's notion of the symbolically functioning object – posits rather the absence of the body: shoe, gloves, a mirror, a bicycle seat. They are like symbolic narratives of erotic sensations, each highly personal in character.

Jacques-André Boiffard's photographs of three big toes, which accompanied Bataille's 'Le Gros Orteil' are photographic paradigms of a fetishised body fraction. The heavy chiaroscuro isolates the toe from its body; as reproduced in *Documents*, the toe is cropped from the original photograph of the foot and enlarged, dramatised and magnified in a wholly fetishistic process. The toe itself, though, is erect, its aggressive verticality confounding the base horizontality of its normal position. In the text, Bataille turns the 'classic fetishism of the foot' to account in terms of his arguments about 'base seduction' contrasting with the seduction of ideal beauty. The 'sacrilegious charm' of the foot of the Spanish Queen, which obsessed the Count of Villamediana and led to his death at the hands of the King, rested, Bataille argues, in the fact that it did not significantly differ from the hideous and deformed foot of a tramp.[52]

Five photographs of Paris monuments by Boiffard, illustrating Robert Desnos's 'Pygmalion et le sphinx',[53]

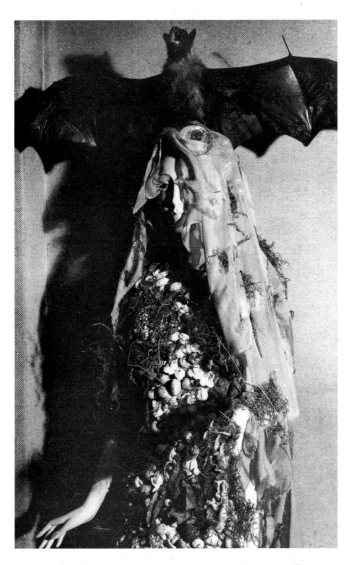

Photograph by Man Ray of the *Exposition Internationale du Surréalisme*, Paris, 1938
Mannequin by Marcel Jean

Jacques-André Boiffard
Big Toe, feminine subject,
twenty-four years old
From Georges Bataille,
'Le Gros Orteil', *Documents*, No.6, 1929

Jacques-André Boiffard
Big Toe, masculine subject,
thirty years old
From Georges Bataille,
'Le Gros Orteil', *Documents*, No.6, 1929

Jacques-André Boiffard
Big Toe, masculine subject,
thirty years old
From Georges Bataille,
'Le Gros Orteil', *Documents*, No.6, 1929

Jacques-André Boiffard
Photograph of Bartholdi's *Monument de la
Défense Nationale*, Paris
From Robert Desnos, 'Pygmalion et le Sphinx',
Documents, No.1, 1930

rather blank belly-shots of elaborate lumps of stone, raise the notion of the fetish in the context of the 'ethnological journeys' the Surrealists made in the heart of their own city. Like the statue of Étienne Dolet, place Maubert, which, Breton recounts in *Nadja*, always simultaneously attracted him and filled him with an insupportable malaise, there is a disproportion between their apparent role and their effect.[54] Desnos is interested in the contradiction between the materiality, the heavy weight of these statues and the elevated aspirations they are meant to symbolise, underlined grotesquely in monuments to speed, flight or telecommunications. They may, even more appropriately, be taken as fetishes to a nation's idea of progress, military might and glory, and thus classic examples of the mechanism of disavowal – that, at any rate, is the way the Surrealists saw them. Monuments, it was once suggested, are to history as the fetish is to the maternal phallus. In order to deny the absence of something that doesn't exist, you fill the gap, blanking out the absence and endowing this *material* object with the lineaments of your desire.

Aragon, in *Paris Peasant*, imagines the stone statues of capital cities becoming idols of a new religion, before which the people would come to worship and sacrifice. 'We have the phallophoria of Trafalgar Square, where one-armed Nelson is the witness of a nation's hysteria. And Frémiet's Joan of Arc ... not to mention the magnificent apotheosis of Chappe at the foot of a telegraphic scaffold.'[55] Boiffard's photographs of these monuments are reminders that the fetish could work for the Surrealists in playful and satirical, as well as perverse and sexual, ways.

Pablo Volta *Au Musée Grevin*
From *Eros: Exposition InteRnatiOnale du Surréalisme*,
exhibition catalogue, Galerie Daniel Cordier, Paris 1959–60

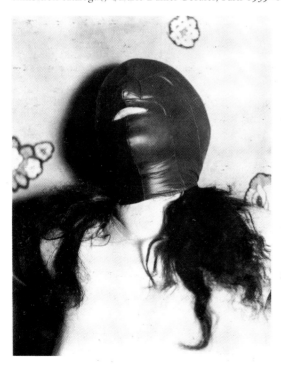

Leather mask conceived by W. Seabrook, photo attributed
to Jacques-André Boiffard, 1930
J. Paul Getty Museum, Malibu, California

NOTES

1. 'Un dictionnaire commencerait à partir du moment où il ne donnerait plus le sens mais les besognes des mots', Georges Bataille, 'Informe', *Documents*, No.7, Paris, 1929, p.382

2. Carl Einstein, 'André Masson: Étude Ethnologique', *Documents*, No.2, 2nd year, p.95

3. Sigmund Freud, *Totem and Taboo*, London, 1965, p.18

4. William Pietz, 'The Problem of the Fetish', *Res* No.9, Spring 1985, pp.10–11

5. Michel Foucault, *The Order of Things: An Archaeology of the Human Sciences*, London, 1985, p.379

6. André Breton, 'Introduction to the discourse on the paucity of reality' (1925), in *What is Surrealism?*, ed. Franklin Rosemont, Pluto Press, London, 1978, p.27

7. See for example Marianna Torgovnik, *Gone Primitive*, Chicago, 1990, or Nicholas Thomas's 'Colonial Surrealism: Luis Buñuel's *Land Without Bread*, *Third Text*, Spring 1994, p.25

8. See Charles-Robert Ageron, 'L'Exposition coloniale de 1931: mythe républicain ou mythe impériale?', *Les Lieux du mémoire*, Vol.1, Paris, 1984

9. A major sale of Breton's and Éluard's collections, 'Sculptures d'Afrique, d'Amérique, d'Océanie' at the Hôtel Drouot in 1931, coincided with the Colonial Exhibition. The catalogue listed two masks described as 'Fétiches M'Gallé' from the Ogoué region of Gabon. Éluard's list of ethnographic objects sold to Roland Penrose in 1937 describes only three of the African sculptures, the Gabon 'reliquaries', as fetishes, thus suggesting an attempt (if misplaced) to be precise in the use of the term

10. Georges Bataille, 'L'esprit moderne et le jeu des transpositions', *Documents*, No.8, 2nd year, 1920, p.489. Taking a cue from Mauss, the term 'fetish' is occasionally queried in *Documents*. A photograph of three rare Benin forged iron sculptures is reproduced (opposite, significantly, an anamorphic painting and two of Dalí's androgynous/body fragment paintings of 1928, *Bathers* and *Female Nude*); the commentary asks: 'Fetish trees? but perhaps also genealogical trees, or even trees flowering with freshly cut heads: it is difficult for the ethnographers to decide the nature of these most mysterious of trees ...' (*Documents*, No.4, 1929, p.230). See James Clifford, 'On Ethnographic Surrealism', in *The Predicament of Culture*, Harvard, 1988, for a further discussion of *Documents* and ethnography, and Jean Jamin, 'L'etnographie mode d'inemploi: de quelques rapports de l'ethnologie avec le malaise dans la civilisation', in *Le mal et la douleur*, ed. J. Hainard and R. Kaehr, Musée d'Ethnographie, Neuchâtel, 1986

11. Denis Hollier, *Against Architecture* (1974), MIT, 1989, p.112

12. Carl Einstein, 'André Masson, Étude ethnologique', *Documents*, No.2, 1929, p.93; Michel Leiris, 'Alberto Giacometti', *Documents*, No.4, 1929, p.209

13. Marcel Mauss, *Œuvres Complètes*, Paris, 1968, Vol.1, p.560. To Mauss's disgust, Kingsley persistently used the term 'joujou' ('French, used by the natives'). Curiously, this was the subject of one of Marcel Griaule's 'critical dictionary' entries, which he discusses in terms close to those one might expect for 'fetish'. 'The first Portuguese ... who landed on the African coast, facing the immense problems of the beliefs,

mysteries, powers, gods, black spirits, resolved them all immediately into a single word: DjouDjou … A ridiculous word from an ethnographic point of view, but a very elegant one if put in its place, that is if one considers it as nothing but a term of African *lingua franca [sabir]* and the *lingua franca [sabir]* of exhibitions.' *Documents*, No.6, 1930, pp.367-8

14. Adrian Pettinger, 'Why Fetish?', *Perversity: New Formations*, No.19, Spring 1993, p.92

15. William Peitz, 'The Problem of the Fetish 1', *Res*, No.9, Spring 1985, p.8

16. William Peitz, 'The Problem of the Fetish 2', *Res*, No.13, Spring 1987, p.41

17. William Peitz, 'Fetishism and Materialism', in *Fetishism as Cultural Discourse*, ed. Emily Apter and William Peitz, Cornell University, 1993, p.130

18. Karl Marx, *Capital*, London, 1942, p.57

19. ibid. p.46

20. Alfred Binet, 'Le fétichisme dans l'amour', *Revue Philosophique*, part 1, August 1887, part 2, September 1887, p.144. Mutations in the etymology of fetishism continue: the catalogue to the 1994 V&A exhibition *Revolt into Style* gives the meaning 'charming', a novel derivation from 'charm' in the magical sense

21. ibid. p.145

22. Dr R. von Krafft-Ebing, *Psychopathia Sexualis* (1886), translation by F.J. Rebman of the revised and expanded twelfth German edition, London, n.d. [*c*.1922], p.218

23. ibid.

24. ibid.

25. As Krafft-Ebing pointed out (in *Psychopathia Sexualis*, op.cit.), his examples were all of female clothing because most of the cases he and other psychologists had studied were men, but he did not rule out the possibility of female fetishists, and indeed among Binet's examples, drawn from Charcot's and Magnon's cases, was one of a woman who developed a fetishistic attachment for a man's voice

26. ibid. p.218

27. ibid. case 95, p.230

28. William Peitz, 'The Problem of the Fetish 1', *Res*, No.9, p.7

29. ibid.

30. Michel Foucault, *The History of Sexuality*, London, 1984, p.154. Surrealism itself profoundly influenced later radical critiques such as Foucault's *History of Sexuality*, and was responsible for publishing some of the first writings of two of the most influential figures in Structuralist thought in the fields of psychoanalysis and ethnography: Lacan and Lévi-Strauss

31. See Robert Nye, 'The medical origins of sexual fetishism', in *Fetishism as Cultural Discourse*, op.cit. The poet Apollinaire, who coined the term 'surréaliste', wrote a play entitled *Les Mamelles de Tirésias*, a piece of mildly satirical propaganda for childbearing, presented as a 'drame surréaliste'

32. *Recherches sur la sexualité*, Archives du Surréalisme, Paris, 1990,

translated as *Investigating Sex*, ed. José Pierre, Verso, London, 1992. The first two 'conversations' were published in *La Révolution Surréaliste*, No.10/11, 1928

33. Salvador Dalí, 'The object as revealed in Surrealist experiment', *This Quarter*, Paris, 1932, p.199. I have slightly altered the translation, which rendered Breton's 'Introduction au discours sur le peu de réalité' as 'Introduction to the discourse on the poverty of reality'

34. 'Introduction to the discourse on the paucity of reality', in *What Is Surrealism?*, ed. Franklin Rosement, Pluto Press, London, 1978, p.26

35. ibid. p.25

36. ibid.

37. Le Corbusier, *The Decorative Art of Today*, London, 1925. See also Briony Fer, 'The hat, the hoax, the body', in *The Body Imaged*, eds K. Adler and M. Pointon, Cambridge, 1993

38. Salvador Dalí, 'Objets Surréalistes', SASDLR, No.3, 1931, p.16

39. Salvador Dalí, 'The object as revealed in Surrealist experiment', op.cit. p.206

40. ibid.

41. Herbert Read. Foreword to *Surrealist Objects and Poems*, London Gallery Ltd, London, 1937

42. Georges Bataille, 'L'oeil', *Documents*, No.4, 1929, p.216

43. See Yves Bonnefoy, *Giacometti*, Paris, 1991, p.196; and Hal Foster, *Compulsive Beauty*, MIT, 1993, p.92; also Rosalind Krauss, 'Alberto Giacometti', in *Primitivism in 20th Century Art*, ed. W. Rubin, New York, 1984, for a discussion of Giacometti and 'hard primitivism'

44. André Breton, 'L'Objet Fantôme', op.cit. p.20 (author's translation)

45. Michel Leiris, *Documents*, No.4, 1929, p.209 (author's translation)

46. Michel Leiris, *Journal 1922-1989*, Paris, 1992, p.157

47. Salvador Dalí, 'The object as revealed in Surrealist experiment', op.cit. p.202

48. Hans Bellmer, 'L'Anatomie de l'Amour', *Le Surréalisme en 1947*, Paris, 1947, p.108 (author's translation)

49. ibid. p.109

50. Rémy de Gourmont, *Le Songe d'une femme*, Paris, 1916, p.145 ('Voilà que ses deux seins menus et aigus s'exaspèrent et tremblent; ils deviennent des ballons; ils étouffent la femme nue qui s'offrait; ils se couchent sur leur tige courte; ils sont deux grands champignons blancs surmontés d'une coque rose …')

51. Bellmer, op.cit. p.109

52. Georges Bataille, 'Le Gros Orteil', *Documents*, No.6, 1929, p.297

53. Robert Desnos, 'Pygmalion et le Sphinx', *Documents*, No.1, 1930, p.33

54. André Breton, *Nadja* (1926), Paris, 1964, p.25

55. Louis Aragon, *Paris Peasant* (1926), London, 1971, p.167

Robert Mapplethorpe
Photograph of Louise Bourgeois, 1982

Fetish and Form

in Contemporary Art Roger Malbert

A Freudian Thing

FREUD'S FAMOUS PAPER on 'Fetishism' is disappoint-
ingly brief, a mere seven-and-a-half pages. He discusses
the subject elsewhere in his work but never at greater
length. How tantalising is his reference in the 1927 paper
to the extraordinary cases of fetishism he has encoun-
tered, the details of which 'for obvious reasons … must
be withheld from publication'![1] Freud's theory is con-
structed around this omission of evidence; he offers only
a single example before proposing a universal explanation:
'In every instance, the meaning and the purpose of the
fetish turns out, in analysis, to be the same. It revealed
itself so naturally and seemed to me so compelling that
I am prepared to expect the same solution in all cases of
fetishism.'[2]

Freud's explanation, that the fetish represents a sub-
stitute for the imagined missing penis of the mother, is
based on a theory of castration anxiety that pertains by
definition solely to men. Women are by this account
logically incapable of fetishism – for how could a girl
experience in early childhood the same 'trauma' on
discovering that her mother lacks a penis? Freud hardly
bothers to justify the partialism of his theory; it is perhaps
best accounted for by his comment, in a related context,
that 'the factor of sexual overvaluation can best be studied
in men, for their erotic life alone has become accessible
to research. That of women – partly owing to the stunt-
ing effect of civilised conditions and partly owing to their
conventional secretiveness and insecurity – is still veiled
in an impenetrable obscurity.'[3]

It is easy to see why a theory born of the observa-
tion of male neurotics in a patriarchal European culture
seventy or eighty years ago should be in need of revision
today, not least after a sexual revolution that has trans-
formed social perceptions of female desire. Yet Freudian

psychoanalysis remains an essential key to the study of
fetishism, for cultural and feminist theory as well as art
criticism – despite its phallocentrism, and the theoretical
impasse Freud creates by his exclusion of women. The
model of the sexual 'pervert' with a secret obsessional
attachment to an inanimate object or material seems
especially pertinent to our consumerist society. The cases
that Freud studied were extreme instances of something
which, he said, affects us all 'in normal love', to some
degree.

The situation only becomes pathological when the longing for
the fetish passes beyond the point of being merely a necessary
condition attached to the sexual object and actually takes the
place of the normal aim, and further, when the fetish becomes
detached from a particular individual and becomes the sole
sexual object. These are, indeed, the general conditions under
which mere variations of the sexual instinct pass over into
pathological aberrations.[4]

It is fetishism as social phenomenon rather than
pathological condition that concerns us here. As the
imagery of fashion and popular culture trades on allusions
to taboo sex, the shiny, impersonal appeal of the fetish,
if only in the form of a leather jacket, is given common
currency. Freud himself allowed for a looser meaning of
the term, when he commented, facetiously, that 'in shop-
ping all women are fetishists'.[5] In this diluted sense, a
fetish need no longer be a private obsession, hidden in
shame, but a 'taste' to be flaunted, a mark of individuality,
wealth or daring.

It is worth dwelling further on Freud's fetishism
paper because he airs there a concept that has continued
importance for cultural theory and aesthetics: that of
'disavowal'. The fetishist is said to disavow his perception
of difference, that is, he simultaneously affirms and denies
his perception of the missing phallus. The result is a split-

ting of the ego, which enables him to retain the cherished illusion while giving it up as incompatible with reality. The concept of disavowal applies especially well to film aesthetics, firstly because the 'technological transcendence' of cinema requires of the viewer a double consciousness, combining suspension of disbelief, or credulity, and incredulity; and secondly because the collective fantasies represented in popular cinema can be seen to mask neurotic fears exactly as the fetish object does. In Laura Mulvey's view, 'Cinema finds its most perfect fetishistic object, though not its only one, in the image of woman',[6] and her analysis of fetishisation in Hollywood cinema attributes those fantastic constructions of flawless feminity to castration anxiety. Concepts like disavowal are a source of liberation for feminist aesthetics, Mulvey writes, because they make visible 'the gap between an image and the object it purport[s] to represent and thus, a mobility and instability of meaning'.[7] This mobility, the shifting space between signifier and signified, is a key to 'the language of displacement'; it is potentially as liberating for the artist as for the cultural theorist – and also, incidentally, for the fashionable dresser, since it brings to the fore the possibilities of disguise and play inherent in the masquerade.

The paradox in the Freudian theory is that since the 'maternal phallus' exists only as an imagined necessity in the mind of the young boy, what is really perceived by him is the lack of a lack. However, Freud himself seems to identify with the male perception, thereby implying a real lack in the body of woman. This is no mere entrapment in language, for he describes the palpable effect on the male consciousness of the first sight of a woman's genitals in terms of horror and revulsion: 'Probably no male human being is spared the fright of castration at the sight of a female genital.'[8] The flower of feminine sexuality is perceived as a gash, a wound, a sign of castration. The violence and misogyny behind this image is unmistakable, and it is not surprising that women have been outraged by it. Yet if it is true that the male unconscious harbours such a fantasy, then violence and misogyny must lie at the heart of civilisation – as indeed, we know they do.

The fetish is inert, without consciousness, and of course incapable of the reciprocity that another human being can offer, and demand. In psychoanalytical terms it represents a 'compromise', a half-way house on the road from self to other, for those unable or unwilling to go the whole way. Objects such as shoes, underwear, leather gloves, and materials such as leather, fur and rubber are typical fetishes, but the body-part precisely illustrates how the slippage between nature and culture gives scope for obsessional fixation. Culture determines which parts of the body are exposed and which concealed; fashion and ornament enhance the parts revealed, with special attention to the edges of clothing, the passage from cloth to skin, the line at the neck, shoulder, ankle or thigh. The less that is revealed, the more those visible parts are likely to excite the fetishist; they tantalise because they hint at or stand in for the parts that are concealed, especially the zone most forbidden to public view. Thus the visual appeal of the fetish may in fact be negligible; its significance is all in the mind.

There seems to be little dissent today from the 1927 theory of male fetishism, at least among amateur psychologists such as art historians and cultural theorists. The question of female fetishism, however, the existence of which is now widely recognised, continues to exercise psychoanalysts and feminists. It is of course an aspect of the larger problem of the psychoanalytical account of female sexuality. Jacques Lacan interpreted Freud in the light of linguistic theory and expounded a concept of the phallus as signifier within the symbolic order of language, a function as important for woman (it being the signifier of desire and of her desire to be desired) as for man. Feminine sexuality is thus defined in terms of displacement ('the organ actually invested with this signifying function [the phallus] takes on the value of a fetish') and narcissism ('it is in order to be the phallus, that is to say, the signifier of the desire of the Other, that the woman will reject an essential part of her femininity, notably all its attributes through masquerade').[9] Lacan has influenced many commentators on sexual difference and alienation but as a total theory of woman's sexual identity this is clearly far from adequate. The phallus remains – albeit in metaphysical form – positioned at centre-stage. No allowance is made for the possibility of an alternative symbolic order, in which the vagina signifies plenitude rather than lack – or for a non-genitally focused subjectivity that makes the polymorphously perverse body the site of multiple meanings.

Probably the most significant work of art to be produced in response to, and within the terms of, Lacanian psychoanalysis remains Mary Kelly's *Post-Partum Document*. A detailed documentation and analysis of the mother-child relationship, the work describes the mother's experience of loss and separation as her child developed into the symbolic realm of language. The artist's explicit aim is to explore 'the possibility of female fetishism', considering the loved child as a surrogate phallus, the loss of which is tantamount to castration:

In order to delay, disavow, that separation … the woman tends to fetishise the child: by dressing him up, by continuing to feed him no matter how old he gets, or simply by having another 'little one'. So perhaps in place of the more familiar notion of pornography [a male defence against the fear of castration], it is possible to talk about the mother's memorabilia – the way she saves things – first shoes, photographs, locks of hair or school reports.[10]

Post-Partum Document offers a female alternative to the castration complex but also, at another level, a representation of the work itself with its obsessive systematisation and extreme methodical detail, as a fetish.

The fetish offers security, unaltering attraction and an aura of quasi-religious significance. Parallels with the work of art are obvious enough, and it is not surprising that artists, whose involvement with their materials and creations may well be obsessional, are especially prone to fetishistic attachments. Equally, it is not difficult to impute to collectors and other lovers of art a perverse overvaluation of the artist's trace, especially since the traditional categories of artists' materials have broken down and every fragment or relic of a cult figure like Joseph Beuys is accessible to fetishisation.

Fetishism in recent art belongs primarily to the realm of objects and their photographic representations, rather than painting; the latter can depict but not embody the absolute fixity of association that the fetish demands, it can never become the thing itself. This is because the fetish must be tactile, its surface should shine, or glint and ideally, it should smell – or at least suggest a smell. Dada and Surrealism remain the base line for artists making irrational, perverse or transgressive objects, and it is arguable that since the ultimate aims of the Surrealist project remain unfulfilled, subsequent generations have no alternative but to re-enact those earlier subversive gestures. What has changed most significantly, apart from the technological options available to the contemporary artist, is the cultural context – the popular imagery, art history, philosophy and sexual politics that are now inextricably associated with the idea of the fetish.

The Surrealist fetish object is usually thought of as 'poetic': charged with mysterious power and significance. In contemporary art, on the other hand, the concept of 'abjection' has been recently employed to describe an art of things that appear wretchedly insignificant, art in which base materials, detritus, dirt and human effluent, are employed in a deliberately provocative, anti-heroic way, to attack taboos and the boundaries of the 'ideal bodily imago'.[11] Just as Freud reduced humanity's highest ideals to their source in the depths of the unconscious, many artists today seek to uncover the degraded bodily existence behind the façade of civilisation. Fetishistic art shares some concerns with recent art defined as abject, pathetic or uncanny: in its anti-idealism and exploration of repressed meanings and unorthodox materials.

Fetishism is not a school or movement in art, though there is a growing body of theoretical writing on the subject that is certain to interest and inform many of the artists working in this vein. That is one reason for referring briefly to the literature before turning to the artists and their work. An artist's interpretation of the world is not dependent on theory, which, without practice, is a circular affair. As creators and manipulators of images, artists engage with their materials in a complex way – emotionally, imaginatively and physically. In the discussion that follows, the fetishistic overtones of the work are emphasised, but this is only one aspect. All artists are unique, none more so than those who have the courage and perversity to explore their 'private' obsessions in public. We need many more examples – *pace* Freud – before we can generalise about the fetish in art today.

The Artists

Sylvie Fleury

Sylvie Fleury makes an art out of shopping. She chooses exclusive products in the realm of feminine consumption – make-up, perfume, shoes and clothes. These luxuries are collected by her and displayed, complete in their elegant packaging, as trophies of her expeditions (plates 18 and 19). The carrier bags themselves are beautiful, both in design and connotation; they evoke sensual freedom and good taste (essential, too, for the appreciation of art) and worldly sophistication: London, Paris, New York, Milan. Such expensive shops are frequently located near to commercial art galleries and their customers must often be the same discriminating collectors. How luxurious to buy and never use, to discard as soon as the object of desire has been acquired! Sylvie Fleury's gesture of disposal, the careless scattering of things, is unashamedly extravagant, insouciant. It hints at decadence, the intoxication of trying on new clothes, of undressing and dressing, each time to delight in a new sensation, to be sheathed, caressed, transfigured: the experience justifies the expense.

Alternatively, the unopened shopping bags could be taken as a sign of frustration and dissatisfaction, the process of consumption interrupted at a crucial moment, arrested in mid-flow. By depositing her purchases in a public place, an art gallery, and walking away, Fleury declares her Duchampian indifference to the things she has chosen, denying herself the pleasure of possessing them – or denying their status as pleasure-giving possessions. They are merely signs – true commodity fetishes, for the purchases are never opened but remain wrapped and concealed. 'Between image and content remains an unspoken lining,' she says, 'and besides, aren't we all reversible?'[12]

No shopping expedition is complete, Fleury suggests, without the purchase of 'at least one pair of shoes'. In her video, *Twinkle*, the artist is seen from a motionless point at knee-height, repeatedly trying on flamboyant high-heeled shoes, changing from black lace skirt to tight silver lamé trousers, abandoning each pair of shoes on the floor after trying them. The fixed stare of the camera is voyeuristic in its intentness on the nimble bare feet as they are expertly inserted and withdrawn. The repetition becomes obsessional, perverse, and the continued act of looking fetishistic. The shoes, all brand new, might be those of a star or a prostitute. Indecision (the work 'has to do with someone having a very hard time deciding what to wear') translates into striptease.

Fleury's art seems to be determinedly affirmative and superficial, inviting us to admire charming and beautiful things and the beautiful women who model them. There is no moralising sub-text, and if we are tempted to find in her work a hint of a critique – of artifice or vanity or exchange and surplus values – her own disclaimer should warn us off: 'I'm quite against feminism. I read all women's magazines – or at least I try to. For me that's a full-time job and it inspires my work. And this is the answer to those women who think that they cannot afford to do a thing like that.'[13]

Carlos Pazos

Bric-à-brac from second-hand shops is Carlos Pazos's material; fake fur and silks, mass-produced little statues, artificial pearls in (real) oyster shells, sentimental scenes painted on hardboard, soft pornography, chains, keys and kitchen paraphernalia, brushes and knives. It would be wrong to say that he transmutes this lowly material through imaginative assemblage into 'art', simply, for the parts retain their distinct, garish identities and the in-

Sylvie Fleury
Stills from video *Twinkle*, 1992 [Cat.67]

OPPOSITE ABOVE: Carlos Pazos
What a Bitch!, 1988 [Cat.76]
Galería Joan Prats, Barcelona

OPPOSITE BELOW: Carlos Pazos
Sweetening Wendy, 1986 [Cat.78]
Galería Ciento, Barcelona

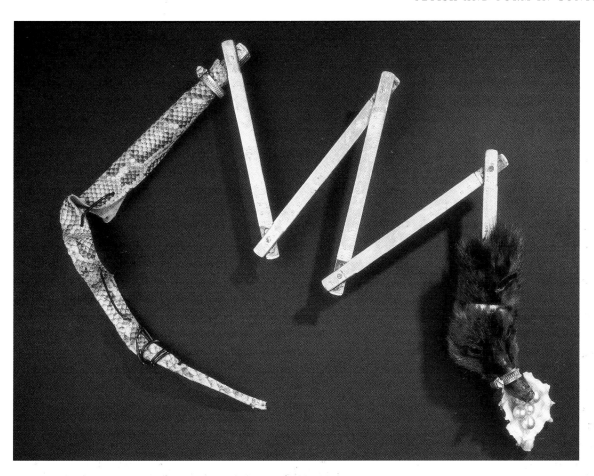

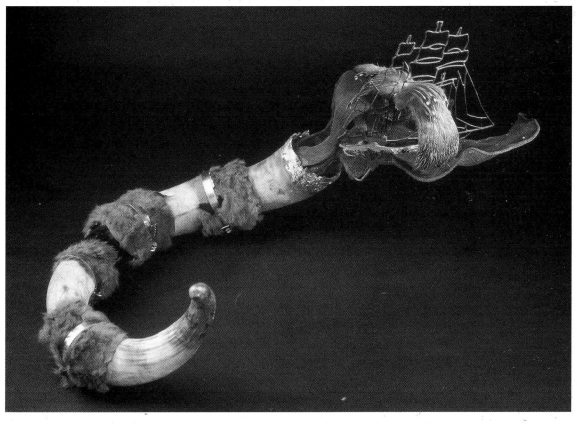

sincerity of that ludicrous realm of cheap imagery seems to be endorsed rather than altered by the accumulation of elements. Nor is this quite Bad Taste, in the post-modern sense of cynical negation. There is too much human sympathy in Pazos's celebration of popular culture; and too much enjoyment of the glitter and brilliant flashing colours. He treats kitsch as an infinite resource overflowing with poetic associations, memories and fantasies, its very inauthenticity somehow a proof of genuineness, of a real connection – at some time – with somebody's life. Its circulation second-hand is poignant because it is practically worthless, sold and bought by the poor. 'Taste' is beside the point; like a joke or popular song, these fragments of ephemera enjoyed a passing moment of favour, and they still seem to be buoyed up by it, gleaming and colourful, loudly confident that they are loved. Pazos chooses things that are 'so ugly that they are no longer annoying, you forget their ugliness'.[14]

The sword in *She Left Deep Scars in My Heart* (plate 20) is arrogantly hooked into the crotch of the swimming costume as if about to flick it high into the air: a final swaggering gesture of prowess or – since she has gone – indifference. The sexual violence of the image is tempered by the anachronism of both sword and costume (a flick-knife would have had quite a different import). Bones crossed like bound arms, straps dangling like the legs of a decapitated chicken, spouting fake pearls at the throat, this effigy stands for the departed lover.

Dorothy Cross

The Amazons of Greek mythology were a warrior race of women who cut off their right breasts to improve their efficiency with bow and arrow. The startling power of Dorothy Cross's single-breasted torso, *Amazon* (plate 17) derives from a similarly awesome and unnatural combination of ideas: ferocity and domesticity, the animal and the human. Mannequins are a prototype of the uncanny, an article of furniture in human form. This torso is elegant and trim-waisted, supported on a dainty, three-legged mahogany stand. The sleek coat of fur covering it is patterned in a 'fashionable' combination of white and brown, which erupts at the chest into a brazenly swelling single breast, thrust forward in a parody of masculine, military-style assertion and culminating in a gnarled, leathery teat, resembling the head of a penis. This 'phallic confusion' adds to the disorientating effect of freakish abomination. A cow's udder, a soft pendulous shape evoking sustenance and care, is here converted into an

upturned figure of fertility.

Dorothy Cross has explored the metaphorical resonance of the udder in a number of applications, stretching and inflating the rubbery skin over saddles, shoes, silver dishes and beer bottles, and turning it into rugby and croquet balls. Its soft, hairy surface, which hardens when dried, is like armour, and her surgical transformations thus make play with issues of sexual difference as well as the relation of the animal to the human. The cow is probably the quintessence of motherhood in the popular imagination; her reliability, gentleness, infinite patience and mindlessness exemplify the virtues most valued in the maternal role. The isolation of the udder – or breast – in Cross's assemblages signifies the separation of the body from the head, the suspension of rational thought that is supposed to accompany motherhood. By 'taking the knife' to the udder she enacts a violation of that sacred role, and dissects also the crude mysogynistic variations on the theme of the cow, while ironically resurrecting the phantom of the 'phallic mother' that so haunts the creative mind in its desire 'to bring a new object into the world'.[15]

Annette Messager

'A fetish is a story masquerading as an object,' wrote the psychiatrist Robert Stoller.[16] Annette Messager's series, *Histoires des robes*, recalls both body and life of the wearer of the communion gowns, nightdresses, skirts and evening robes that she presents, framed under glass and adorned with mementoes. The dresses are souvenirs whose meaning can only be explained by the accompanying story, told here not in whole but in fragments. Pinned on to the dresses are individually framed black-and-white photographs of parts of the body, drawings and watercolours. The narrative is to be read as we would read our own past in memorabilia and old belongings; the difference here is that we have nothing but images, redolent with personal associations, but anonymous: these might be the souvenirs of an amnesiac. The fragmentation and multiplication of images is a realistic solution to the problem of representing the past, or rather the past as it exists in the present – the whole is irrecoverable.

Annette Messager describes herself variously as artist, collector, practical woman, trickster and hawker. The intimate visual language of clothes, drawings and handwritten messages is a part of her strategy – 'a reaction to the fact that ever since I was studying, the work of art was always judged in terms of strength and power –

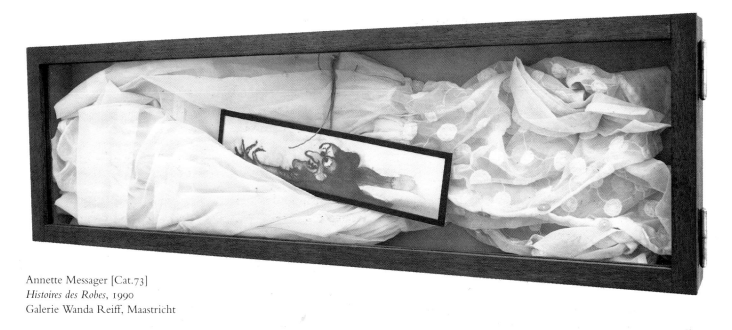

Annette Messager [Cat.73]
Histoires des Robes, 1990
Galerie Wanda Reiff, Maastricht

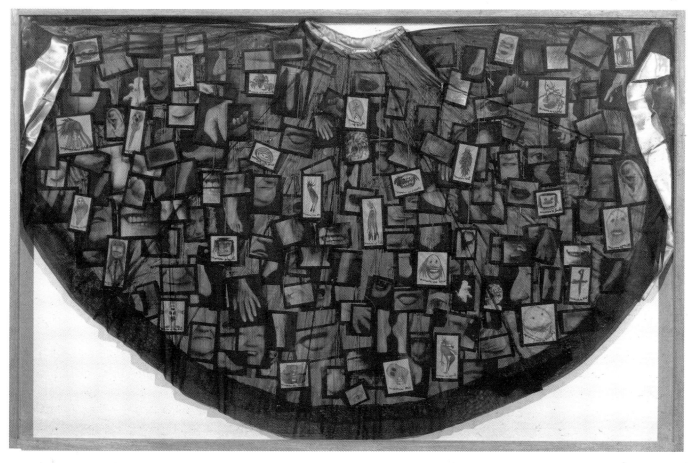

Annette Messager
Maman-Histoires des Robes, 1990
Galerie Wanda Reiff, Maastricht

95

virility in other words. I felt that opposing these little details of day-to-day female life with "high" art was already a critical statement in itself.'[17]

Messager speaks of the private albums, the 'Journaux Intimes', which she compiled in the 1970s as giving her:

… the possibility of affording the public nothing more than a glimpse and forcing them to become voyeurs, peeping through the keyhole. And even when I look at the super-impositions that I do now, I still find myself working on the same idea of hiding while showing, stimulating curiosity, suggesting that what lies underneath is more important than what you actually see. In this way, there is always the idea of secrecy even if it is a false secrecy because it ends up being put on exhibition.

It would not disparage these works to suggest that they are entirely framed by Catholicism. The Catholic church's immense historical resonance, its command over the rituals of birth, marriage and death, its symbolism, cults and the relics of the saints, the reservoir of popular beliefs and superstitions, the miraculous cures, all these offer a treasure-house of imagery and associations for the artist. Messager appropriates the sacred and sentimental language of devotional life and subtly, tenderly, subverts it. Her imagery is reminiscent of funerary shrouds and vestments and the pathos-laden ritual of the votive offering. In *Mes voeux* [My vows], of 1988-9, Messager mimics the accumulations of *ex voto* plaques in cathedrals, with small framed photographs of body parts. 'She never represents organs like the lungs, the trachea or the intestines,' the critic Sigrid Metken observes:

But one finds in her work the representation of the sexual organs generally absent from ex-voto offerings (besides the representation of wax breasts or testicles). Nipples, virile members of different sizes, mounds of Venus, pubic hair (enriched by 'offerings' of real hair …) provoke such an erotic impression that one might, at first glance, consider these ensembles as hymns to sexual pleasure.[18]

Renée Stout

Fetishism is culture-specific, deriving its meaning from local, if not personal and secret, codes. Many artists play on the psycho-sexual implications of the fetish and the idea of displacement associated with it. For African artists, however, other connections have more immediate force, for the word was of course first used to describe – albeit pejoratively – spiritual practices in Africa. Power objects

like the *nkisi* have long been recognised in the West for their tremendous aura and affinities with the material form of assemblage in modern art, but for Renée Stout and other African-American artists, their ritual healing use is perhaps of greater interest. Elements of traditional African religion and medicine remain present in African-American culture, and Stout has explored the scattered legacy of knowledge among her older relatives and others in the black community, visiting herbalists, 'spiritual supply stores' and cemeteries in New Orleans and the Mississippi Delta, to discover the occult significance of roots, seeds, claws, teeth, snake-skins, bark and wood, hair, beaded dolls, feathers, earth and shells. She has incorporated these things (often concealed in bags or bundles) into her assemblages to 'activate' them, and she gives her works titles – *Fetish*, *Ceremonial Object*, *Womba Doll* – which make explicit reference to African traditions. 'I'm not just doing the art,' she says. 'It's beyond that.'[19]

In a Christian, or monotheistic, context such borrowing could lead to pastiche. However, the multiplicity of animistic beliefs, and the cross-currents of African influence and communication throughout the Americas, make for a greater liberty of forms and imagery than monopolistic, institutional religions like Christianity permit. In her search for a spiritual lineage, Stout draws connections between the conjuration and root medicine practices of the Mississippi Delta, Haitian voodoo and the spiritual systems of the Kongo and Yoruba people of Africa. For example, the custom of placing 'memory-jars' containing things belonging to the dead on their graves has deep cultural resonance; yet it leaves the contemporary artist free to reflect on her own past and that of her ancestors without recourse to a fixed iconography. A shrine or fetish may be packed with personal associations, assembled according to the artist's intuitive and visceral response to objects and materials.

When historical continuity has been broken by forced migration and slavery, a preoccupation with the fragments of past traditions may be a means to recovery. As an American artist, Renée Stout participates in the American system of cultural exchange, yet she maintains an identification with an entirely different culture, and this 'double consciousness'[20] enables her to make art which is also something more: an instrument of transformation or protection. The distinctions between art, religion and medicine are anyway arbitrary and variable. In 1988 Stout created a self-portrait that fuses the Western tradition of introspection with African ritual. A life-sized figure hung with bundles containing medicines,

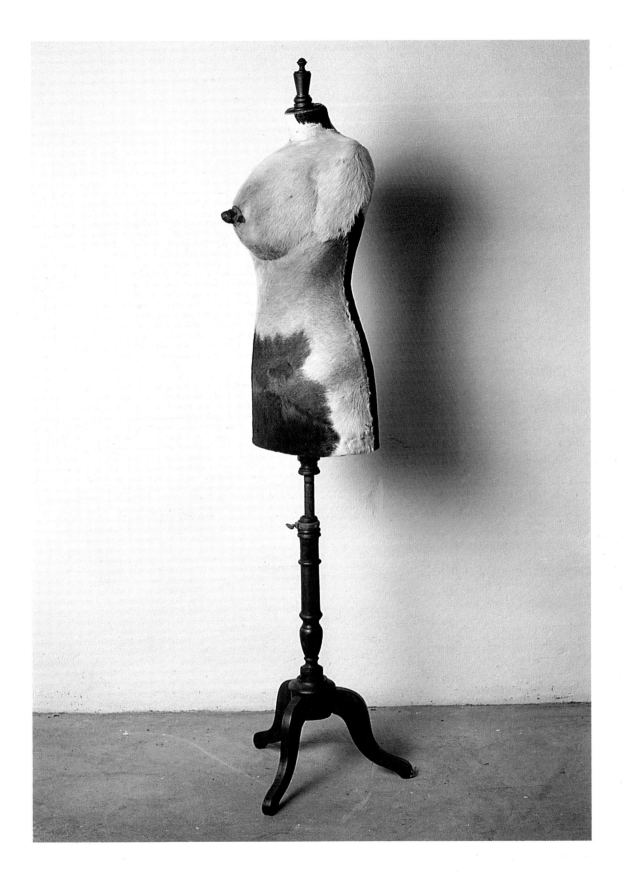

COLOUR PLATE 17
Dorothy Cross
Amazon, 1992 [Cat.64]
Collection Avril Giacobbi

COLOUR PLATE 19
Sylvie Fleury
Wild Pair, 1994
Art & Public Geneva

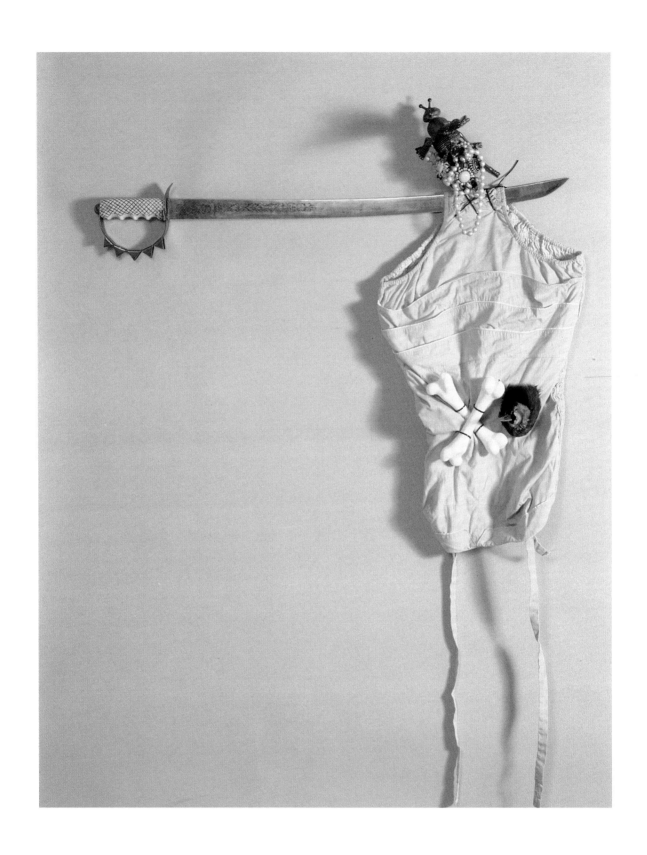

COLOUR PLATE 20
Carlos Pazos
She Left Deep Scars in My Heart and in My Chequebook
1988 [Cat.77]
Galería Joan Prats, Barcelona

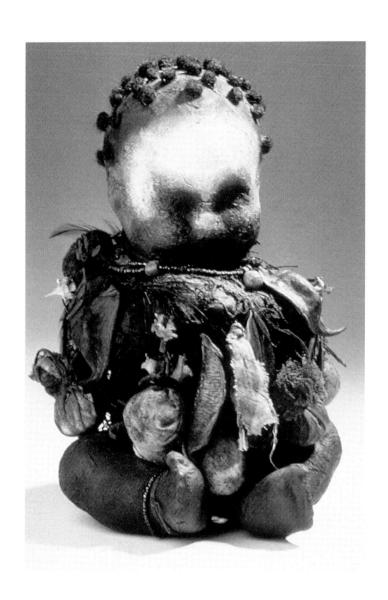

COLOUR PLATE 21
Renée Stout
Fetish No.3, 1989
Collection Kristin Chambers

COLOUR PLATE 22 Tania Kovats
Untitled, 1993 [Cat.69]
Laure Genillard Gallery, London

COLOUR PLATE 23 Tania Kovats
Untitled, 1993 [Cat.68]
Laure Genillard Gallery, London

COLOUR PLATE 24
Sonia Boyce
Funki-dreads, 1995

COLOUR PLATE 25
Sonia Boyce
Nylon Hair Cushion (detail), 1994

COLOUR PLATE 26
Hadrian Pigott
Instrument of Hygiene (case 1), 1994
Saatchi Collection, London

COLOUR PLATE 27
Joseph Cornell
Object (Roses des Vents), 1942–53
Museum of Modern Art, New York
Mr and Mrs Gerald Murphy Fund
© The Joseph and Robert Cornell Memorial Foundation

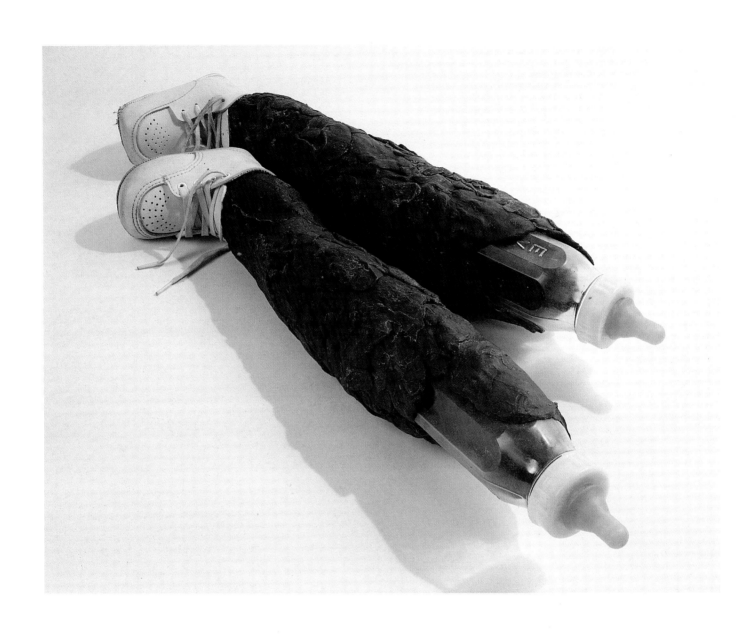

COLOUR PLATE 28
Rona Pondick
Baby, 1989 [Cat.80]

OPPOSITE:
COLOUR PLATE 29
Jordan Baseman
Closer to the Heart, 1994 [Cat.57]

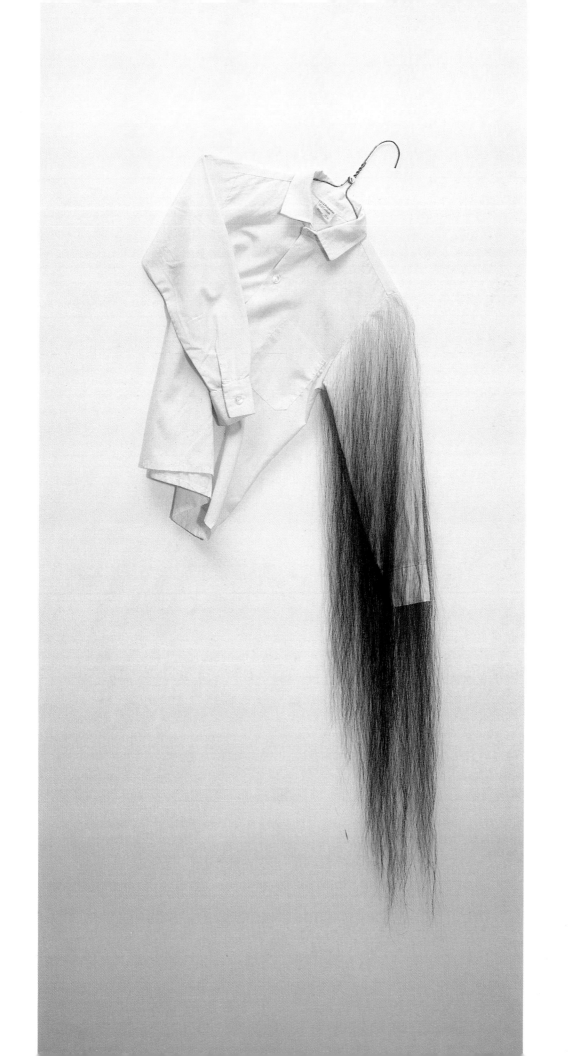

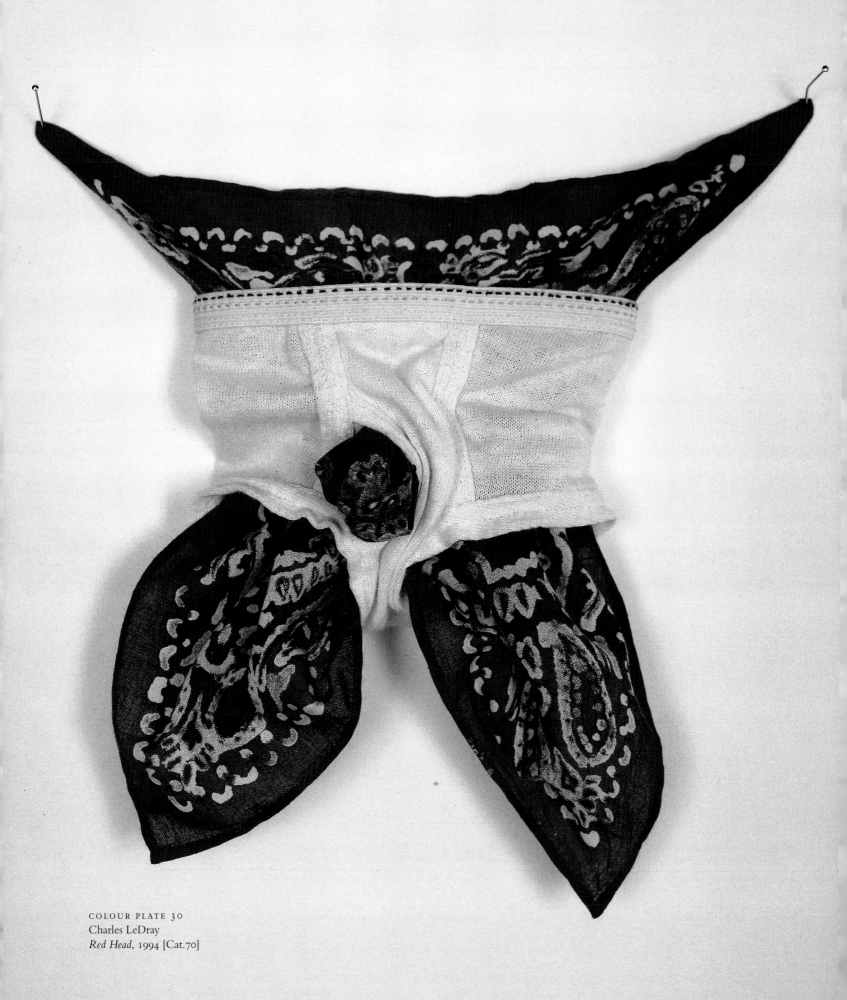

COLOUR PLATE 30
Charles LeDray
Red Head, 1994 [Cat.70]

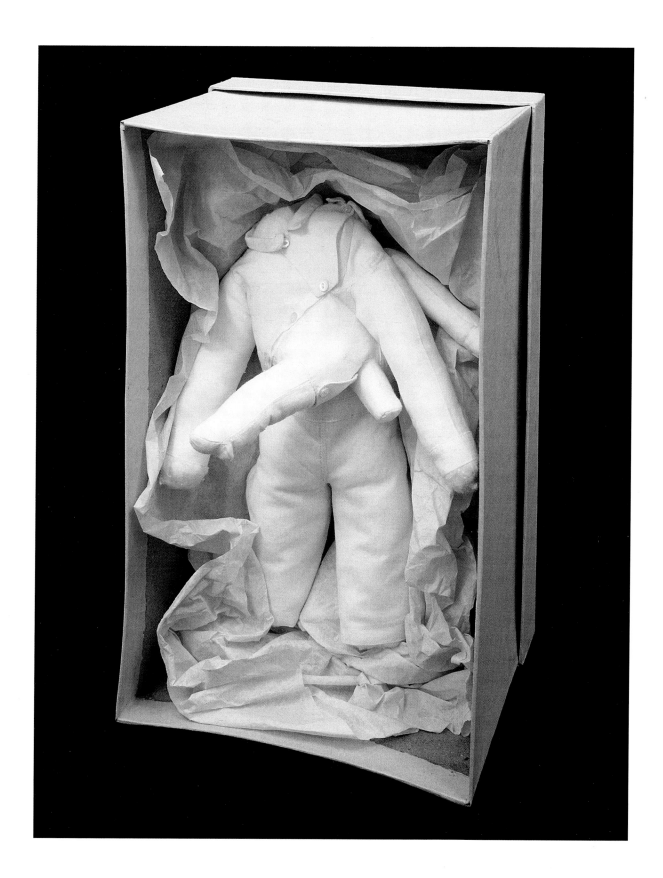

COLOUR PLATE 31
Charles LeDray
Secret Shame, 1991 [Cat.71]
Association 'Autour de Gilles Dusein'

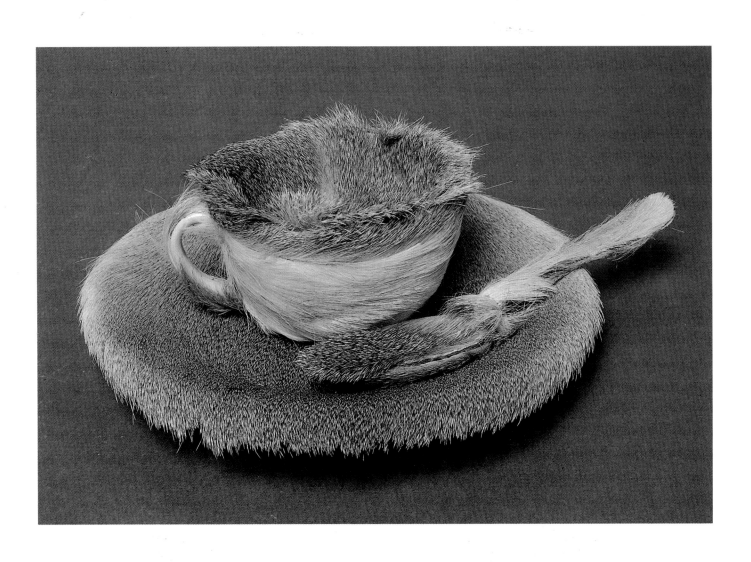

COLOUR PLATE 32
Meret Oppenheim
Fur Breakfast, 1936
Museum of Modern Art, New York

with cowrie shells for eyes and a glass-fronted box embedded in the stomach containing dried flowers, a postage stamp from Niger and an old photo of a baby (left).

Young children, babies and dolls feature in many of Stout's assemblages, signifying an innocence that can ward off evil. *Fetish No.3* (1989) (plate 21) is a power doll laden with bags of medicines, feathers, beads and hair. Small balls of the artist's own hair are stitched into the top of the head. Stout frequently refers to hair and uses it in her work '… because hair is so important to me that I want everybody's hair that's close to me'. A drawing and notes in her note-book correspond to this sculpture, giving a fictitious account of its acquisition by a 'Colonel Frank' from 'the people of Ibn Island'.

They told him that it was very effective in warding off evil because of the form it took. They said that babies were born totally innocent therefore they were above evil thoughts and deeds. On Ibn Island, any household that did not have a baby under two years of age had a fetish like this one to guard the home and its inhabitants from evil and corruption. Once a baby reached the age of two years he got his first haircut. The hair was then gathered up and taken to the island witchdoctor who would create little balls by rolling a small amount of hair between his two palms. His wife would then create a baby's form out of clay covered with cloth and attach these balls of hair to the head. The spirit of the baby's youth and innocence would be bestowed upon the fetish through the hair balls and even though the child would grow up the house would still be protected.[21]

Page from Renée Stout's personal notebook, 1989

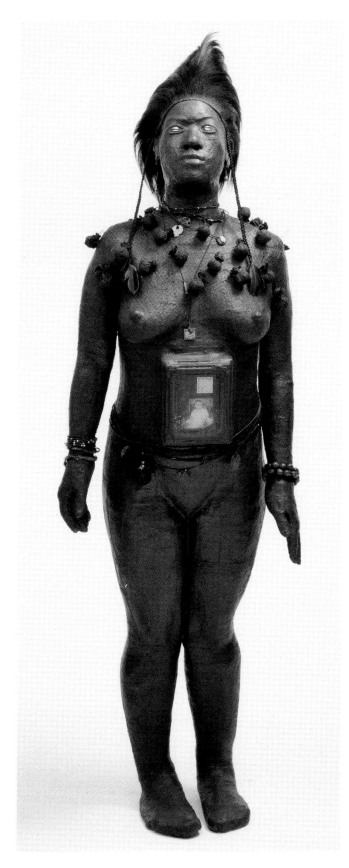

Renée Stout *Fetish No.2*, 1988
Dallas Museum of Art,
Metropolitan Life Foundation Purchase Grant

Tania Kovats

Tania Kovats's bodily relics – a ball of black hair and a scattering of toe-nail clippings – are embalmed in two clear solid cubes of polyurethane. They are endowed with a special aura – religious or sentimental. What would be thrown away is preserved, beautifully, as a specimen of some importance, a thing to be admired. Light has a quasi-mystical role in Kovats's work,[22] it is the element in which these things seem to hang suspended, magnified, so that each wisp of hair is distinct, each yellow crescent translucent. A Christian reading is unavoidable – the more so when it is known that Kovats has also cast a small figurine of the Virgin Mary in the same form, and in another work placed such a figure under the protective shield of a condom. God's consciousness of every infinitesimal detail of existence is a metaphysical idea; it equalises humanity and raises the mundane and insignificant to a transcendental plane. The modernist profanation of this idea – as, for example, in James Joyce's 'That is God … A cry in the street'[23] – turns it on its head. It gives way to fetishism, a world of signs without the Logos. In Tania Kovats's relics, the passion that might have been attached to an object of worship seems compressed into material form: the soul is restored to the body.

Marina Warner writes:

Hair is organic, but less subject to corruption than all our organs; and like a fossil, like a shell, it lasts when parted from the living organism to which it once belonged. In spite of its fragility, lightness, even insubstantiality, hair is the part of our flesh nearest in kind to a carapace. Its symbolic power, its centrality to body language, and its multiplicity of meanings … depend on this dual character, which can never be divided: on the one hand, hair is both the sign of the animal in the human, and all that means in terms of our tradition of associating the beast with the bestial, and of nature and the natural with the inferior and despised aspects of humanity; on the other hand, hair is also the least fleshly production of the flesh. In its suspended corruptibility, it seems to transcend the mortal condition, to be in full possession of the principle of vitality itself.[24]

Sonia Boyce

The profusion of hairdressers and wig shops in Brixton is proof of the vitality and importance of the culture of hair, especially among black people, in Britain today. Many women and girls wear wigs, braids and extensions as a matter of course, and there is no embarrassment about artifice – synthetic hair can be worn as proudly as the 'genuine' human article. Seeing such flamboyant self-expression on the streets, it is easy to believe that the identity conflicts and negative self-images induced by the racist European stigmatisation of African hair are a thing of the past. As Kobena Mercer writes in 'Black Hair/Style Politics': 'Black practices of stylisation today seem to exude confidence in their enthusiasm for quoting and combining elements from any source – black or white, past or present – into new configurations of cultural expression.'[25]

However, as Mercer emphasises, hair is 'a key ethnic signifier' and therefore at a certain level, in a society where race and social status are interconnected, all black hairstyles are ultimately political. The old stereotypes linger; but the debate can no longer be framed simply in terms of binary opposition between straight and curly, artificial and natural. On the one hand, 'Relaxing cremes, gels, dyes and other new technologies have enabled a width of experimentation that suggests that hair-straightening does not mean the same thing after as before the era of Afro and Dreadlocks',[26] while on the other, traditional African braiding and plaiting styles are now part of the culture in Britain and America.

The dressing of hair requires skill and a sympathetic rapport with the head being handled. The hairdresser's hands may be occupied all day on the same head, twisting hair and weaving in braids, which are attached so tightly they will last for months. It is like sculpture, demanding close aesthetic attention to surface, pattern and silhouette. Sonia Boyce has taken wigs and hairpieces as sculptural material and investigated their tactile qualities and symbolic associations, detached from the everyday activity of beautification. The sexual appeal of natural hair as a fetish derives partly from its smell (unique to the body of the wearer), as well as its texture. Wigs and artificial hair confound the fetishistic impulse, since although suggestive of the body, they are devoid of intimate traces. Boyce handles both natural and synthetic hair with an enquiring, delicate care, signifying, among other things, a respect for women's skills and creativity.

At the same time, false hair is a source of humour, even if most jokes about this detachable appendage owe their comic power to the idea of castration (making them, no doubt, all the funnier for women). The associations of hair with the genitalia are wittily evoked by Boyce in a series of small hair 'pouches' made from nylon tights, another prime fetish material, shaped

Sonia Boyce *Plaited Hairpiece*, 1993

Hadrian Pigott

ambiguously, but with inescapable sexual overtones. Black hair stuffed into a nylon 'cushion' made from a 'flesh-toned' (pinkish-grey) stocking, appears to grow through the fine mesh, a velvet opening on one side inviting the fingertips to enter. Like other objects in this group, some of which take a more phallic form, it was made to be handled.

In the installation, *Do You Want to Touch?*, Boyce created a small theatre of tactile sensations, a resource, perhaps, for those curious white people who would like to feel the tight curls of African hair. Here, silky synthetic braids were also available to be touched, and a wad of wavy brown hair offered as a 'sample' for fondling. Boyce has made a bedspread from black hairpieces, a thick, luxurious coat without any suggestion of warmth. The inappropriate spreading of such material over a bed or a floor recalls Mary Douglas's definition of dirt as 'matter out of place',[27] its uncanny effect is due to a similar contravention of symbolically ordered relations.

Following the rejection of Duchamp's *Fountain* by the Independents Exhibition hanging committee in 1917, an anonymous article in its defence appeared in the Dada magazine, 'The Blind Man': 'Now Mr Mutt's fountain is not immoral, that is absurd, no more than a bathtub is immoral. It is a fixture that you see every day in plumbers' show windows.'[28]

Judging from the market today in washing and cleansing materials, standards of personal hygiene have never been higher. In their sale of new luxury flats and houses, builders and estate agents can predict with confidence their clients' needs; one bathroom per person looks like the trend for the future. Bathrooms are sanctuaries for self-examination and ablutions: the body's natural odours are supplanted by chemical scents and it is thereby socialised. The compulsion to wash is a symptom of social maladjustment, guilt or at least unease – yet the body cannot be too clean.

Hadrian Pigott has worked with soap, modelling it

finely into the (paradoxically convex) hollow of a bath or wash-basin. In an improvised group show in a smart London display flat, he introduced a choice of coloured toilet papers and separate soaps for different parts of the body into an already well-equipped bathroom. *Instrument of Hygiene* (case 1) (plate 26) was shown in the same exhibition, an old-fashioned wash-basin, with soaps and copper fixtures and fittings, housed in a moulded leather-ette case with red velvet-lined interior. When shut, the shape of the case has an aura of professional specialism, like an élite briefcase, or a travelling case for musical or medical instruments. Its mysterious language of convexity and concavity is also sexually suggestive, with possible implications of sado-masochistic apparatus.

Like Duchamp's urinal and Robert Gober's sinks, Pigott's basin plays on the sculptural purity of bathroom equipment, as well as its human connotations. The smoothly rounded edges and surfaces of those receptacles seem as though they might have evolved through wear, repeated handling or running water, a parody of the artistic process. The forms have a 'rightness' about them which is almost aesthetically satisfying – they lend them-selves so easily to unconscious bodily use while remaining impersonal, the trace of each episode washed away (ideally), restoring them to pristine neutrality.

It is the subtle disordering of categories that gives *Instrument of Hygiene* its perverse edge. The smart leatherette case suggests the overvaluation of its contents – its red velvet interior is enough to make the sleek white porcelain basin seem almost indecently exposed, stripped of function, a thing for show or entertainment. The absurdist analogy with a musical instrument is carried through in the plumbing components and soap (like the mouthpiece and rosin), ready for assembly and performance.

Rona Pondick

There is a matter-of-fact simplicity about Rona Pondick's allusions to bodily functions and infantile cravings that must derive from her Minimalist education (she studied with Richard Serra and Joel Shapiro at Yale). The baby bottles, shoes and wax turds constitute a repertoire of grossly suggestive elements whose elucidation need not be laboured: they are as blatant and self-sufficient as the hairy limbs and cigarette ends in a Philip Guston paint-ing. The message is one of ambivalence, of desire, re-vulsion and dependency, and of the close imaginative link between nourishment and excrement, nipple and penis,

milk and semen. In interview, Pondick replies to a question as to her influences: 'Kafka and my mother'. That is to say, anxiety and dread have a place here as well as irony, black humour and a sense of the grotesque.

Scatalogical imagery in art is usually connected with aggressive humour, satire or violent nihilism, a weapon in the assault on humanity's 'higher' aspirations and values. In infant psychology, the anal is a pre-Oedipal stage in the process of character-formation. The boundaries of the body are discovered and a metaphor is born: faeces as baby, phallus, gift. (Later, the unconscious will assimilate money and art to this equation.) Pondick's representations of childhood are as if felt through the body of the infant. A tiny pair of shoes, in *Baby* (plate 28), is sufficient to con-vey the identity of the wearer. The pair of brown wax 'legs' with baby bottles sticking out of them give the barest, most efficient portrait of infantile emotion and will.

Pondick says that a shoe can be

… a stand-in for a person. For example, you can take a pair of shoes, place them in the middle of a room and they can tell you the sex, age, and possibly profession of a person. Shoes don't tell stories, but they are highly suggestive objects. They are minefields ready to be explored … I specifically use worn shoes. I found that a new pair of shoes didn't have the meta-phoric reading that a worn pair had … A worn pair of shoes have a sense of memory as do teeth and hair. These are all potent images that I like to use because they evoke so much.[29]

Jordan Baseman

Jordan Baseman uses human hair in his work, but for him it is not the identification with a particular individual but its universality that is important. He buys it by the ounce from a wholesale supplier to wigmakers, and it is precisely the anonymity of this human harvest that intrigues him. He has used it to decorate a wall, attaching each strand individually to cover the surface with something like the density of the hairs on a man's shin, so that it seems alive, rippling at the slightest breath. Handled so intimately, he discovers each hair to be different, finer or coarser, lighter or darker than the last. In *Closer to the Heart* (plate 29), long hair falls from the left shoulder and sleeve of a stan-dard white button-down boy's shirt. The hair may signify femininity, creativity and nonconformity against the regulation style of masculine attire. (Baseman is interested in the way clothes for children mimic adult styles, im-posing on the child a predetermined code not only of

dress but of behaviour.) But the effect of this luxuriant growth, not from the skin but apparently from the fibres of the cloth, is disturbing, like incongruous hair on the face and palms of a werewolf.

Perhaps the artist was recalling North American ideals of regularity and hygiene when he conceived *A Near-Perfect Set of Teeth*. Like so many of his compatriots, as a child his teeth were braced and compressed into line, in the interests of formal symmetry and a straight smile. Rotting teeth give tangible proof of the deterioration of the body over time. This disembodied straight smile, of teeth plucked from the mouths of the dead at a London dental hospital, stands as a solemn monument to mortality.

Jordan Baseman
Pretty Baby, 1994 [Cat.58]

Charles LeDray

It is one of the ironies of the old gender stereotypes that domestic activities like cooking and sewing, considered feminine in the home, are often, when professionalised, reascribed to men. These prejudices have still not completely broken down, and minute tasks such as needle-work and embroidery, when undertaken for pleasure rather than work, continue to be thought of as 'feminine'; the necessary virtues of patience and quietism are assumed to be more commonly found in women. And, in the traditional hierarchy of arts and crafts, needlework stands commensurately low, classified mainly as 'folk' or 'functional'. This issue has long been contested by women artists especially, and those undervalued skills have now rightly entered the canon of legitimate art practice, to take their place alongside the lofty pursuits of hammering and sawing, cutting and pasting. Today, the artist's intentions and the intellectual context of an arte-fact determine its position in the aesthetic order of things, the craftsmanship is secondary.

For Charles LeDray, the use of vernacular handicraft skills is symbolically important, and his meticulous crafts-manship is intrinsic to the meaning of the work. LeDray's tiny, hand-crafted garments and soft toys are sewn and assembled with a painstaking precision which seems, coupled with their sexual overtones, obsessional and unsettling. He seeks through his handicraft to 'legitimise the pathology of the hand', its motion – and emotion – registered in the minute variations of the stitches. The small scale suggests a miniature realm for children, but the truth is more complicated. Miniaturism here is a means of distancing; these things are small because they are far away, not in space – like Giacometti's diminutive figures and heads – but in time. They are effigies belonging to a childhood fantasy or trauma; the detail brings them right up close and they seem charged with unappeasable passion, rage or terror. There is a sense that things have not turned out right in the family; harmony has been disrupted by a violation or attack, or the birth of a mon-ster. *Secret Shame* (plate 31) is a miniature christening cos-tume for a freak infant; it contours the shape of hidden deformities, and allows for two heads. There is pathos in this image, for the exquisitely crafted outfit implies that the 'monster' has been accepted, with all its problems. Yet it remains in its box, ready to be hidden away (the artist recalls visiting a museum of pathology where two-headed children were 'pickled in boxes and labelled "monsters"'). Perhaps the same is true of *Untitled/Broken Bear* (p.118) whose dismemberment may signify not a

Charles LeDray
Untitled/Broken Bear, 1993 [Cat.72]

sadistic attack, but the deconstruction of an archetypal 'transitional object', and an emblem of the childhood self, in preparation for its reconstitution in a new form.

Red Head (plate 30) is an 'infantile portrait' of a red-haired girl known to the artist, illustrating a trauma after which she 'reinvented herself' in the guise of a boy, as a defence against sexual abuse. LeDray recalls that the girl's mother noted in her journal a discussion with her seven-year-old daughter, who asked why men's underwear had a hole at the front. The girl's mother replied that it was a 'hanky pocket' ('presumably she thought that all young ladies should have a hanky pocket!' LeDray remarks drily). The red bandanna doubles as a symbol of the spillage of blood, the blood of the child's broken hymen. The Surrealist fetish must be informed by trauma, Hal Foster argues,[30] it must originate in one of the primal scenes or fantasies – which include seduction and castration. *Red Head* epitomises the art-object as fetish: its meanings, although conscious, are as condensed as those of an authentic fetish-object. It is homely, familiar and reassuring – the dainty needlework executed with consummate skill – yet also perversely menacing, coolly delivering the dreaded image of castration/deflowering.

Tony Oursler

In his essay for the exhibition, *The Uncanny*, artist-curator Mike Kelley, friend and sometime collaborator of Tony Oursler, quotes from the psychoanalyst Janine Chasseguet-Smirgel:

Puppets, mannequins, waxworks, automatons, dolls, painted scenery, plaster casts, dummies, secret clockworks, mimesis and illusion: all form a part of the fetishist's magic and artful universe. Lying between life and death, animated and mechanic, hybrid creatures to which hubris gave birth, they all may be likened to fetishes. And, as fetishes, they give us, for a while, the feeling that a world not ruled by our common laws does exist, a marvellous and uncanny world.[31]

The notion of the uncanny, theorised as a category of art, derives from Freud, who used the German word 'unheimlich', meaning 'disquieting', to suggest the disruption of the familiar by apprehensions of 'otherness'. Kelley quotes from Freud's essay an example of an uncanny feeling which 'doubts whether an apparently animate object is really alive; or conversely, whether a lifeless object might not in fact be animate'.[32] Tony Oursler's sculptural installations with small-scale video projectors invest effigies made out of rags and discarded clothing with an uncanny human spirit. A miniature talking face projected on to the blank head of a dummy recounts desperate stories about adolescence, misfortunes or moments of claustrophobic panic. Imprisoned absurdly in an inanimate bundle of cloth, face distorted by the convex bulge of the padded head, the tiny displaced personage soliloquises with an intensity that produces in the viewer an unwilling identification.

The gap between technological imagery and physical experience is so familiar that we no longer perceive the distance. The ubiquitous spectacle of the electronic media seems to be merely an extension, or projection, of

Organ Play #2 presents a dialogue (between Tony Oursler and Constance Dejung) about the relation of the body's parts (this time the internal organs) to the whole. The talking mouths are projected onto organs in a jar.

Tony Oursler
Organ Play #2, 1994 [Cat.75]
Collection SUMAK, Cologne

C: You know somethin' you can take out in one piece
T: Well … oh, I see. If it's diffu … so if you just keep taking pieces out
C: … Yeah?
T: … and the body gets smaller and smaller and lighter and lighter, you cut things away …
C: … yeah
T: Cut the things away.
C: … uh-huh, … well, uhm … let's see …
T: (kissing noises)
C: Well, you know the – you couldn't take out the brain, could ya?
T: I'm not talking about that part of the body.
C: Oh, …
T: I'm talking about – What I'm talking about is from – say the neck – down to the genitals.
C: Oh, O.K. O.K.
T: The soft … the soft organs … the soft tissue, I mean it's …
C: I know, I know somebody who doesn't have the gall bladder. Is that an organ? The gall bladder? I know somebody

who does … I know a couple people: they don't have gall bladders … and, uh … I think they're very you know, they're complete, they're whole. Is that a place to start? That's a easy one.
T: Well that's a place to start if you're trying to remove all of them, if your goal is to remove them all.
C: Yeah.
T: Then replace them with machines, or …
C: Yeah, I think it's worrisome.
T: Well, if you think of each organ as a filter.
C: Um-hmm.
T: I would like you to think of each organ as a filter.
C: Um-hmm, as a filter. You mean something that … uhm, is like a membrane between the outside and the inside.
T: Well …
C: Like the place where the outside passes through to the inside, and makes the outside less hostile to the inside?
T: Well, it's like the keeper of the gate.
C: Yeah.
T: Keeper of the gate.

our own subjectivity. By the simple device of displacement, by shifting the image to a surface which denies it the 'perfect sheen' of immaterial presence, Oursler breaks the illusion. He approaches technology as a bricoleur, improvising sculptural assemblages from humble found materials, and animating them with fragmented narratives of drugged fantasy, disorientation and paranoia.

Patrick Corillon

In 1988, Patrick Corillon invented the fictional character of Oskar Serti, a poet and composer, born in Budapest in 1881, who died in Amsterdam in 1959. With the aid of a few simple props – a music stand, a small folding screen, plinths, boxes and empty frames – he composes a conceptual setting for the presentation of extracts from Serti's writings and reminiscences. These are printed on plaques or played on a tape (supposedly from a radio interview with the poet, recorded shortly before his death). This odd disparity of formal elements, of minimalist display and elaborate narrative content, is an essential part of Corillon's strategy: the spectator is asked to read into these slight visual effects imaginary incidents of great import. This is surely a metaphor for the poet's own delusions, born of a propensity to invest insignificant details with exceptional meaning.

Oskar Serti's elliptical stories conjure up a world of exquisite connoisseurship and refined sensation, the superior inward life of a poet whose impressions are illumined with peculiar insight. It is this inner life, in fact perplexed by misconceptions and thwarted desires, that Corillon commemorates in his installations. One story conerns a mosquito which the poet has successfully willed to sting both himself and a woman he longs for, thereby achieving a vicarious union in this mixing of their bloods. Moments later he sees a man who is his rival for the attentions of the woman swat the mosquito with a volume of the poet's own newly published verse. Corillon exhibits the stain on the wall and gently memorialises this incident as one of crucial biographical significance.

This example should be enough to illustrate the artist's ingenious humour, but there is a perverse, fetishistic impulse, too, in many of his poet's obsessions. These are stories of displacement and substitution. A scrap of serviette accidentally caught under Serti's ring is passed in a handshake to a poetess whom he has been striving to impress with his verse, and is accepted by her as a poetic offering – the first acknowledgement she has ever given him. Serti as a professor secretly contrives to photograph his favourite female students as they glance up, unable to resist the note he has placed on his desk requesting them not to look at the ceiling. Their wide-eyed curiosity, with overtones of religious rapture, and exposed throats, excite the poet, but later he realises 'with bitterness that he had never shared this powerful emotion with them; he had always been too much a slave to his base instincts'.

Mutual misapprehension, a confusion between two interpretations of the same object (a shirt drying, and stiffening, on a line) or event (a sketcher's encounter with a girl in the park); this is the basis of many of Serti's stories of poetic perception enlivened by desire. Sometimes, two accounts are given of the same incident, to be read in turn from different standpoints. The space between these two irreconcilable versions is the void into which the poet's desire vanishes; he is left with his disappointment and – thoroughly unreliable – memories. Instability of meaning is further evoked in stories of a painted image confused with its subject, the poet's fixation on the latter, a woman with whom he is infatuated, gradually slipping on to her painted representation until all recollection of the original is lost.

Sophie Calle

So remarkable is the story of Sophie Calle's career as an artist that it is always tempting to recount it in its entirety. Each project is like an episode illuminating and altering the others. It is important to note that her first clandestine adventure, following strangers through the streets of Paris, was undertaken with no thought of herself as an artist, but rather from psychological necessity, as a way of reorienting herself to a city to which she was returning after seven years' absence. That, at any rate, is how Sophie Calle 'la fableuse', the maker of stories, tells it.

The camera and the notebook, equipment of the private eye, are the means with which she documents her (self-)assignments. In *Suite Vénetienne* she trails a man to Venice, where she follows him obsessively, noting his every move in the streets. She seems driven by an inner compulsion, but the fragments of evidence she produces tell their own story of irresolution and failure to connect. Photographs show the subject caught from behind as he disappears into a crowd or over a bridge. Disguised as a blonde, she eludes recognition; her aim is to maintain a ritual attachment while avoiding any encounter with the man whom she has chosen, in true Dadaist spirit, entirely at random. After a suspenseful few days, she breaks off the relationship in a Paris station, separating for ever from the

Patrick Corillon, *Doormat*, 1994

Doormat, 1994

Whenever a stupid publisher rejected one of his manuscripts, Oskar Serti would return home feeling the need to be on his own. Before shutting himself away in his study for hours on end, he would wipe his feet vigorously on the doormat to clean off all the squalor of the outside world.

On 3 March 1934, Serti set out to see a small-time publisher in the country. But so reluctant was he to face another rejection that he turned on his tracks without going through with the meeting. Back home, in an attempt to rid himself of the disgust he felt for himself at his own cowardliness, he removed his shoes and wiped his bare feet energetically on the coarse bristles of the doormat.

At the sight of dark trails of blood on the mat, Serti decided to wipe his feet again, and again, until he was sure they were perfectly clean.

man she has made the object of passionate pursuit but never met.

The bounds of legitimate enquiry are transgressed more dangerously, perhaps in *l'Hôtel* (1983), also set in Venice, where the artist takes a job as a hotel chambermaid. She secretly photographs the personal belongings of the absent occupants of the rooms she cleans, sneaking glimpses of the contents of suitcases, noting arrangements of things on bedside cabinets. She imagines the owners of these things and 'bonds' with them, exactly as a portraitist might enter into the life and mind and possessions of a subject.

As in *Suite Vénetienne*, the subjects of her scrutiny in *l'Hôtel* are left unaware, and undisturbed. Calle's intrusions may seem aggressive but in fact she is discreet, possibly even shy. She is aware of guilt and danger but defies them, exposing herself as well, in certain projects, as if to emphasise that her investigations are really objective enquiries into the nature of privacy and the personal.

In *La Filature* Calle arranges to have herself followed by a private detective. Compounding his description of her movements with her own, she creates a little allegory of displaced subjectivity. The artist, traditionally the observer of others, is here displaced by the look of the other. She returns to the theme of role reversal in *Autobiographical Stories* (opposite). Taking a job as a stripper in Pigalle – partly because she needs money, partly because 'I thought it was a shame to be ashamed, and I wanted to avenge by doing it' – she experiences what it is like 'to be watched'.[33] In this work she uses snapshots of herself on stage watched by an assembly of men, and also presents photos of her clothes and mementoes, captioned with her memories of the times they represent: the wedding gown she wore on her first night with a new lover; the bathroom robe (like her father's) with which another lover, in her youth, had shielded her from the sight of his sex; a drawing of herself nude made in a life-drawing class she posed for, methodically slashed by the blade of the draughtsman.

These intimate disclosures (whether fictitious or true) are, like Sophie Calle's adventures in pursuit of strangers, stories of fetishistic attachment. The sexual dialectic of the gaze, the restless curiosity that impels the eyes to search, to spy, to steal, this is one of Sophie Calle's obsessions and it is closely related to that pathology described by Freud, quoted at the beginning of this essay: 'when the longing for the fetish becomes detached from a particular individual and becomes the sole sexual object'.[34] Calle's deliberately self-defeating strategies, pursuing her subjects with such fixed determination

The Wedding Dress

I had always admired it from afar. Since childhood. On 8th November – I was thirty. He allowed me to visit him. He lived several hundred kilometres from Paris. I took with me in my suitcase a wedding dress of white silk with a small train. I put it on for our first night together.

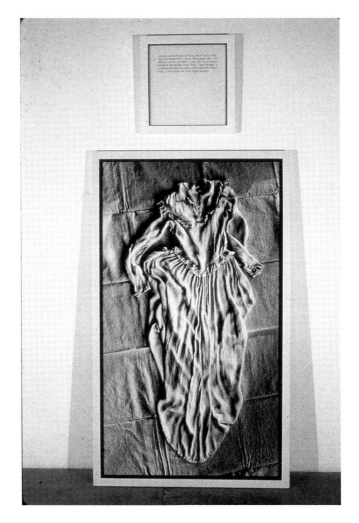

Sophie Calle
Autobiographical Stories: The Wedding Dress
1988 [Cat.61]
Galerie Chantal Crousel, Paris

while avoiding direct contact, fetishise the presence of the other. The delayed encounter, during which period of suspense the other is held vividly in consciousness, may be a defence against trauma. Something happened – but, after all, it was nothing.

The Razor Blade

I was posing nude every day between 9 o'clock and midday. And every day, a man sitting on the extreme right of the first row drew me for three hours. Then at midday precisely he took a razor blade out of his pocket and without taking his eyes off me, he meticulously cut up his drawing. I didn't move, I watched him do it. Then he left the studio, leaving the cut up pieces of myself behind him. The scene was repeated twelve times. On the thirteenth day I didn't go to work.

The Dressing Gown

I was eighteen years old. He opened the door for me. He wore the same dressing gown as my father. A long dressing gown of white towelling. He was my first lover. For a whole year he agreed never to show himself to me nude in his sexual regions, other than his back. Thus, in the morning if it was light, he rose turning carefully and went to put on the white dressing gown. On his departure, he abandoned me.

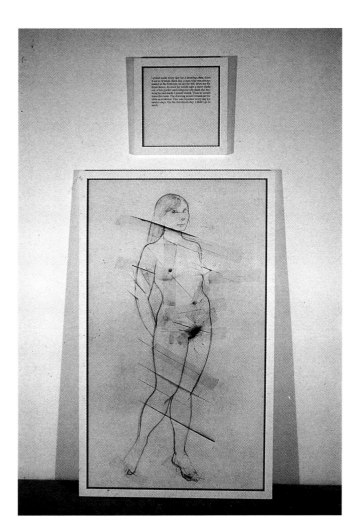

Sophie Calle
Autobiographical Stories: The Razor Blade
1988 [Cat.62]
Galerie Chantal Crousel, Paris

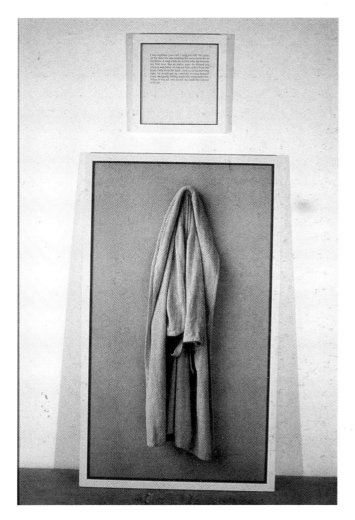

Sophie Calle
Autobiographical Stories: The Dressing Gown
1988 [Cat.63]
Galerie Chantal Crousel, Paris

NOTES

1. Sigmund Freud, *On Sexuality*, Penguin, London, 1991, p.351

2. ibid. p.351

3. ibid. p.63

4. ibid. p.67

5. Quoted in L. Gamman and Merja Makinnen, *Female Fetishism, A New Look*, Lawrence and Wishart, London, 1994

6. Laura Mulvey, 'Some Thoughts on Theories of Fetishism', *October*, 66, Summer 1993, p.12

7. ibid. p.3

8. Freud, op.cit. p.354

9. Juliet Mitchell and Jacqueline Rose, *Feminine Sexuality: Jacques Lacan and the École Freudienne*, Norton, New York, 1985, p.84

10. Mary Kelly, *Post-Partum Document*, Routledge and Kegan Paul, London, 1983, p.189

11. Simon Taylor, 'The Phobic Object: Abjection in Contemporary Art', in *Abject Art*, Whitney Museum of American Art, New York, 1993, p.16

12. Sylvie Fleury, *The Art of Survival*, Neue Galerie am Landesmuseum, Joanneum, Graz, 1992

13. ibid.

14. Victoria Combalia, *Carlos Pazos, 1983-1986, Una Selección*, Galerie Ciento, Barcelona, 1986

15. Donald Kuspit, 'The Modern Fetish', *Artforum*, Vol.27, October 1988, p.132

16. Robert Stoller, *Observing the Erotic Imagination*, Yale University Press, 1985 (quoted in Gamman and Makinnen, op.cit. p.44)

17. Gianni Romano, 'Talk Dirt: Interview with Annette Messager', *Flash Art*, Summer 1991, p.102

18. Sigrid Metken, *Annette Messager: comédie tragédie, 1971-1989*, Musée de Grenoble, 1989 (quoted in Annelie Pohlen, 'The Utopian Adventures of Annette Messager', *Artforum*, September 1990, p.116)

19. Michael D. Harris, 'Resonance, Transformation and Rhyme: The Art of Renée Stout', in *Astonishment and Power*. National Museum of African Art, Smithsonian Institution Press, Washington, 1993

20. ibid. p.108

21. ibid. p.136

22. This is noted by William Jeffett in 'Tania Kovats', *Arte Factum*, 48'93, Summer 1993, pp.52-3

23. James Joyce, *Ulysses*, The Bodley Head, London, 1966, p.42

24. Marina Warner, 'Bush Natural', *Parkett*, No.27, 1991

25. Kobena Mercer, *Welcome to the Jungle: New Positions in Black Cultural Studies*, Routledge, London, 1994, p.124

26. ibid. p.124

27. Mary Douglas, *Purity and Danger*, Penguin Books, Harmondsworth, 1967, p.48

28. Anne d'Harrioncourt and Kynaston McShine (eds), *Marcel Duchamp*. Museum of Modern Art, New York, 1973, p.283

29. Octavio Zaya, 'I can express it any way I want. An interview with Rona Pondick', *Atlantica, Internacional Revista de las Artes*

30. Hal Foster, *Compulsive Beauty*, MIT Press, Cambridge, Mass., 1994, p.48

31. Quoted in Mike Kelley, *The Uncanny*, Arnhem Gemeentemuseum, 1993, p.3

32. ibid. p.5

33. Gianni Romano, 'Sophie Calle: Rituel de la habituel', in *Lapiz*, Vol.10, No.82-8

34. Freud, op.cit.

List of Works in the Exhibition

Dimensions are given in centimetres in the form height × width × depth.

SECTION 1:
African Works

1 Power figure (*nkisi*)
Kongo people, Central Africa
Wood, iron and vegetable fibre
82 × 30 × 26
Trustees of the British Museum, London
Illustrated p.52

2 Power figure (*nkisi*)
Kongo people, Central Africa
Wood, iron, cotton cloth, raffia, feathers, glass
beads, gourd, seed pods
85 × 33 × 42
Trustees of the British Museum, London

3 Power figure (*nkisi kozo*) in the form of
a double-headed dog
Kongo people, Central Africa
Wood, iron, resin, vegetable fibre and bone
28 × 25 × 66
Trustees of the British Museum, London
Illustrated p.61

4 Power figure (*nkisi*)
Kongo people, Central Africa
Wood, iron, cloth and vegetable fibre
85 × 43 × 26
Trustees of the British Museum, London
Illustrated p.56

5 Power figure (*nkisi*)
Kongo people, Central Africa
Wood, iron, string, cloth and fibre
55 × 23 × 20
Trustees of the British Museum, London
Illustrated p.57

6 Power figure
Songye people, Central Africa
Wood, feathers, hyde, cloth, teeth, beads,
string and animal hair
75 × 34 × 15
Trustees of the British Museum, London

7 Charm gown
Asante people, Ghana
Cloth, leather, shell and metal
126 × 91
Trustees of the British Museum, London
Illustrated p.60

8 Female power figure (*nkisi*)
Kongo people, Central Africa
Wood
21 × 9 × 7
Exeter City Museums

9 Female power figure (*nkisi*)
Kongo people, Central Africa
Wood with cloth
24.5 × 9 × 9
Exeter City Museums

10 Power figure (*nkisi kozo*)
in the form of a dog
Kongo people, Central Africa
Wood with nails, cloth
21 × 45 × 13
Exeter City Museums

11 Power figure (*nkisi*) with plumed headdress
Kongo people (Vili), Central Africa
Wood, glass, metal, resin, feathers
Height 73
Collection Marc Leo Felix
Colour Plate 5

12 Female power figure (*nkisi*)
Kongo people (Manyanga), Central Africa
Wood, iron, 'magical' substances contained
inside the work
Height 68
Collection Marc Leo Felix
Colour Plate 4

13 Power figure
Songye people, Central Africa
Wood, copper, brass tacks, horn, snakeskin,
hyde, vegetable fibre, feathers, 'magical'
substances contained inside the work
Height 71
Collection Marc Leo Felix
Colour Plate 15

14 Power figure
Songye people, Central Africa
Wood, hyde, animal pelt, copper, metal,
'magical' substances contained inside the work
Height 85
Collection Marc Leo Felix

15 Power figure
Songye people, Central Africa
Wood, horn, vegetable fibre cord, animal skin
and teeth, seeds, snakeskin, 'magical' substances
contained inside the work
Height 86
Collection Marc Leo Felix

16 Power figure
Songye people, Central Africa
Wood, horn, hyde, animal teeth, snakeskin,
raffia, string, glass beads, vegetable fibre, cloth,
'magical' substances contained inside the work
Height 63
Collection Marc Leo Felix

17 Power figure
Songye people, Central Africa
Wood, copper, hyde, string, horn, 'magical'
substances contained inside the work
Height 50
Collection Marc Leo Felix

18 Power figure
Songye people, Central Africa
Wood, copper, metal, hyde, snakeskin,
vegetable fibre, cloth, shells, brass tacks, glass
beads, animal pelt, feathers, 'magical'
substances contained inside the work
Height 49
Collection Marc Leo Felix
Colour Plate 12

19 Power figure
Songye people, Central Africa
Wood, commercial cloth, leather, cane, metal,
seeds, antelope horns, human bone, turtle
shell, snakeskin, 'magical' substances contained
inside the work
Height 51
Collection Marc Leo Felix

20 Power figure
Songye people, Central Africa
Wood, cowrie shells, snakeskin, animal pelt,
copper, brass tacks, 'magical' substances
contained inside the work
Height 44
Collection Marc Leo Felix

21 Power figure
Songye people, Central Africa
Wood, hyde, snakeskin, vegetable fibre cord,
animal horn, 'magical' substances contained
inside the work
Height 32
Collection Marc Leo Felix

22 'Altar' with three figures
Songye people, Central Africa
Wood, hyde, animal claw and horns, metal,
copper, wire, seeds, pigments, 'magical'
substances contained inside the work
Height 78
Collection Marc Leo Felix
Colour Plate 10

23 Power figure
Songye people, Central Africa
Wood, 'magical' substances contained inside
the work
Height 119
Collection Marc Leo Felix

24 Power figure tied to necklace
Kongo people, Central Africa
Wood, raffia, seeds, shells and bones
15 × 20
Collection Marc Leo Felix
Colour Plate 7

25 Power figure tied to necklace
Kongo people (Yombe), Central Africa
Wood, string, raffia, 'magical' substances
contained inside the work
Height 16
Collection Marc Leo Felix
Colour Plate 6

26 Charm gown
Asante people, Ghana
Nineteenth century
Cotton and leather
90 × 100
The Royal Pavilion, Art Gallery and Museums,
Brighton
Colour Plate 3

27 Power figure (*nkisi*)
Kongo people (Yombe), Central Africa
Wood, metal, textiles, feathers, seeds, shells,
mirror, nails
Height 58
Katholieke Universiteit, Leuven
Colour Plate 8

28 Power figure (*nkisi*)
Kongo people (Yombe), Central Africa
Wood, textile, glass, shells, wax, metal
Height 114
Katholieke Universiteit, Leuven

29 Priest's (*nganga's*) rattle
Kongo people, Central Africa
Wood
Height 41
Katholieke Universiteit, Leuven
Illustrated p.59

30 Figure of a missionary
Kongo people, Central Africa
Nineteenth century
Wood
Height *c*.27.5
Katholieke Universiteit, Leuven
Illustrated p.18

SECTION 2: Surrealism

31 Jacques-André Boiffard
Untitled (foot and shoe), 1930
Black-and-white photograph
Lucien Treillard Collection, Paris

32 Jacques-André Boiffard
Big Toe, 1929
Black-and-white photograph
Lucien Treillard Collection, Paris

33 Jacques-André Boiffard
Big Toe, 1929
Black-and-white photograph
Lucien Treillard Collection, Paris

34 Jacques-André Boiffard
Carnival Mask, 1929
Black-and-white photograph
Lucien Treillard Collection, Paris

35 Jacques-André Boiffard
Carnival Mask, 1929
Black-and-white photograph
Lucien Treillard Collection, Paris

36 Jacques-André Boiffard
Carnival Mask, 1929
Black-and-white photograph
Lucien Treillard Collection, Paris

37 Eli Lotar
Three photographs of sculptures by Giacometti
Black-and-white photographs
Lucien Treillard Collection, Paris

38 Man Ray
Eight photographs of the dressed mannequins
in the Surrealist Street at the 1938 *Exposition
Internationale du Surréalisme*, Galerie Beaux-
Arts, Paris
Black-and-white photograph
Lucien Treillard Collection, Paris

39 Man Ray
Gift (replica of 1921 original)
Iron and tin tacks
15 × 9
Lucien Treillard Collection, Paris

40 Jacques-André Boiffard
'Camées Durs …', 1928 for André Breton's
Nadja
Black-and-white photograph
Lucien Treillard Collection, Paris

41 Hans Bellmer
Doll 1936/49
Colour photographic print
Lucien Treillard Collection, Paris

42 Hans Bellmer
The Top
Painted bronze, 1968, after lost model of 1938
c.76 × 46
Galerie André-François Petit, Paris

43 Hans Bellmer
Untitled (String), 1959
Black-and-white photograph
Galerie André-François Petit, Paris

44 Hans Bellmer
Doll, 1936/49
Coloured photographic print
Galerie André-François Petit, Paris

45 Eugène Atget
Untitled ('Coiffures postiches'), 1926-7
Black-and-white photograph
The Board of Trustees of the Victoria and
Albert Museum, London
Exhibited at Nottingham and Norwich only

46 Eugène Atget
Untitled (Window Display, Mannequins), 1926
Black-and-white photograph
The Board of Trustees of the Victoria and
Albert Museum, London
Exhibited at Nottingham and Norwich only

47 Eugène Atget (printed by Abbot)
Ragpicker's Hut, printed 1956
Black-and-white photograph
The Board of Trustees of the Victoria and
Albert Museum, London
Exhibited at Nottingham and Norwich only

48 Bill Brandt
Figure-head, Scillies, *c*.1936
Black-and-white photograph
The Board of Trustees of the Victoria and
Albert Museum, London
Exhibited at Nottingham and Norwich only

49 Bill Brandt
Flea Market, Paris, 1929
Black-and-white photograph
The Board of Trustees of the Victoria and
Albert Museum, London
Exhibited at Nottingham and Norwich only

50 'Cabinet of Curiosities 1'
Works selected by Dawn Ades from a private
collection in England, and Lee Miller Archives

51 'Cabinet of Curiosities 2'
Works selected by Dawn Ades from the
ethnographic and natural history collections
at the Royal Pavilion, Art Gallery and
Museums, Brighton

52 Salvador Dalí
Retrospective Bust of a Woman, 1933/77
Not exhibited

53 Salvador Dalí
Symbolically Functioning Scatalogical Object,
1931/74
Not exhibited

54 Joseph Cornell
Untitled, *c*.1940
Wooden box, mirrors, sand paper, thimbles and
cardboard
21.5 (diameter) × 11 (height)
Private collection, courtesy Faggionato Fine
Arts, London
Illustrated p.72

55 Oscar Dominguez
Untitled, 1957
Mixed media, including velvet, fragment of
clothing with zipper, plaster cast of female
genitalia with pubic hair added, plastic flowers
54 × 40
Courtesy Timothy Baum, New York

56 Farnese de Andrade
Being, 1986-94
Wood, metal, stone and photo
c.51 × 30.5
Collection the artist

SECTION 3:
Contemporary Artists

57 Jordan Baseman
Closer to the Heart, 1994
Child's shirt, human hair
125 × 38
Collection the artist
Front Cover Image and Colour Plate 29

58 Jordan Baseman
Pretty Baby, 1994
Doll and human hair
43 × 14
Collection the artist
Illustrated p.117

59 Jordan Baseman
A Perfect Set of Teeth, 1995
Teeth and steel pins
Collection the artist

60 Sonia Boyce
Small Hair-pieces, 1993–4
Hair
Collection the artist

61 Sophie Calle
Autobiographical Stories: The Wedding Dress, 1988
Texts, black-and-white photographs with
wooden frames, six gelatin-silver prints
Photographs each *c*.100 × 170; enlarged text
50 × 50
Courtesy Galerie Chantal Crousel, Paris
Illustrated p.122

62 Sophie Calle
Autobiographical Stories: The Razor Blade, 1988
Texts, black-and-white photographs with
wooden frames, six gelatin-silver prints
Photographs each *c*.100 × 170; enlarged text
50 × 50
Courtesy Galerie Chantal Crousel, Paris
Illustrated p.123

63 Sophie Calle
Autobiographical Stories: The Dressing Gown,
1988
Texts, black-and-white photographs with
wooden frames, six gelatin-silver prints
Photographs each *c*.100 × 170; enlarged text
50 × 50
Courtesy Galerie Chantal Crousel, Paris
Illustrated p.123

64 Dorothy Cross
Amazon, 1992
Cow udder and tailor's dummy
Height 159
Collection Avril Giacobbi, London
Colour Plate 17

65 Patrick Corillon
The Portrait, 1995
Wood and curtain
130 × 100
Collection the artist

66 Sylvie Fleury
Untitled, 1995
Shopping bags
Dimensions variable
Collection the artist

67 Sylvie Fleury
Twinkle, 1992
Video
Courtesy Laure Genillard Gallery, London
Two stills illustrated p.92

68 Tania Kovats
Untitled, 1993
Clear polyurethane, hair, wooden base
15 × 15 × 15
Courtesy Laure Genillard Gallery, London
Colour Plate 23

69 Tania Kovats
Untitled, 1993
Clear polyurethane, toenails, wooden base
15 × 15 × 15
Courtesy Laure Genillard Gallery, London
Colour Plate 22

70 Charles LeDray
Red Head, 1994
Cloth, thread, dye, pins
20 × 20 × 4
Collection the artist
Colour Plate 30

71 Charles LeDray
Secret Shame, 1991
Fabric, thread, buttons, cotton, tissue paper
40.5 × 25.5 × 19.5
Association 'Autour de Gilles Dusein'
Colour Plate 31

72 Charles LeDray
Untitled/Broken Bear, 1993
Fabric, thread, buttons
3 × 21.5 × 2.5
Collection the artist
Illustrated p.118

73 Annette Messager
Histoires des Robes, 1990
Mixed media with vitrine
28 × 93 × 8.5
Courtesy Galerie Wanda Reiff, Maastricht
Illustrated p.95

74 Annette Messager
Histoires des Robes, 1990
Mixed media with vitrine
98 × 156 × 7
Courtesy Galerie Wanda Reiff, Maastricht

75 Tony Oursler
Organ Play #2, 1994
Performance by Tony Oursler and
Constance Dejung
2 video projectors, 2 VCRs, glass,
formaldehyde, animal organs
Dimensions variable
Collection SUMAK, Cologne
Illustrated p.119

76 Carlos Pazos
What a Bitch!, 1988
Mixed media, including wooden ruler, snake-
skin, animal's head, oyster with pearls, metal
band and plastic cable
Maximum width 167
Courtesy Galería Joan Prats, Barcelona
Illustrated p.93

77 Carlos Pazos
*She Left Deep Scars in My Heart and in My
Cheque Book*, 1988
Mixed media, including bathing costume,
sabre, metal objects with stone, plastic necklace
and head of bird
120 × 90
Courtesy Galería Joan Prats, Barcelona
Colour Plate 20

78 Carlos Pazos
Sweetening Wendy, 1986
Mixed media, including horn, fur, metal straps,
feathers, metal cloth, forged iron
90 × 35 × 43
Courtesy Galería Ciento, Barcelona
Illustrated p.93

79 Hadrian Pigott
Instrument of Hygiene (case 2), 1995
Upholstered fibreglass 'instrument' case with
wash-basin and accessories
90 × 50 × 43
Collection the artist

80 Rona Pondick
Baby, 1989
Wax, baby bottles, shoes
9 × 58.5 × 28
Collection the artist
and courtesy José Friere Fine Art
Colour Plate 28

81 Renée Stout
Ogun, 1995
Mixed media
89 × 17
Collection the artist and David Adamson
Gallery, Washington DC

127

Select Bibliography

Apter, E. and Pietz, W. (eds) *Fetishism as Cultural Discourse*, Cornell University Press, Ithaca and London, 1993

Baudrillard, J. *For a Critique of the Political Economy of the Sign* (translated by Charles Levin), The Telos Press, St Louis, 1981

Deleuze, G. *Coldness and Cruelty* (published with Leopold von Sacher-Masoch, *Venus in Furs*), Zone Books, New York, 1991

Fetish, Princeton Architectural Journal, 1992

Fondation Dapper, *Objets Interdits*, Éditions Dapper, Paris, 1989

Foster, H. *Compulsive Beauty*, MIT Press, Cambridge, Mass. and London, 1993

Freud, S. *Fetishism* (1927), in *On Sexuality*, Vol.7, The Pelican Freud Library, Penguin, London, 1991

Freud, S. *Three Essays on the Theory of Sexuality* (1905), in *On Sexuality* as above

Gamman, L. and Makinen, M. *Female Fetishism. A New Look*, Lawrence and Wishart, London, 1994

Kunzle, D. *Fashion and Fetishism*, Rowman and Littlefield, Towota, NJ, 1982

MacGaffey, W. *Astonishment and Power*, Smithsonian Institution Press, Washington, 1993

Marx, K. *Capital: A Critique of Political Economy* (1887), Vol.1, Vintage, New York, 1977

New Formations. A Journal of Culture/Theory/Politics, No.19 (Special issue on Perversity)

Nooter, Mary, *Secrecy, African Art that Conceals and Reveals*, The Museum of African Art, New York, 1993

Pietz, W. *The Problem of the Fetish*, Parts 1, 2 and 3a, *RES*, No.9 (1985), No.13 (1987), No.16 (1988)

Rosemont, E. *What is Surrealism?*, Pluto Press, London, 1978

Simpson, David, *Fetishism and Imagination*, The John Hopkins University Press, Baltimore, 1982

Thompson, R. F. and Cornet, J. *The Four Moments of the Sun. Kongo Art in Two Worlds*, National Gallery of Art, Washington, 1981

Vale, V. and Juno, A. *Modern Primitives*, Research Publications, San Francisco, 1989

Photographic Credits

Copyright by-lines